WONDERS
OF THE WORLD

WONDERS OF THE WORLD

50 Must-See Natural and Man-made Marvels

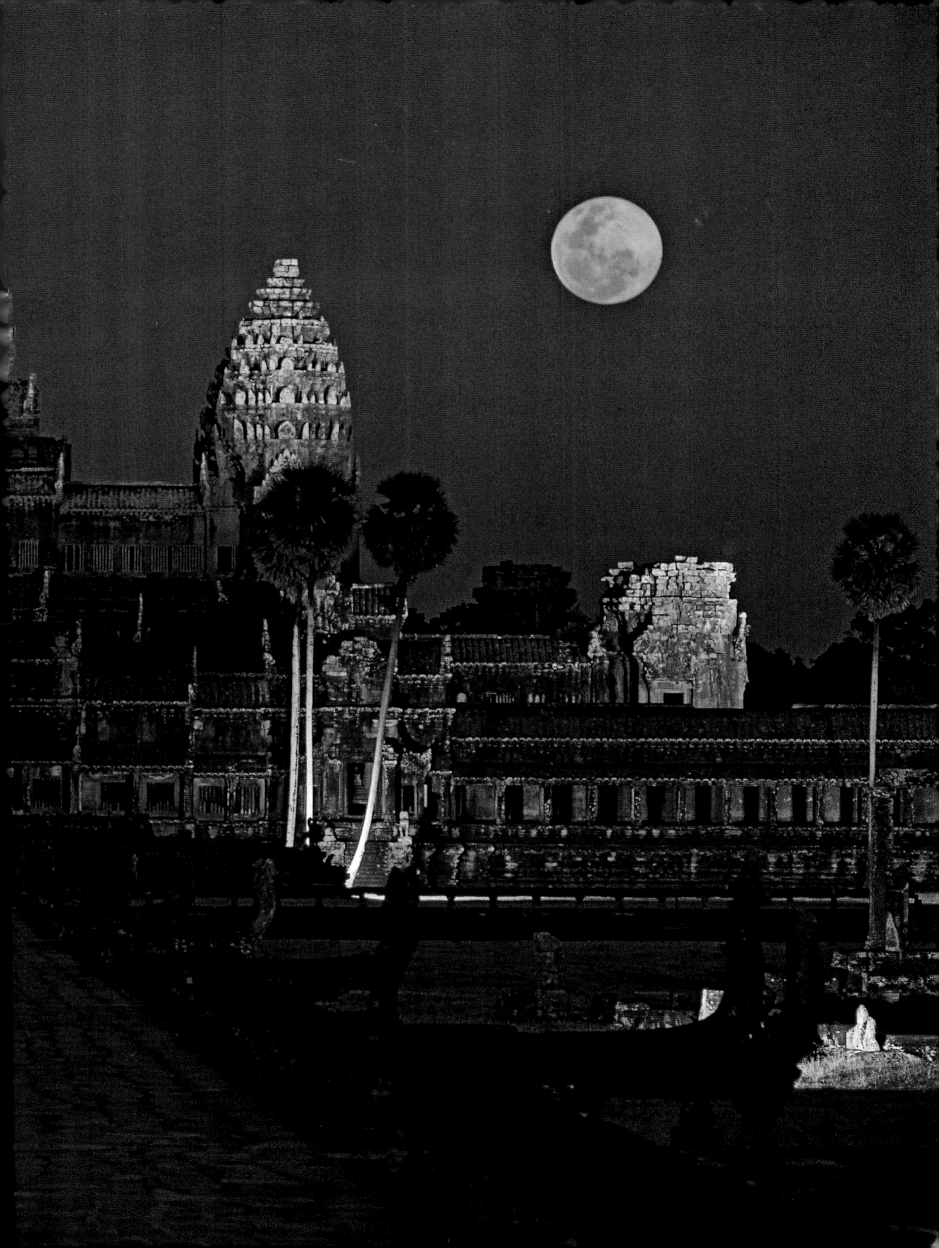

LIFE Books

EDITOR Robert Sullivan
DIRECTOR OF PHOTOGRAPHY Barbara Baker Burrows
CREATIVE DIRECTOR Mimi Park
DEPUTY PICTURE EDITOR Christina Lieberman
WRITER-REPORTER Hildegard Anderson
COPY EDITORS Parlan McGaw (Chief), Barbara Gogan, Danielle Dowling
PHOTO ASSISTANT Forrester Hambrecht
CONSULTING PICTURE EDITORS Mimi Murphy (Rome), Tala Skari (Paris)

PRESIDENT Andrew Blau
BUSINESS MANAGER Roger Adler
BUSINESS DEVELOPMENT MANAGER Jeff Burak

TIME INC. HOME ENTERTAINMENT
PUBLISHER Richard Fraiman
GENERAL MANAGER Steven Sandonato
EXECUTIVE DIRECTOR, MARKETING SERVICES Carol Pittard
DIRECTOR, RETAIL & SPECIAL SALES Tom Mifsud
DIRECTOR, NEW PRODUCT DEVELOPMENT Peter Harper
ASSISTANT DIRECTOR, BOOKAZINE MARKETING Laura Adam
ASSISTANT PUBLISHING DIRECTOR, BRAND MARKETING Joy Butts
ASSOCIATE COUNSEL Helen Wan
BOOK PRODUCTION MANAGER Suzanne Janso
DESIGN & PREPRESS MANAGER Anne-Michelle Gallero
BRAND MANAGER Shelley Rescober

Special thanks to Glenn Buonocore, Jim Childs, Susan Chodakiewicz, Jacqueline Fitzgerald, Rasanah Goss, Lauren Hall, Jennifer Jacobs, Brynn Joyce, Robert Marasco, Amy Migliaccio, Brooke Reger, Ilene Schreider, Adriana Tierno, Alex Voznesenskiy, Jonathan White.

EDITORIAL OPERATIONS Richard K. Prue (Director), Brian Fellows (Manager), Keith Aurelio, Charlotte Coco, John Goodman, Kevin Hart, Norma Jones, Mert Kerimoglu, Rosalie Khan, Patricia Koh, Marco Lau, Brian Mai, Po Fung Ng, Lorenzo Pace, Rudi Papiri, Robert Pizaro, Barry Pribula, Clara Renauro, Donald Schaedtler, Hia Tan, Vaune Trachtman, David Weiner

Published by **LIFE** Books

Time Inc.
1271 Avenue of the Americas
New York, NY 10020

ISBN 13: 978-1-60320-087-5
ISBN 10: 1-60320-087-8
Library of Congress Control Number: 2009928252

"LIFE" is a trademark of Time Inc.

We welcome your comments and suggestions about LIFE Books. Please write to us at:
LIFE Books
Attention: Book Editors
PO Box 11016
Des Moines, IA 50336-1016

If you would like to order any of our hardcover Collector's Edition books, please call us at 1-800-327-6388 (Monday through Friday, 7:00 a.m.–8:00 p.m., or Saturday, 7:00 a.m.–6:00 p.m., Central Time).

Visit Us at **LIFE.com**

TALK ABOUT WONDERS! Talk about Wonders! This is, simply put, the most amazing collection of professional photography on the Web, with millions of iconic images from LIFE magazine's archives, never-before-seen LIFE pictures and up-to-the-minute news photos. And right now you can visit a gallery of more of the World's Wonders. Go to: LIFE.com/books/wondersoftheworld.

ENDPAPERS: Deep space, as seen from the Hubble Space Telescope. Courtesy NASA.
PAGE 1: Mount Everest by Christopher Herwig/Getty. Please see page 108.
PAGES 2–3: Angkor Wat by Larry Burrows. Please see page 46.
THIS PAGE: The Golden Gate Bridge by Jean Du Boisberranger/Aurora. Please see page 78.

Contents

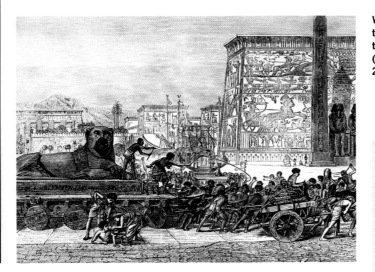

Introduction

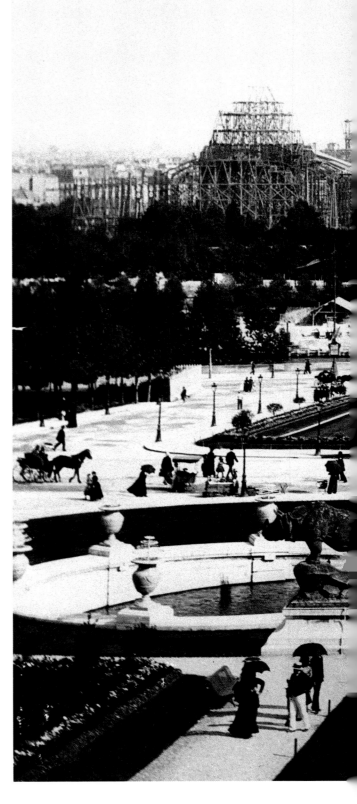

Wonders of the man-made kind take time, care and a ton (or many tons) of work. The Great Pyramid (please see page 12) rises in the 26th century B.C. . . .

Some Kind of Wonderful

There is a Switzerland-based organization called the New7WondersFoundation that has, since its founding in 2001, been engaged in spurring two of mankind's seemingly irresistible urges: to contemplate the world's wonders and to make up lists and rankings. The foundation's first initiative was to come up with a New Seven Wonders of the World collection to replace, or at least considerably freshen, the original, famous set—only one member of which, the Great Pyramid of Khufu in Egypt, was still in existence. To that end, New7Wonders threw open the doors of its Web site and invited the world's citizenry to cast votes. As others in the media (and even governmental agencies) have pointed out, since a person could send in limitless ballots, the competition was hardly scientific. Still, it seems amazing that some 100 million opinions were received in what is considered the largest poll in world history.

We will meet the winning Wonders beginning on page 26 of our book, as well as several candidates in the foundation's latest beauty contest, the New 7 Wonders of Nature, in the section that begins on page 92. The organizers in Switzerland hope that more than a billion people will participate in their Nature contest, which will extend into 2011.

All of this frenzied Web-based activity only serves to confirm: We love our Wonders, and we are genetically predisposed to argue about which of them is most wondrous. It has been ever thus. The idea of ranking man's (as opposed to God's) greatest creations can be traced all the way back to the 5th century B.C., when the Greek historian Herodotus of Halicarnassus, a most peripatetic man, listed some must-sees in his History. His choices, limited to the sacred number seven, included the Great Pyramid, which Herodotus had marveled at during a visit to Giza around 450 B.C., the Hanging Gardens of Babylon and five other constructions.

So the game was afoot with Herodotus, but his was hardly the final list. In fact, four of the seven Wonders that have come to be regarded as the Seven Wonders of the Ancient World (to distinguish them from all the other lists of Wonders that have come in their wake) didn't yet exist in Herodotus's lifetime.

As to what debate ensued concerning his choices, and what discussion went on during the several subsequent edits of his list, we will never know. All we can be sure of is that there was serious debate and discussion. In the 3rd century B.C., for instance, Callimachus of Cyrene, chief librarian of the Alexandria Mouseion, wrote a book called *A Collection of Wonders Around the World.* How Callimachus's opinion differed from Herodotus's is unknown because all that survived the destruction of the library in 48 B.C. was the book's title. A century after Callimachus, Antipater, a minor poet in the Phoenician city of Sidon, also published an account of the world's Wonders. Like Herodotus, Antipater sought to serve as a Baedeker by

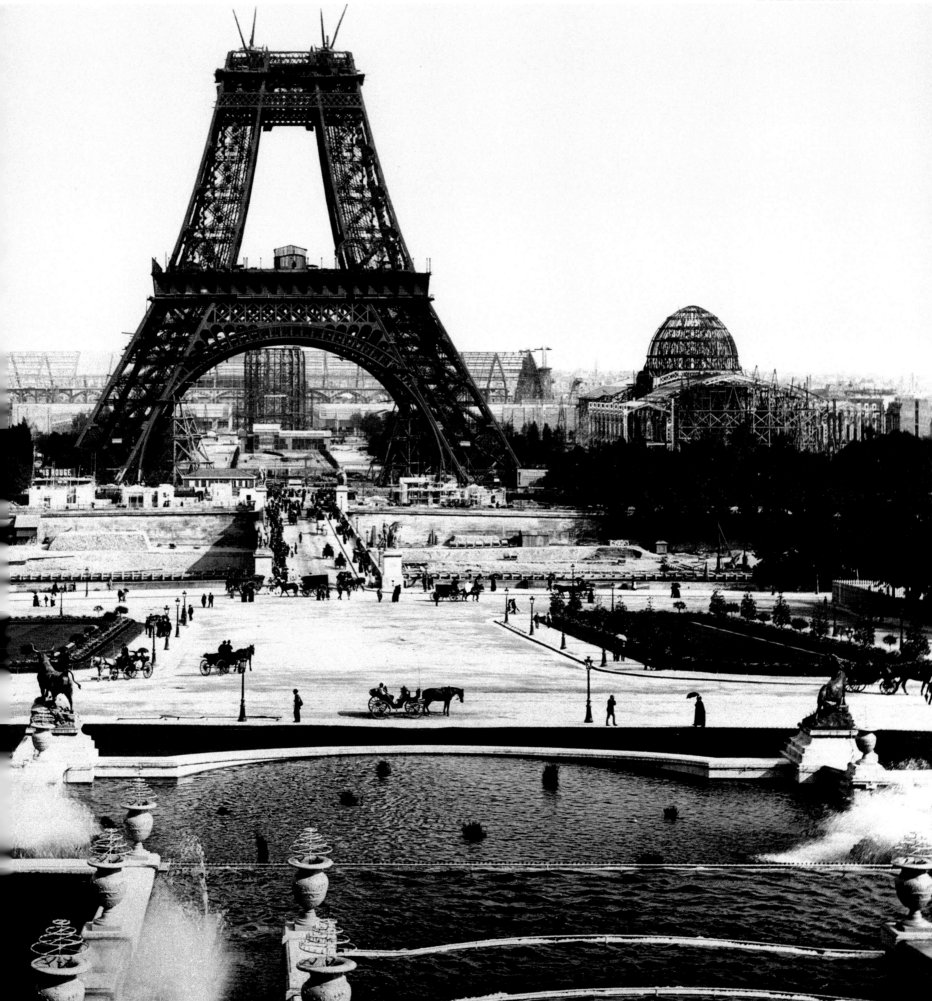

. . . And the Eiffel Tower
(please see page 60) grows
in Paris in the 1880s . . .

Introduction

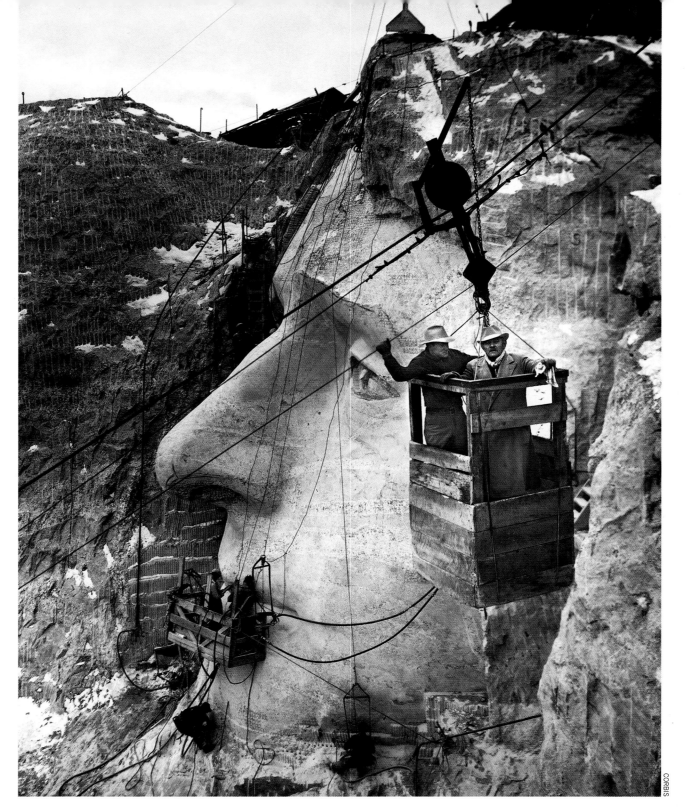

. . . Thomas Jefferson takes shape on Mount Rushmore (please see page 86) in 1935 . . .

CORBIS

recommending certain tourist sites that shouldn't be missed in one's lifetime. His seven included the Great Pyramid, which had been built circa 2551–2528 B.C.; both the Walls and Gardens of Babylon, dating from between 605 and 562 B.C.; Phidias's mammoth statue of Zeus, which rose in Olympia around 430 B.C.; the Temple of Artemis at Ephesus, completed circa 325 B.C.; and the Colossus of Rhodes, which first dominated that city's harbor in 282 B.C.

As we can see, Antipater felt no obligation to limit his list to the antiquities—the last few would have been considered modern in his time. Nor did he discriminate geographically: One of his Wonders was in Europe (Greece's Zeus), four in Asia (the two Babylonian entries, plus the Artemis temple and the tomb of Mausollos, both in Asia Minor, now Turkey), one in Africa (the Great Pyramid) and one on an island in the Aegean Sea, the Colossus in Rhodes.

How could Antipater have passed up the Great Wall of China and England's Stonehenge? The answer is simple: He didn't know they existed. Why did he not include Athens's Parthenon or the Palace of Knossos on Crete, the ruins of which are today quite as mind-boggling as Khufu's tomb? Beats us.

Antipater, in his day, had competition from other compilers, but his collection obviously caught the public's fancy and proved durable. Over the centuries commentators have urged additions and deletions; Rome's Colosseum was often nominated after it was dedicated in A.D. 80, and as

we will see, it is one of the people's choices on the New7Wonders list. But only Babylon's Walls have been dropped from the original, now canonical collection of Wonders, supplanted by the great lighthouse in the Egyptian port city Alexandria, built about the same time as Rhodes's Colossus.

The magnificent seven that we today regard as the Wonders of the Ancient World, the sites of which we will visit on the pages immediately following this introduction, received their final codification late in the Middle Ages when Dutch architect Maerten van Heemskerck (1498–1574), working from Greek source material, depicted them in a series of dramatic engravings. Since then the list has traveled through time unchallenged.

But if aspirant listers couldn't dislodge any of the consensus Ancient Wonders, they could certainly compile lists of other things—and they have. Historians of the late Middle Ages nominated Seven Wonders of the Medieval Mind, including the Colosseum; Stonehenge; the Great Wall; the Catacombs of Kom el-Shoqafa in Egypt; the Leaning Tower of Pisa in Italy; the Hagia Sophia cathedral in Istanbul, Turkey; and the Porcelain Tower of Nanjing in China. At regular intervals there have been groupings of Modern Wonders, and in the section of our book beginning on page 60 we will look at many of today's candidates for such a club. In 1990 the conservation organization CEDAM International came up with a list of Underwater Wonders, and in 1996 the American Society of Civil Engineers, having conducted a worldwide survey, issued a list of seven technological marvels.

8

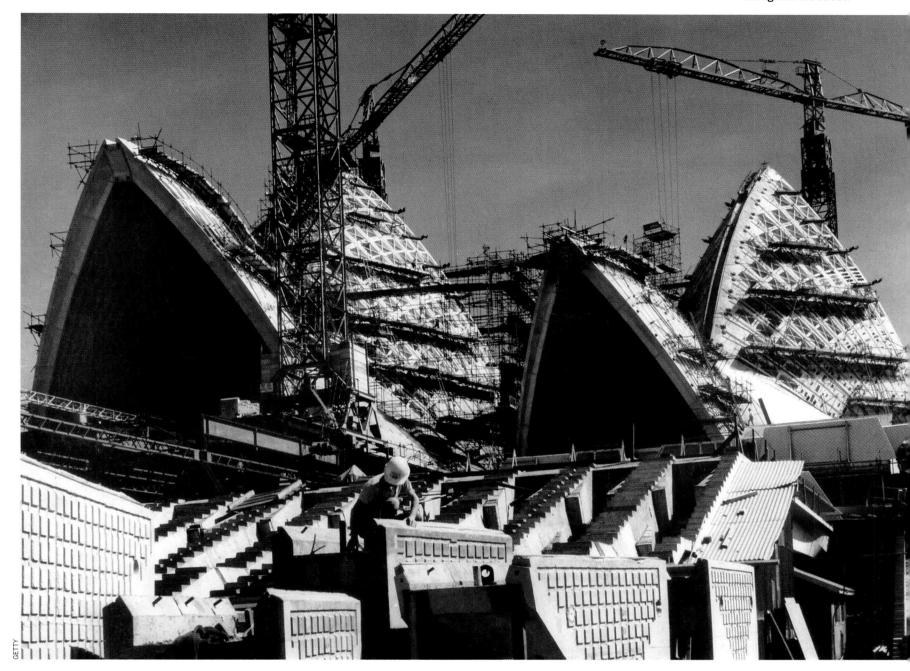

. . . And work continues
on the Sydney Opera House
(please see page 68)
throughout the 1960s.

As the New7Wonders Foundation's second big contest indicates, there has always been an interest in selecting the Natural Wonders of the World. An obvious problem is, there are seven-times-seven such Wonders—and more. Even a casual surfing of the Internet yields Seven Natural Wonders lists that include Mount Fuji in Japan, Mount Kilimanjaro in Tanzania, the Matterhorn in the Swiss Alps, central Australia's Ayers Rock, Italy's Blue Grotto, the island of Krakatoa in the Indian Ocean, Canada's Bay of Fundy, Argentina and Brazil's Iguaçu Falls, Africa's Sahara Desert and Nile River, and, domestically, Yosemite Valley and its giant sequoias in California, the Petrified Forest and the Meteor Crater in Arizona, Niagara Falls, Alaska's Land of Ten Thousand Smokes, Rainbow Bridge National Monument in Utah, Red Rocks Amphitheater in Colorado, Carlsbad Caverns in New Mexico, and Stevie Wonder, citizen of the U.S. and, it can be argued, the wide, wide world.

Most if not all of the lists agree on a Big Three: the Great Barrier Reef, a glittering chain of coral reefs off Queensland, Australia; Mount Everest, the Himalayan peak in south-central Asia that is the world's highest; and the mile-deep Grand Canyon in Arizona. But then things get complicated. Do you go with the world's tallest waterfall, the 3,212-foot-high Angel Falls in Venezuela, or that which is arguably the world's most awesome, Victoria Falls on the Zimbabwe-Zambia border? What more strongly inspires a sense of wonder—Siberia's immense Lake Baikal or Scotland's mystical Loch Ness?

As with our Wonders of Today section, we do not confine ourselves to a mere seven in our chapter on the natural world. We offer up twice seven—14—instead. Any fewer than that simply seemed unfair.

Besides, who are we to say what's what? There's a contest ongoing right now, and you, too, can play. Make up your own list, as many have before you.

We at LIFE did just that in putting together this deluxe edition of our book: We came up with The Seven LIFE Wonders, a collection of natural and man-made majesties that, we felt, our readers might like to hang on their walls at home. Then we went to our vast photography archive and selected choice prints by seven famous LIFE photographers and, using a technique that we first employed in last year's *Classic Collection* book, we inserted the prints in a special section beginning on page 128. As you will find: When you remove the print, the picture still exists on the page, so your beautiful book remains whole.

Enjoy these pages, then, and these prints. Perhaps they will inspire you to venture forth and seek out some of these Wonders for yourself. We hope so. Take our urging, and that of none other than the immortal bard, William Shakespeare, who wrote in *Two Gentlemen of Verona:*

I rather would entreat thy company
To see the wonders of the world abroad,
Than, living dully sluggardiz'd at home,
Wear out thy youth with shapeless idleness.

9

Two Buddhist monks confer in a doorway of one of the Angkor Wat temples in Cambodia, which constitute a Wonder from antiquity that is still active today. Please see page 46.

Wonders of Old

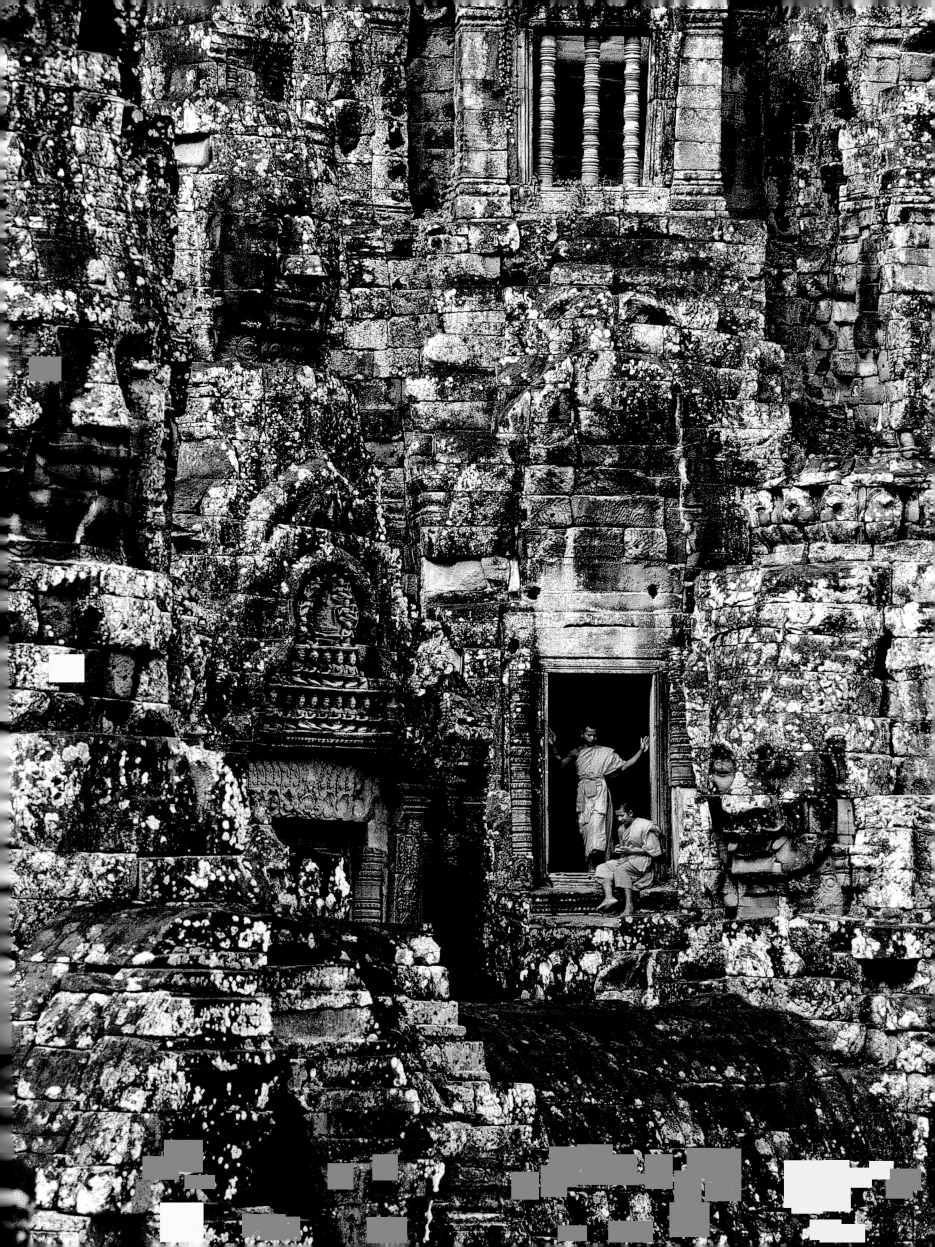

The 7 Original Wonders

The Great Pyramid of Khufu

Egypt's King Khufu (circa 2551–2528 B.C., also known as Cheops or Suphis) ruled for two dozen years during the Fourth Dynasty (2574–2465 B.C.) and was rumored to have been quite a tyrant. Beyond that, and the fact that he was the son of a pyramid-building king named Snefru, precious little is known about him. He clearly approved of Egypt's Old Kingdom tradition of erecting pyramid-shaped superstructures to encase royal tombs and chose the plateau of Giza, on the west bank of the Nile across from Cairo, as the site of his own.

It is believed that 100,000 men worked on the pyramid for up to four months each year for at least 20 years. The word *toil* doesn't begin to tell the tale. Consider that the pyramid's 2,300,000 blocks of stone average 2.5 tons apiece; consider that the blocks had to be dragged by teams of men up

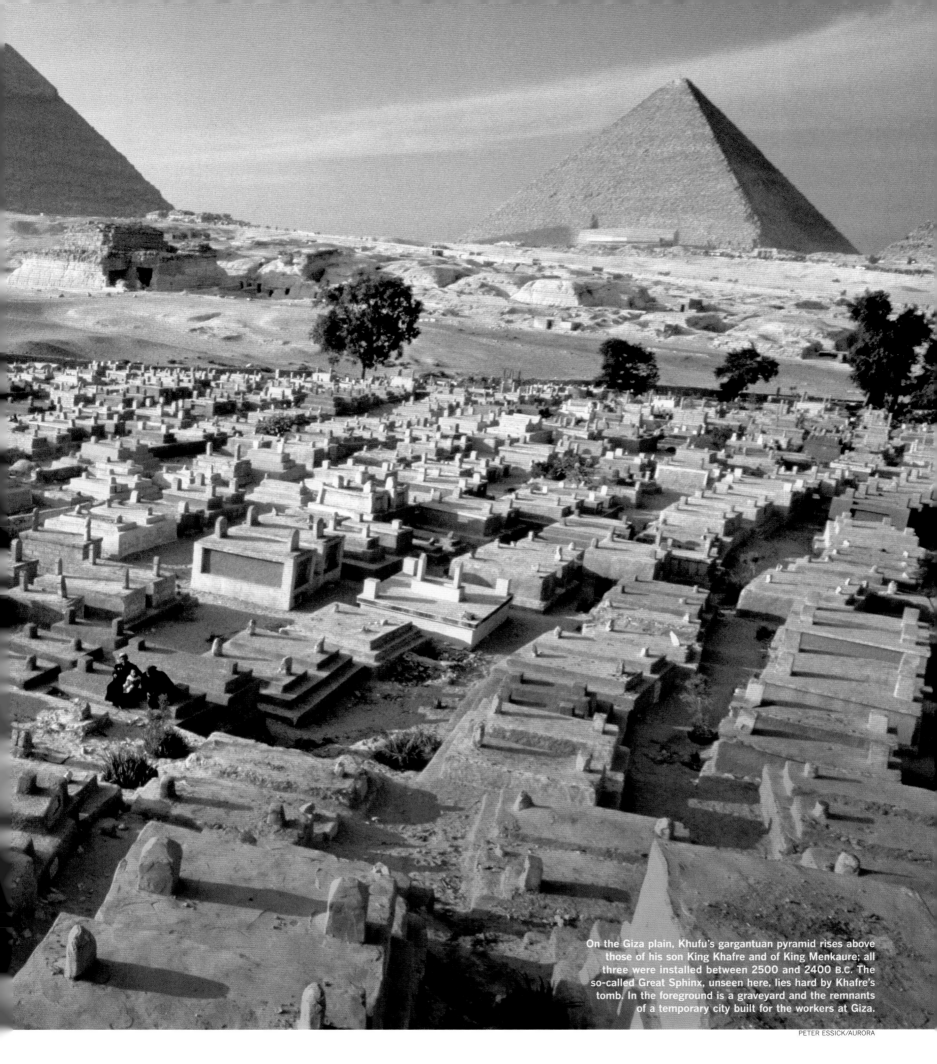

On the Giza plain, Khufu's gargantuan pyramid rises above those of his son King Khafre and of King Menkaure; all three were installed between 2500 and 2400 B.C. The so-called Great Sphinx, unseen here, lies hard by Khafre's tomb. In the foreground is a graveyard and the remnants of a temporary city built for the workers at Giza.

ramps made of mud and brick, and that the ramps then needed to be raised to begin work on the edifice's next level; consider that only the interior stones were quarried nearby because Khufu's architect wanted to use a better-quality white limestone for the casing layer, and this high-grade rock had to be brought from quarries on the other side of the Nile at Tura, then up from a harbor at the plateau's edge; consider that dense granite blocks were required for the burial chamber in the pyramid's center and to serve as plugs for the corridors, and that the heavy granite could be supplied only by a quarry in Aswan, nearly 600 miles south; consider that the pyramid was designed to grow to a height of 481 feet (having lost its uppermost stones to Arab invaders circa A.D. 650, it is now about 450 feet tall) and that its base spread over 13 acres . . . and then consider that ancient man, through blood, sweat and no doubt a considerable flow of tears, pulled it off. We wonder at that still.

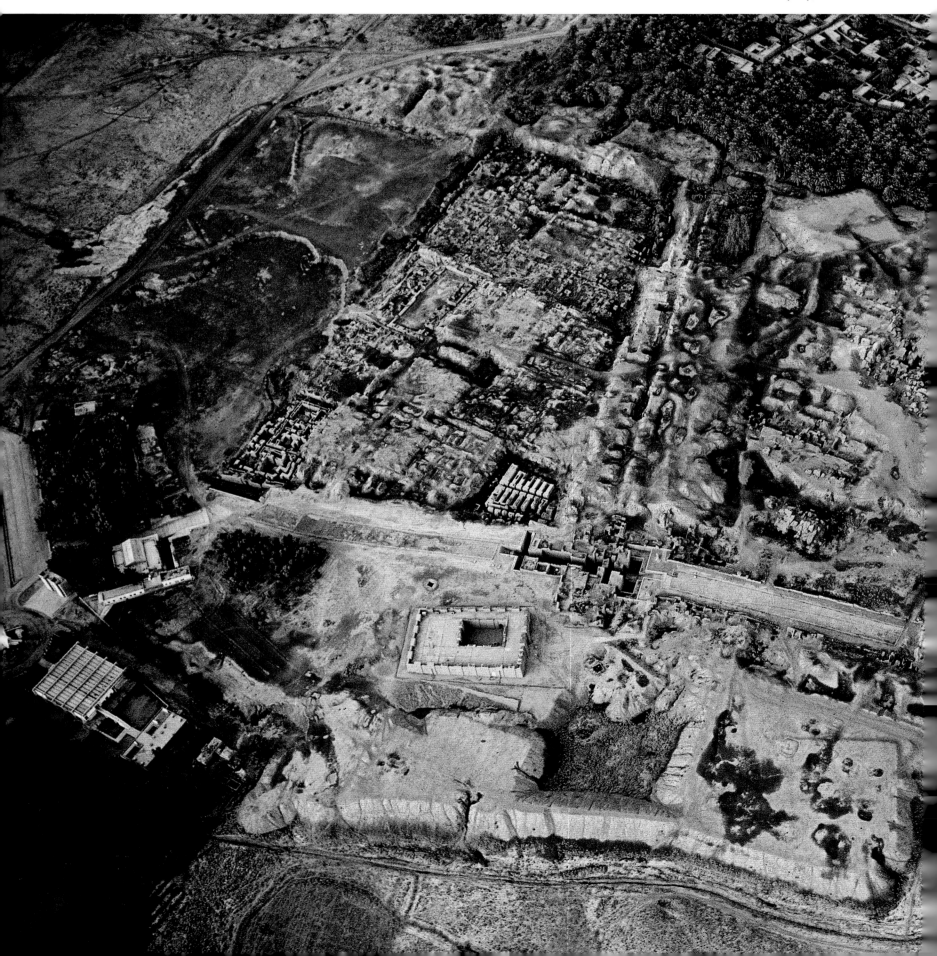

The ruins of Babylon (right), where once there might have been a garden. Below: An overview of Nebuchadrezzar II's city, with the Southern Palace at left and the Northern at right. Were the gardens located in vaulted structures found in the lower right quadrant of the Southern Palace? Or up top, near the river?

NIK WHEELER/CORBIS

GEORGE GERSTER

The Hanging Gardens of Babylon

The story of the Hanging Gardens reads like a fairy tale, and that is as it should be. Set in the 6th century B.C., it goes like this: Nebuchadrezzar II, ruler of Babylon, senses that his wife's lassitude is due to the bland, baked Mesopotamian landscape, a dreary contrast to the lush mountain greenery of her Persian birthplace, Media. To ameliorate Amyitis's gloom, the king orders a fantastic, many-storied brick-and-bitumen structure with terraces, from which all manner of flora would sprout, their life support being a complex irrigation system that draws water from the Euphrates. Amyitis is delighted by her husband's sympathetic gesture, and Nebuchadrezzar is pleased to see his wife's spirits brighten. Everyone in Babylon lives happily ever after.

Some of the above might have actually happened, or none of the above might have happened. There are no contemporaneous accounts of any majestic gardens, hanging or otherwise, and it is an interesting, if melancholy, fact that one of the most inspiring and poetic of the Seven Wonders of the Ancient World may be purely mythical.

What we think we know of the gardens, unconfirmed by any Babylonian cuneiform or evidence in archaeological digs in present-day Iraq, springs from the accounts of Greeks writing just before the time of Christ's birth (in other words, more than five centuries after the gardens were believed to have been planted). Perhaps finally putting oral tradition to the page, Strabo, a geographer, wrote, "It consists of vaulted terraces, raised one above the other, and resting upon cube-shaped pillars. These are hollow and filled with earth to allow trees of the largest size to be planted." The historian Didorus Siculus wrote more gloriously of the entire effect: "This garden was four hundred feet square, and the ascent up to it was as to the top of a mountain, and it had buildings and apartments, out of one into another, like unto a theater."

Stunning. If it ever existed.

In the ruins of ancient Babylon, vaulted structures have been found within the site of the Southern Palace, and theories have blossomed. But while the city's famous surrounding wall has been located, the gardens have not. Alas.

The Colossus of Rhodes

"But even lying on the ground, it is a marvel," observed Pliny the Elder. Good thing, for the Colossus was upright for a mere 60 years or so, the shortest-lived of the Ancient Wonders (unless, of course, the Hanging Gardens never lived at all).

By accounts, it was a celebratory tribute to the Greek sun god Helios, patron of the island of Rhodes, just off the coast of what is now Turkey, in the Aegean Sea. After successfully weathering a siege and reaching a peace agreement with the expansionist Macedonians in 304 B.C., the Rhodians decided to build a statue. Planning took several years and construction another dozen. No machine existed to hoist materials, so a

hill surrounding the statue had to be built higher at each stage, and as much as 10 tons of iron (for the frame) and 15 tons of hammered bronze (for the skin) were brought up and put in place. With sunrays crowning Helios's head, the 110-foot-tall Colossus was finished in 282 B.C. Circa 226 B.C., a violent tremor shook Rhodes, and the big guy suffered a knee injury. With such huge statuary, a lower joint is among the weakest points, and the Colossus came crashing down.

The ruins of Rhodes's monument lay in state for nearly a thousand years. In A.D. 654, Arabs invaded, sacked the city and sold the Colossus's remaining parts to a Syrian. It was said that 900 camels were required to transport the metal to the man's home.

The question many have asked, inspired by old etchings and engravings, appears to have a simple answer, and that is yes: The Colossus of Rhodes did inspire French sculptor Frédéric-Auguste Bartholdi when, in the 19th century, he fashioned his most famous work as an offering to the United States of America. The Statue of Liberty, a Wonder in and of itself, was not only colossal in conception; in framework and covering, it was built in much the same way as the Colossus—extraordinary testimony to the engineering and artistry that was in effect so long, long ago.

Today, bronze deer on pillars are said to mark the footprints of the ancient Colossus—but the deer tell a lie. They flank the entrance to Mandraki Harbor, and the romantic tradition handed down by Rhodians of yore is that their metallic giant straddled this gateway to the city. But such a Colossus, with legs so wide apart, would have been impossibly huge. The statue was possibly on a point east of the bay.

Right: The foundation of the temple as it exists in ruins continues to impress, suggesting the power that the place, and its centerpiece statue, once held. Opposite: Lions' heads that once decorated the temple; and (bottom) a stone portrait of Heracles, son of Zeus.

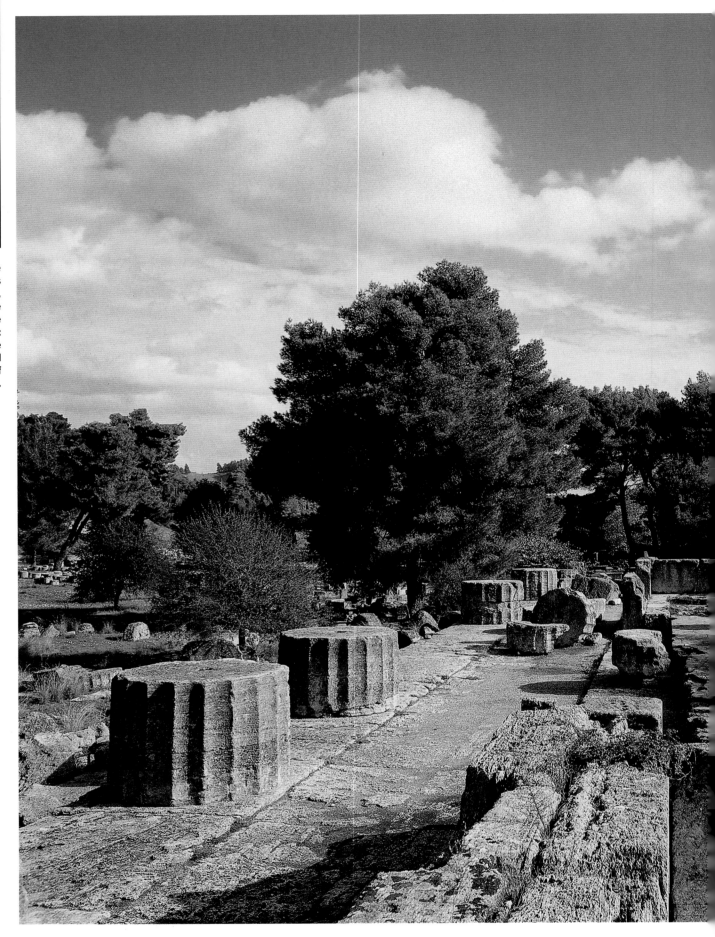

The Statue of Zeus at Olympia

In the 5th century B.C., a statue was wanted for a Doric temple that had been built in Olympia, a Grecian town best known for having hosted those eponymous athletic events each quadrennial since 776 B.C. The right man for the job was clearly Phidias, an Athenian sculptor who had mastered a technique for making massive replicas out of wood, ivory and gold, and whose 40-foot-tall statue of Athena was the main attraction in the Parthenon's central hall. Soon after that masterwork was dedicated in 438 B.C., Phidias ventured west and set up camp in Olympia, there to create Zeus.

In his workshop adjacent to the temple, he fashioned pieces of the statue's core, which would eventually contain 27,545 cubic feet of wood, for later assembly in the temple. To these would be affixed ivory and plates of gold. The figure that Phidias designed was of a seated Zeus, a scepter in his left hand. "On his head is a sculpted wreath of olive sprays," wrote Pausanias. "In his right hand he holds a figure of Victory made from ivory and gold . . . His sandals are made of gold, as is his robe."

The completed statue—40 feet tall upon a base 20 feet wide and three feet high, thoroughly filling the temple's west end—honored the god of gods and drew flocks of worshippers to Olympia. However, when religious observance in the region changed, the statue's fate became dicey. In

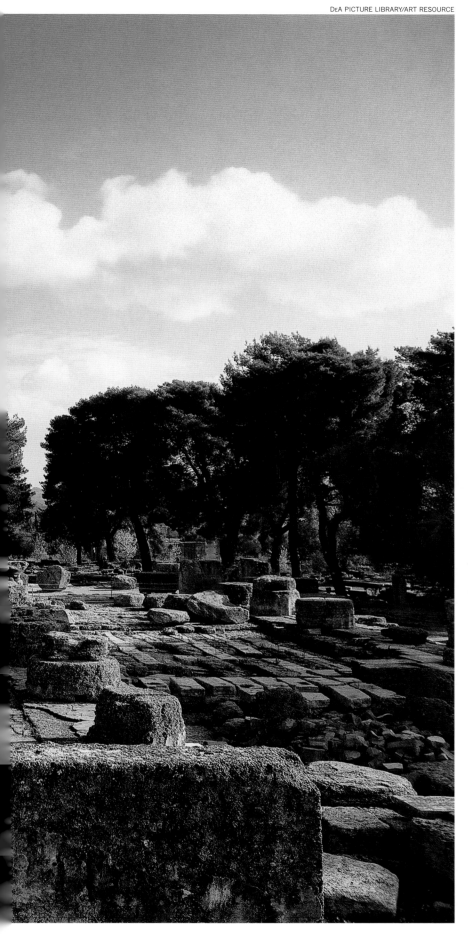

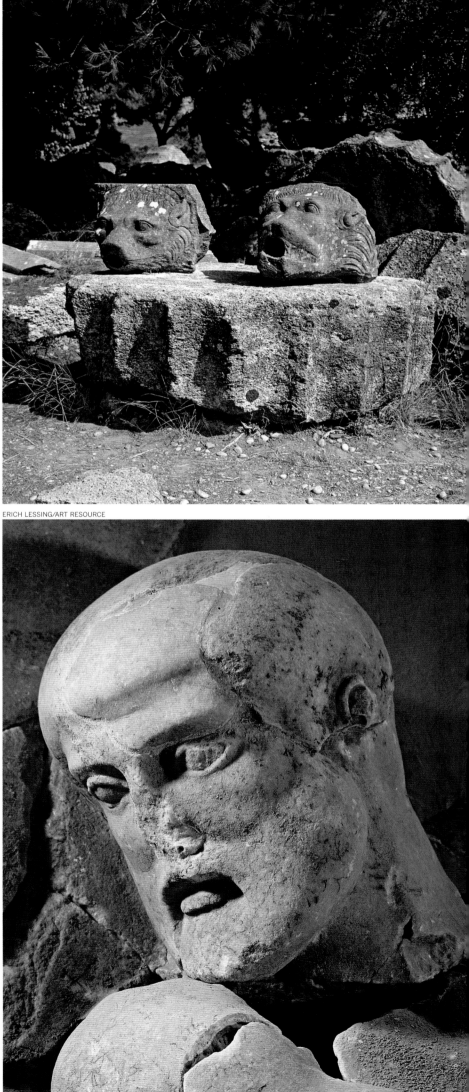

A.D. 393 the Christian emperor Theodosius I declared the Olympic Games a pagan extravaganza and shut them down, meanwhile ordering the Zeus temple closed. Varying reports have the statue then being moved to Constantinople, or destroyed by Theodosius II in the 5th century, or finally obliterated by an earthquake. Fragments of the statue turned up in an 1875 dig, and later excavations found the site of Phidias's workshop and clay molds that had served in the making of Zeus. They testify to an artistic creation on a superhuman scale, suggesting the awe Olympians must have felt for the giant god overlooking them from the hilltop.

What you are looking at here is not the mausoleum; that was destroyed more than 500 years ago. In this picture we see the Castle of St. Peter glowing above the resort city of Bodrum, Turkey. This was the grand palace built by invading Crusaders, who freely helped themselves to the stones of Mausollos's nearby tomb, with little regard for the dead.

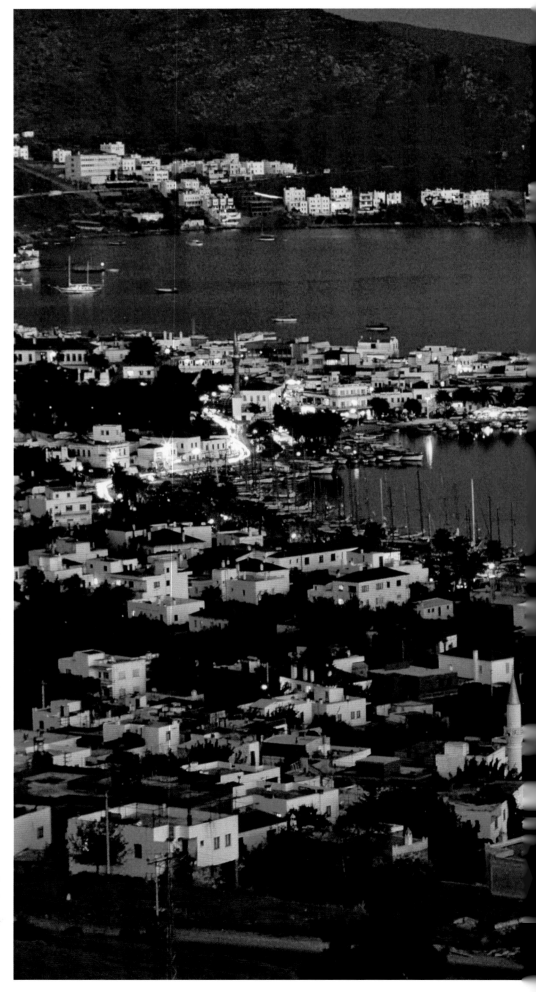

The Mausoleum at Halicarnassus

It might be supposed that this structure had everything to do with King Mausollos of Caria, not least since the grandiose tomb bequeathed to the world a word for all grandiose tombs. But, in fact, the construction of the world's first mausoleum has as much to do with a woman named Artemisia, who was Mausollos's sister, wife and grief-stricken widow.

Mausollos, a leader of the kingdom of Caria in Asia Minor in the 4th century B.C., was a study in contrasts, a man from a society of shepherds and rustics who, himself, had Grecian impulses and manners; a ruthless warlord who nevertheless dreamed of a brotherhood between Greeks and non-Greeks, and who tried to transform his capital in Halicarnassus into a mini-Athens. He died in 353 B.C. Either just before or just after his death, Artemisia commissioned a memorial suitable for her sibling-spouse. She would not challenge the pyramid-mad Egyptians in erecting the world's biggest tomb but would outdo them in style. She raided Greece and made off with its best architects and artists, assembling a veritable all-star roster. Pythias drew designs; Timotheus, Bryaxis and Leochares made statues. Scopas, sculptor of sculptors, left his job at the Temple of Artemis at Ephesus to help with this other major project. The fruits of their labor—a six-acre site whose focal point was a burial chamber encased within a temple that sat upon a 125-by-105-foot podium and included a crowning 24-step pyramid with a four-horse chariot statue for a hat—were beyond stunning.

After Artemisia died, the king and his queen rested in peace there for many centuries. An earthquake shook them up along the way, knocking blocks from the mausoleum's roof, but it wasn't until the Crusades of the late 15th century that the tomb came under mortal pressure. The invading Knights of Saint John of Malta decided to build a castle. In 1494 they began disassembling the temple, and by 1522 all major stones had been carted away for other uses. Today, in the still-standing crusader castle in nearby Bodrum, massive marble blocks glisten, whispering that they were intended for Mausollos, with love, from Artemisia.

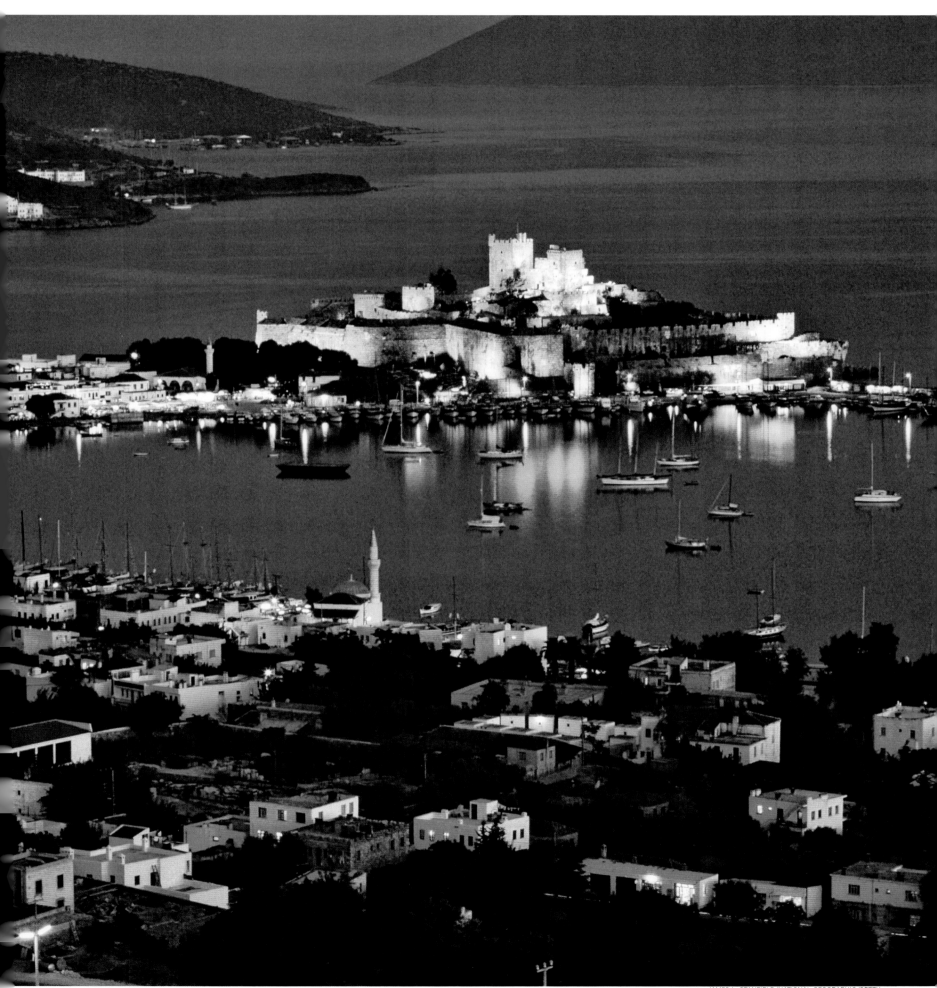

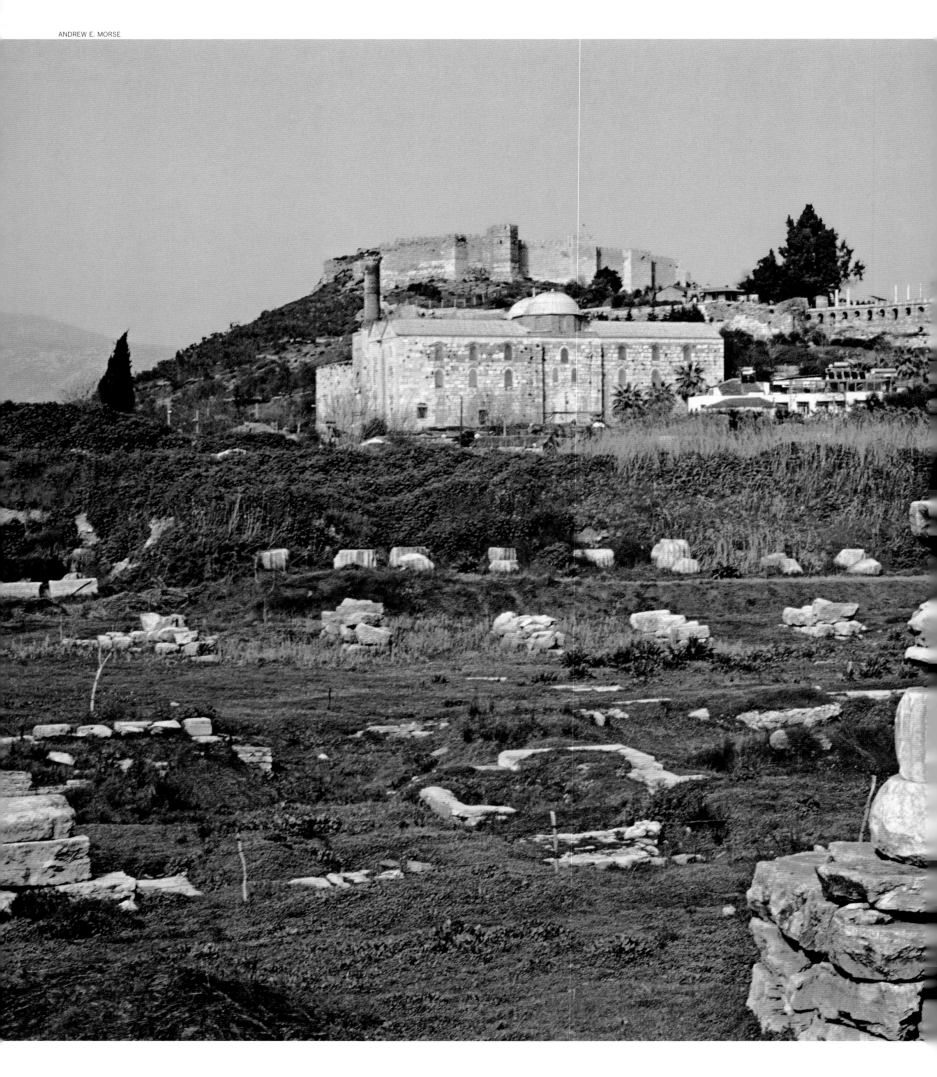

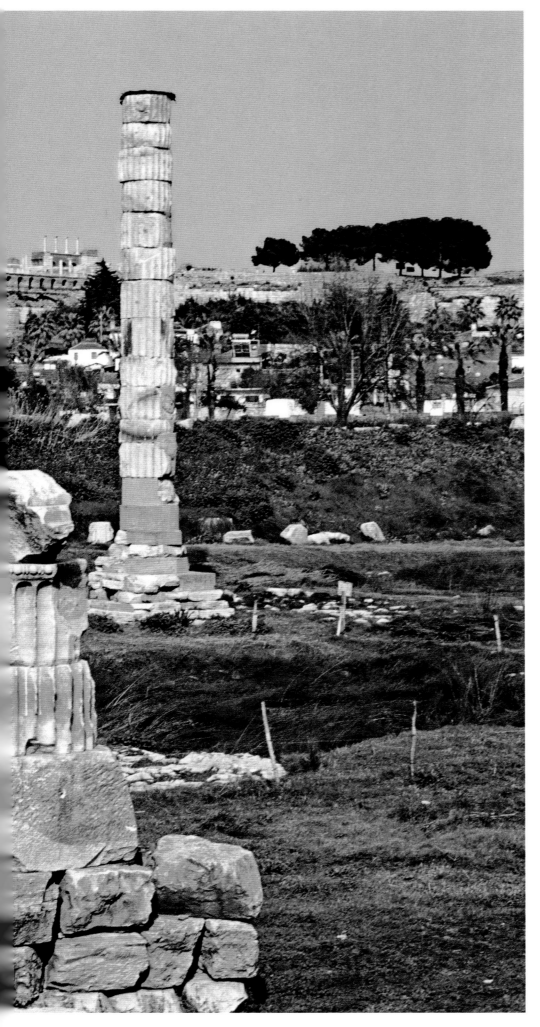

The site of ancient Ephesus and the adjacent town of Selcuk are rife with ruins from various periods, piled one upon another. This Artemisian pillar stands very nearby the remains of a 6th century basilica built by Emperor Justinian and just down the hill from a Byzantine fort built by the Turks.

The Temple of Artemis at Ephesus

"But when I saw the sacred house of Artemis that towers to the clouds," our list-making friend Antipater wrote rapturously, "the [other six Wonders] were placed in the shade, for the Sun himself has never looked upon its equal outside Olympus."

Artemis, goddess of fertility in Asia Minor, held a particular thrall in Ephesus, a city approximately 30 miles south of what is now the Turkish city of Izmir. (As evidence of Artemis's power in the area, consider that when Saint Paul tried evangelizing in Ephesus in the wake of Christ's dramatic life, he couldn't budge the locals from their devotion to the goddess.) While the foundation of the temple that would honor her was built in the 7th century B.C., the base lay bare for decades until Croesus, the fabulously wealthy king of Lydia who had recently conquered Ephesus, commissioned a plan from the architect Cherisphron. The man's masterwork was made of marble, and it was wider and longer than a football field—much larger than the Parthenon—and surrounded by rows of columns on four sides. There was an immense altar in a separate building that faced the temple, and the entire site inspired deep reverence in worshippers of Artemis in much the same way that the Vatican, which we will visit later in our book, influences Christians today.

Modern excavations have revealed that the goddess—and the temple—received offerings from pilgrims from as far away as Persia and India. But one man, clearly, was troubled by all this. After standing for two centuries, the temple was burned down in 356 B.C. by a disturbed individual named Herostratus who was seeking either notoriety or immortality or both. Artemis herself could not be so easily destroyed, and in the next several decades a similar but even larger temple, sponsored in part by Alexander the Great, the new conqueror of Persia, rose on the spot. In A.D. 262 the Goths wrecked this second iteration, and by then, Christianity was on the march, with converts being made day by day. When Saint John Chrysostom ordered the temple destroyed for good in 401, it was the rare Ephesian who much cared.

Below: During excavations in and around ancient Alexandria in the 1990s, a diver has an inscrutable encounter with a sphinx that predates even the Pharos. Right: The immense statue of Ptolemy II emerges from the depths after centuries of immersion.

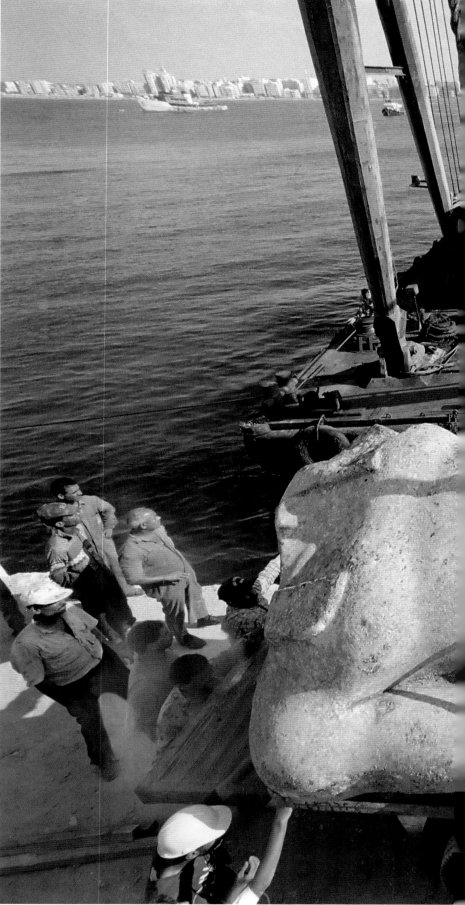

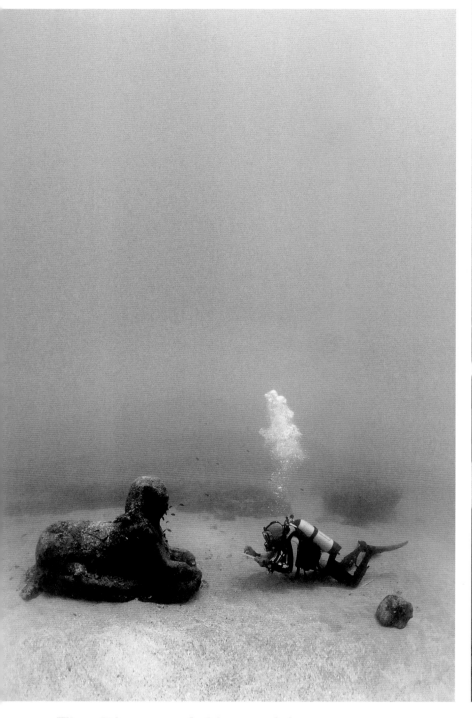

The Pharos of Alexandria

First an island lent its name to a strange building, then the building gave the world a word meaning "lighthouse." The island in Alexandria's harbor was Pharos, and after two Egyptian rulers, Ptolemy I and Ptolemy II, oversaw construction of a skyscraper with a fire at its summit, the phrase *sailing in by Pharos* circulated among mariners. Soon the island and its beacon were synonymous, and today, *faro* means "lighthouse" in Italian and Spanish, while *phare* is the word in French.

Ptolemy I was Alexander the Great's successor and enjoyed a four-decade reign, during which Alexandria grew to be a golden city. The bustle in its port was increasing daily when, in 290 B.C., Ptolemy ordered a lighthouse built—one larger and more effective than any other. The project was seven years old when Ptolemy died circa 283 B.C. His son and successor watched as perhaps another 15 years of work went into the lighthouse. Limestone and granite blocks of up to 75 tons were quarried and dragged to the site; newly devised hoisting systems, which might

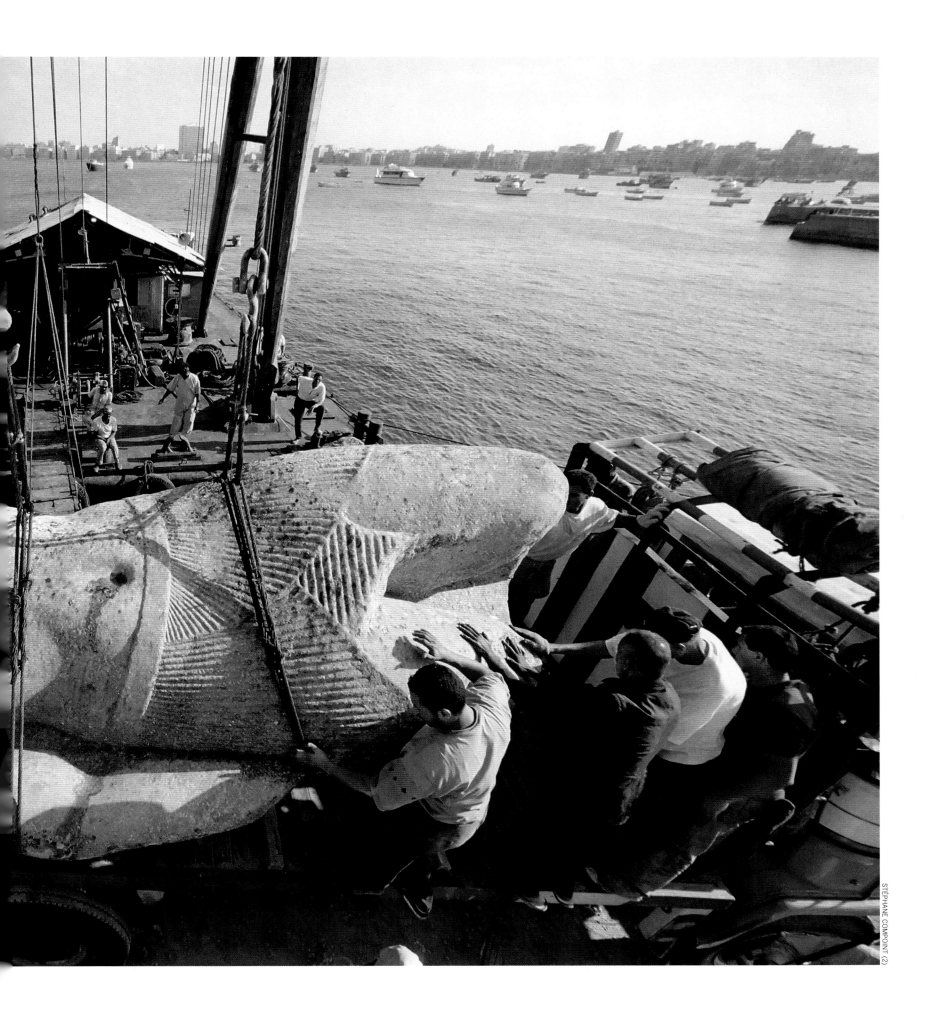

have involved early cranes, lifted them into place. Sculptors fashioned immense statues of Poseidon and Ptolemy II to grace the lighthouse. The lower square tier was finished, then the octagonal middle level and, finally, the cylindrical cupola to house the flame. The 400-plus-foot lighthouse, which finally came online circa 270 B.C., was the world's second tallest building after the Great Pyramid, a status it would retain for nearly 17 centuries. Even today, it would stand proudly—if curiously—alongside 40-story office towers.

As mentioned, the lighthouse was remarkably long-lived, lasting until it was felled by an earthquake in the 14th century, and so we can rely on historical accounts. In the 10th century, the Moorish scholar Idrisi wrote: "It is kept lit night and day as a beacon for navigators throughout the whole sailing season; mariners know the fire and direct their course accordingly, for it is visible a day's sail away. By night it looks like a brilliant star; by day one can perceive its smoke." A day's sail in Idrisi's time could have been a hundred miles, so the Pharos's reach was vast indeed.

The 7 New Wonders

The statue of Christ the Redeemer towers over the 8,150-acre Tijuca National Park, one of the world's largest urban forests; the shining city of Rio de Janeiro spreads out beyond. Rising out of the harbor like a breaching whale is another of Rio's signature attractions, Sugarloaf Mountain.

Christit the Redeemer

T his Wonder is in the tradition of the Artemis Temple and the Statue of Zeus at Olympia in that it is a titanic structure built in tribute to a titanic religious figure.

From the first imagining of a statue to grace the top of Rio de Janeiro's stunning Corcovado Mountain, which rises 2,310 feet above the city's equally sensational harbor, Christianity was to be the theme. In the mid-19th century, Pedro Maria Boss, a local priest, tried—unsuccessfully—to get Brazil's Princess Isabel to free up funds for a religious monument on the summit. The idea was revisited in the 1920s at the instigation of the Catholic Circle of Rio, which raised donations, circulated a petition and solicited designs. It seemed initially that Carlos Oswaldo's sketch of Jesus carrying his cross might be built, but when engineer Heitor da Silva Costa and French sculptor Paul Landowski joined the effort, the open-armed Christ was chosen. The project, which took nine years, cost $250,000 and yielded, on October 12, 1931, a 120-foot-tall, 700-ton reinforced concrete marvel. In its welcoming attitude above the glittering city, it seemed the most suitable monument in the world.

The outer layers of the statue are soapstone, chosen at the time because it is easy to work with and durable. That decision turned out to be invaluable in 2008 when a violent thunderstorm wreaked havoc in Rio. Christ the Redeemer took a direct lightning hit, but was unharmed, as soapstone is an effective insulator.

There is a postscript to this inspiring story that, it should be noted, in no way diminishes the statue's wonderfulness. We said in the introduction to our book that the New7Wonders poll was hardly scientific because a voter could cast an endless stream of ballots. The folks in Brazil saw opportunity in this rule. Millions of corporate dollars were spent in the *Vote no Cristo* (Vote for the Christ) campaign, but whether this caused Rio's marvelous icon to rise above strong runners-up such as Stonehenge, the Acropolis and the Eiffel Tower (all of which we will visit later in our book) will never be known.

This is a small section of the Great Wall at Jinshanling in Hebei Province. The wall is composed of sundry elements, including brick, masonry, hardened earth, pebbles, palm fronds and tree trunks. In recent centuries, many of these materials have been purloined by local peoples needing supplies for their villages.

The Great Wall of China

In a book bearing a considerable cargo of superlatives, let's briefly lighten the load by noting that while the Great Wall of China is indeed the largest man-made thing on our planet, it is not visible from the moon, as so many believed for so long. NASA points out explicitly that the wall is hard to see from the space shuttle, let alone from the lunar satellite.

Having said that, this huge barrier boasts some serious statistics. It extends for 1,678 miles from east to west, but if early sections are included, the total length—owing to loops at various points, and segments where there are double, triple and even quadruple walls—amounts to some 6,214 miles, or more than a fifth of the earth's circumference.

Shi Huangdi, the first ruler of a unified China, conceived some 22 centuries ago the notion of connecting existing ramparts into a monolithic palladium sufficient to comfort an emperor. Smoke signals by day and fires by night would announce intruders. The backbreaking labor was carried out

by captured foes—China's main enemies at the time were nomadic tribes of the northern steppes—plus any peasants who were not vital to agricultural needs. Soldiers stationed along the wall both guarded against belligerents and kept the workers busy at their posts. It is said that for every new yard of construction, there was a corresponding fatality. During the Ming Dynasty, an epic renovation was performed, leaving the wall in a state similar to its present form.

The rest of the tale of the tape is as follows: The wall is 19 feet wide at its base and 15 feet at its top. It stands nearly 30 feet high, and there are gatehouses at varying intervals and watchtowers about 230 feet apart. The wall long served its purpose by frustrating countless potential attackers from the north. Along the way, it has further contributed to the nation as an important icon in popular Chinese culture: the stuff of myth, poem, opera. And today, of course, it's a world-beating tourist attraction.

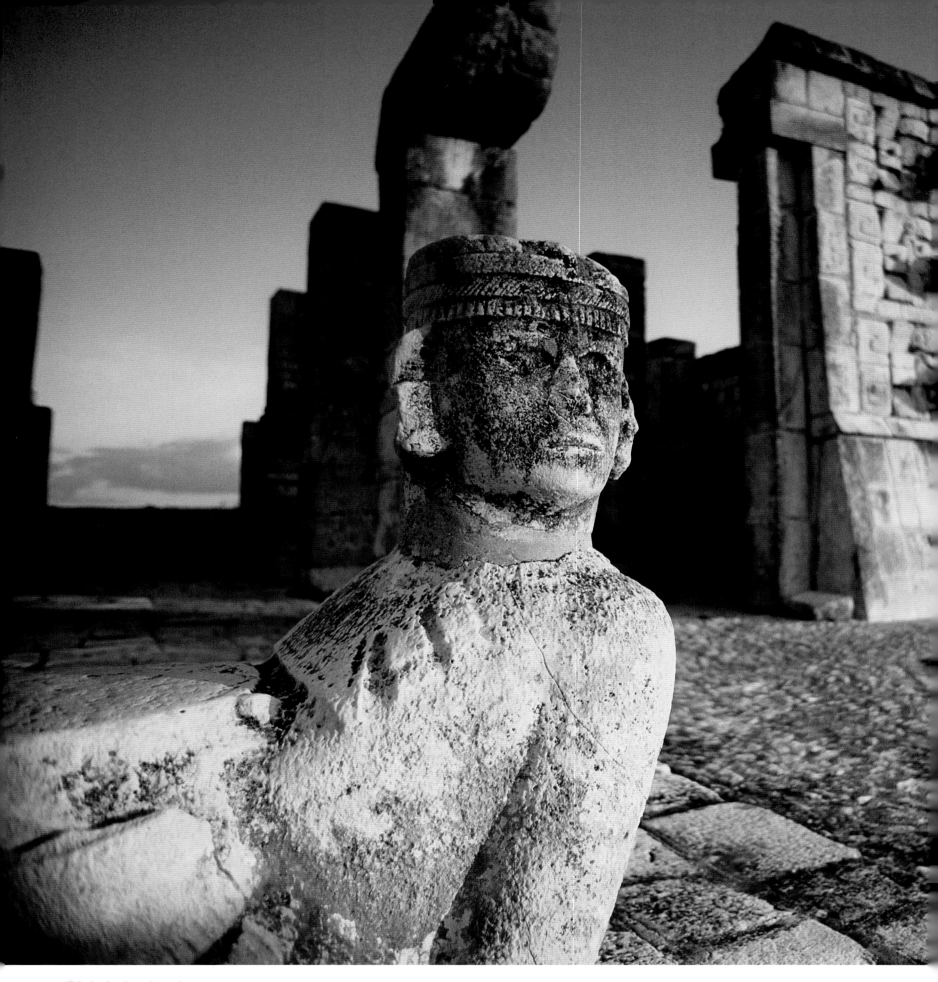

Chichén Itzá

When the New7Wonders folks unveiled the winners of their global contest in 2007, few Wonders watchers wondered why the Colosseum, the Taj Mahal and the Great Wall of China had made the list. But it's safe to say that not everyone was well versed in the story of Chichén Itzá. Machu Picchu they knew about, and they welcomed its inclusion. But what and where is Chichén Itzá?

Well, it is in Mexico, and if it is less well known than other Wonders, it is nonetheless a captivating locale: a six-square-mile site where hundreds of buildings once existed, and where approximately 30 remnants continue to fascinate. Specifically, it is located on the phenomenal Yucatán Peninsula.

Here, some 1,600 years ago, natives began building an agrarian community. Puuc Mayan–style temples and palaces constructed in the 7th century indicate an evolution to an urban center of religious and cultural significance, and by the late 8th and early 9th centuries, a group called the Itzás was in charge of the city. Mayan tradition puts the decline of Chichén Itzá in the early 13th century, but recent evidence found seems to indicate the fall came much earlier. Regardless, before this major economic and political center of the northern Mayan Lowlands collapsed (or at least faded in significance), the Itzás and whoever else lived here erected some extraordinary constructions, several of which can still be seen: the Observatory, the Temple of the

BOB KRIST/CORBIS

Left: The statue keeping watch outside the ruins of Temple of the Warriors is one of many at Chichén Itzá of the Chac-Mool type: a human figure reclining and attentive. What this pose signifies remains uncertain. Below are two buildings that indicate how important astronomy and the calendar were to the people who lived here. Each of El Castillo's four steep sides has 91 steps, for 364 in total, and the platform on top makes 365— one for each day of the year. At the bottom: The Observatory.

TODD KOROL/AURORA

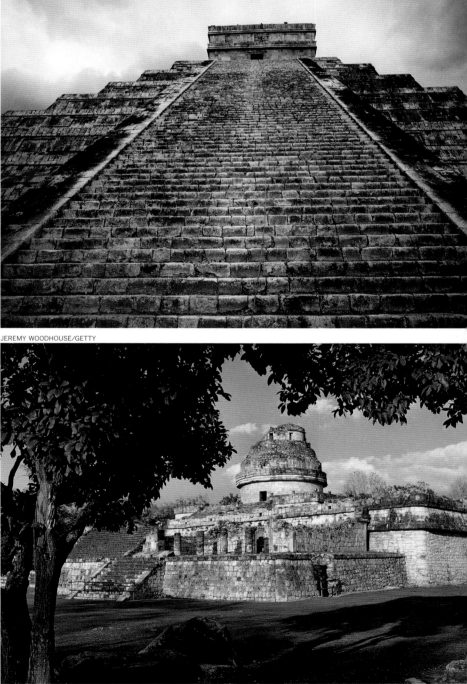

JEREMY WOODHOUSE/GETTY

Warriors, the Ball Court, the Plaza of a Thousand Columns and other buildings with galleries and decorated colonnades. Today, the signature structure is Kukulkan's Pyramid, also known as the Temple of Kukulkan or simply El Castillo (the Castle). This stepped edifice is approximately 75 feet tall with an astronomical orientation. At a certain time of day on the spring and autumn equinoxes, a 37-yard-long shadow grows on the west side of the north staircase—the shadow of the plumed serpent, Kukulkan. Yikes!

And speaking of yikes: By no means was everything sweetness and light in the glory days of Chichén Itzá. Human sacrifice was common, often involving young women, children and the elderly. Listen for the ghosts.

31

The Taj Mahal and its reflecting pool are shrouded in an early morning fog. Made of white marble on a platform of red sandstone, the tomb is part of a complex of such divine harmony and fluidity that it stands as one of man's greatest achievements.

The Taj Mahal

The mausoleum of the 17th century Mogul empress Mumtaz Mahal is grand beyond words. The story concerning its origins is the romantic equal of that associated with the Mausoleum at Halicarnassus.

Shah Jahan loved his second wife, Arjuman Banu Begum, whom he married in 1612, very deeply; she became his Mumtaz Mahal, the "Exalted of the Palace," and bore him 14 children. When she died during childbirth in 1631, Shah Jahan was devastated. The tale goes that within a few months his hair had turned completely white, and within the same amount of time he was making plans to act on his wife's deathbed request: that a monument signifying the grandness of their love be erected.

Arjuman's body was brought to the walled city of Agra, near Delhi, where it waited while 20,000 workers toiled on a glorious tomb designed by two Persian architects. White marble was brought from Rajasthan and other building materials were transported from throughout Asia by an army of a thousand elephants. More than two dozen kinds of gemstones were inlaid in the marble. In 1648, on the 17th anniversary of the empress's death, the Taj Mahal was ceremoniously completed (work on the building

and grounds actually continued until 1653). A Persian inscription explained: "The illustrious sepulcher of Arjuman Banu Begum, called Mumtaz Mahal. God is everlasting, God is sufficient. He knoweth what is concealed and what is manifest. He is merciful and compassionate. Nearer unto him are those who say: Our Lord is God."

The emperor himself made a promise for his new building:

Should guilty seek asylum here,
Like one pardoned, he becomes free from sin.

Should a sinner make his way to this mansion,
All his past sins are to be washed away . . .

So far, a lovely story. The next chapter wasn't so felicitous for Shah Jahan. He was deposed by their son Aurangzeb shortly after the mausoleum's completion and placed under house arrest at the fort in Agra. Subsequently, after his father's death in 1666, Aurangzeb was kind enough to install Shah Jahan's remains next to those of his beloved late wife. The two are united to this day.

This is a rare glimpse of the resting place of the
late emperor and his favorite empress in the
lower tombs of the Taj Mahal. When LIFE
photographer Larry Burrows first applied to shoot
the building inside and out in 1965, he was
rebuffed. No professional had ever before
proposed to shoot the lower tombs, and Indian
officials were fearful that local religious groups
would view the photography as sacrilege.
But Burrows pressed his petition long and hard,
and permission was finally granted, leading
to a glorious 16-page photo essay in LIFE's
November 3, 1967, issue. Said Burrows at the
time, "It took eight months for the Indian
government to make up their minds to let me
go ahead with a job that would greatly
enhance their tourist business." And the work
Burrows produced did just that.

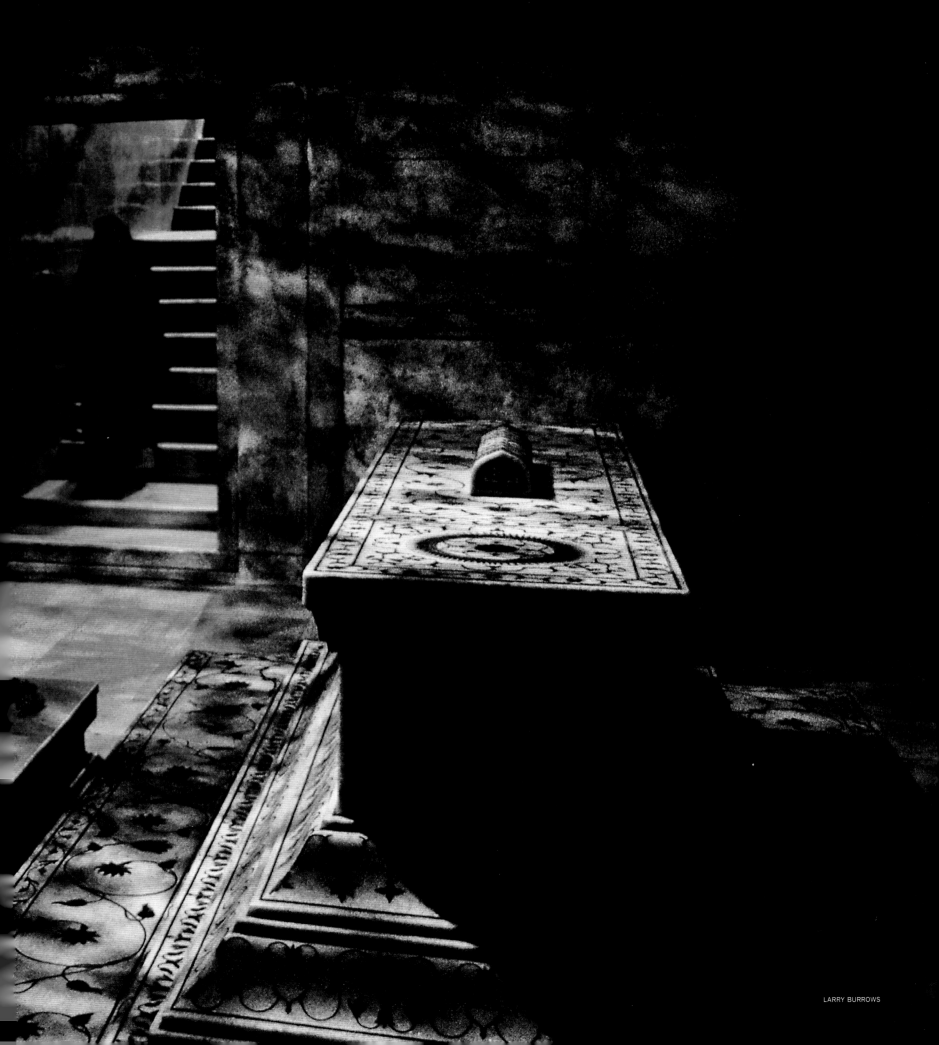

LARRY BURROWS

Below: In the ancient city of Petra, the Al Deir monastery has been carved out of a mountainside. Opposite: Through the Siq Canyon entrance to the city, Al Khazneh, a royal tomb cut into the rock probably between 100 B.C. and A.D. 200, looms. It is fully revealed on the following pages.

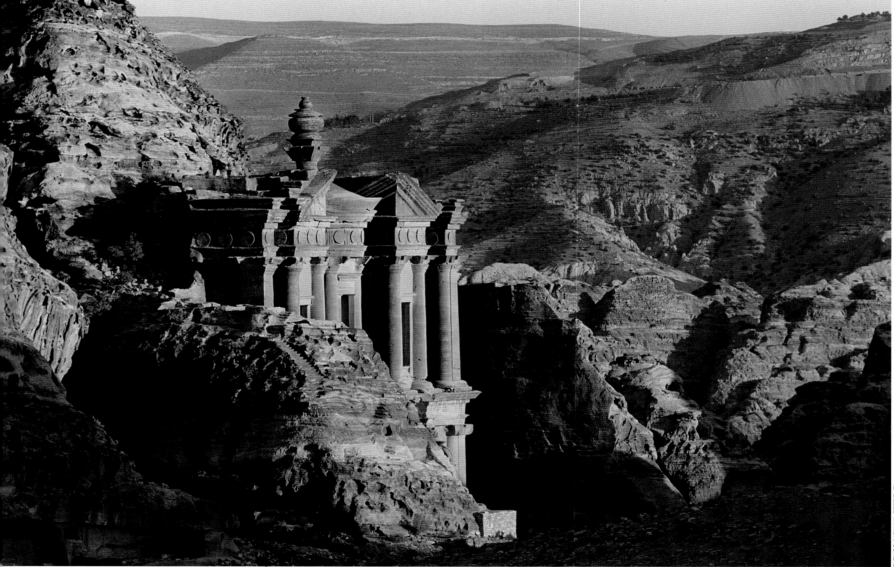

ISABELLE VAYRON/CORBIS

Petra

"A rose-red city, half as old as time."

It is a famous line by a poet who is not so famous anymore. The Englishman John William Burgon wrote his signature verse, "Petra," in the mid-19th century, not very long after the Swiss explorer Johann Ludwig Burckhardt found this extraordinary place deep within the deserts of Jordan and revealed it to the Western world in 1812. Petra indeed seemed half as old as time to modern man in the 1800s. In point of fact, two thousand years earlier it had served as a gateway to the ancient Near East.

It comes into view, sensationally, as you pass through a narrow gorge. Once upon a time, camels came this way, bearing trade goods—spices, textiles. Petra was a port of sorts in the middle of an arid land for a reason that might be guessed: the availability of water. And so the instinctively nomadic Nabataeans, who settled here as early as the 6th century B.C., thrived. They repulsed efforts at takeover by Antigonus, the Seleucid king; by Pompey, the Roman general; by Herod the Great himself—and by the 1st

century B.C., these people, numbering as many as 20,000, controlled the transport of incense and spice on the Arabian Peninsula. Petra was their unofficial capital, the London or Paris of Nabataea, an urban center whose commercial might extended into Syria.

The Romans finally took control of Petra in A.D. 106, and the city went into decline. In 363 an earthquake rocked Petra, and the end was nigh.

The ruins that entrance us today are Nabataean in origin. These ancient people found it easy—relatively easy—to fashion the sandstone on the slope of Mount Hor into temples, tombs and decorative sculptures. A huge monastery, the largest of Petra's monuments, and an equally impressive theater are principal attractions. Al Khazneh, or the Treasury, is perhaps the most famous and elaborate ruin.

If Petra looks like something out of an Indiana Jones movie, this isn't surprising. The site was a star second only to Harrison Ford in *Indiana Jones and the Last Crusade*.

That, the Nabataeans never could have dreamed.

PAULE SEUX/CORBIS

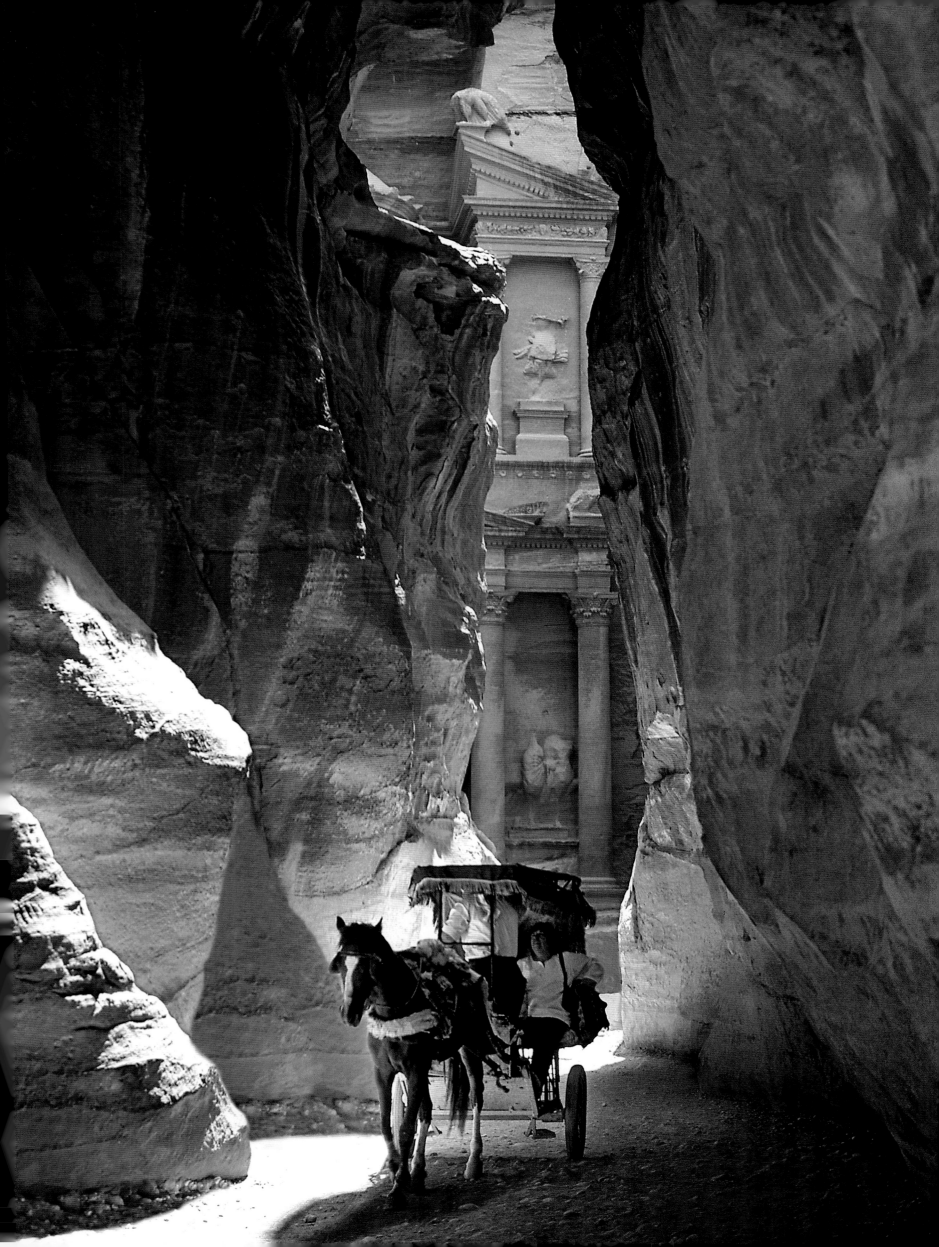

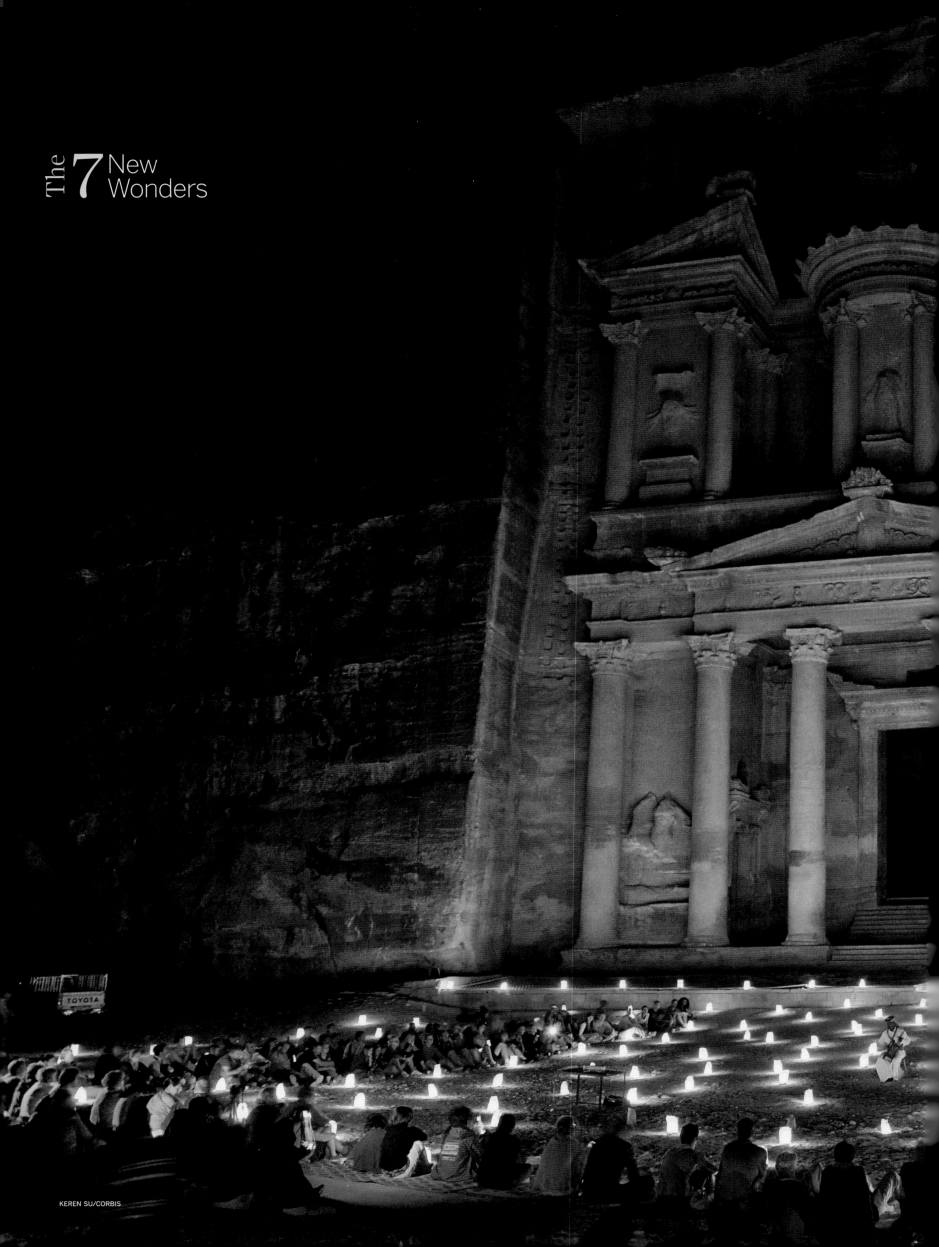

A service by candlelight at Al Khazneh. Why does a mausoleum's name translate as "the Treasury"? Because local lore holds that bandits stashed their ill-gotten gains in a stone urn on the second floor. A much more recent legend was promulgated by the Indy Jones film in 1989: that nothing less than the Holy Grail was inside this building.

What is in the mind of this llama as it overlooks fabulous Machu Picchu, the Peruvian redoubt that is mystical to the point of magic? Of course it is impossible to know, but if any human creation is capable of impressing all the world's beings, this abandoned, pre-Columbian fortress city of the Incas is the one.

Machu Picchu

There are many mystical places on this planet of ours—Himalayan Shangri-Las and South Pacific Bali Hais and a hundred candidates for Atlantis. And then there is Machu Picchu, as real as real can be and the equal of any for romantic mysticism. The fabled "Lost City of the Incas" is no fable, as has been clear to all since 1911, when the American historian Hiram Bingham was led to the site by an 11-year-old Peruvian boy named Pablito Alvarez.

Actually, Bingham used the "Lost City . . ." nickname as the title of his first book, even as he was letting the cat out of the bag. He described an ethereal realm 8,000 feet above sea level, nestled against the high peaks of an Andean mountain ridge. Evidence has subsequently indicated that Europeans had come across Machu Picchu earlier, but it was Bingham's visit that gained international attention and spurred decades of archaeological exploration and discovery.

What has been learned is that Machu Picchu was a redoubt of the Incan people built in the mid-15th century. What it was for remains, all these years later, uncertain. It might have been a religious center, it might have been an economic hub, it might even have been a high-altitude prison. It was located 50 miles from, and well above, the Incan capital, Cusco, and certainly was an adjunct of that city. Whatever its purpose, it was an impressive place. The Incas, world-renowned stonemasons, raised tremendous, mortar-free structures here, 140 of which are imaginable to us as their basic infrastructure survives. Houses, parks and temples can be perceived during a visit to Machu Picchu, not only because the craftsmanship proved so durable but because the Spanish conquistadors never found this super-remote retreat when they conquered the Incas in the 16th century. That is a most poignant footnote to this story: Machu Picchu, so strong in our imagination today, was operative for barely a century. It was abandoned when the Incan Empire fell; then, over the decades, it was hidden by encroaching forest. The locals knew it was up there—locals like Pablito Alvarez. They showed it to Hiram Bingham, and so the story took shape.

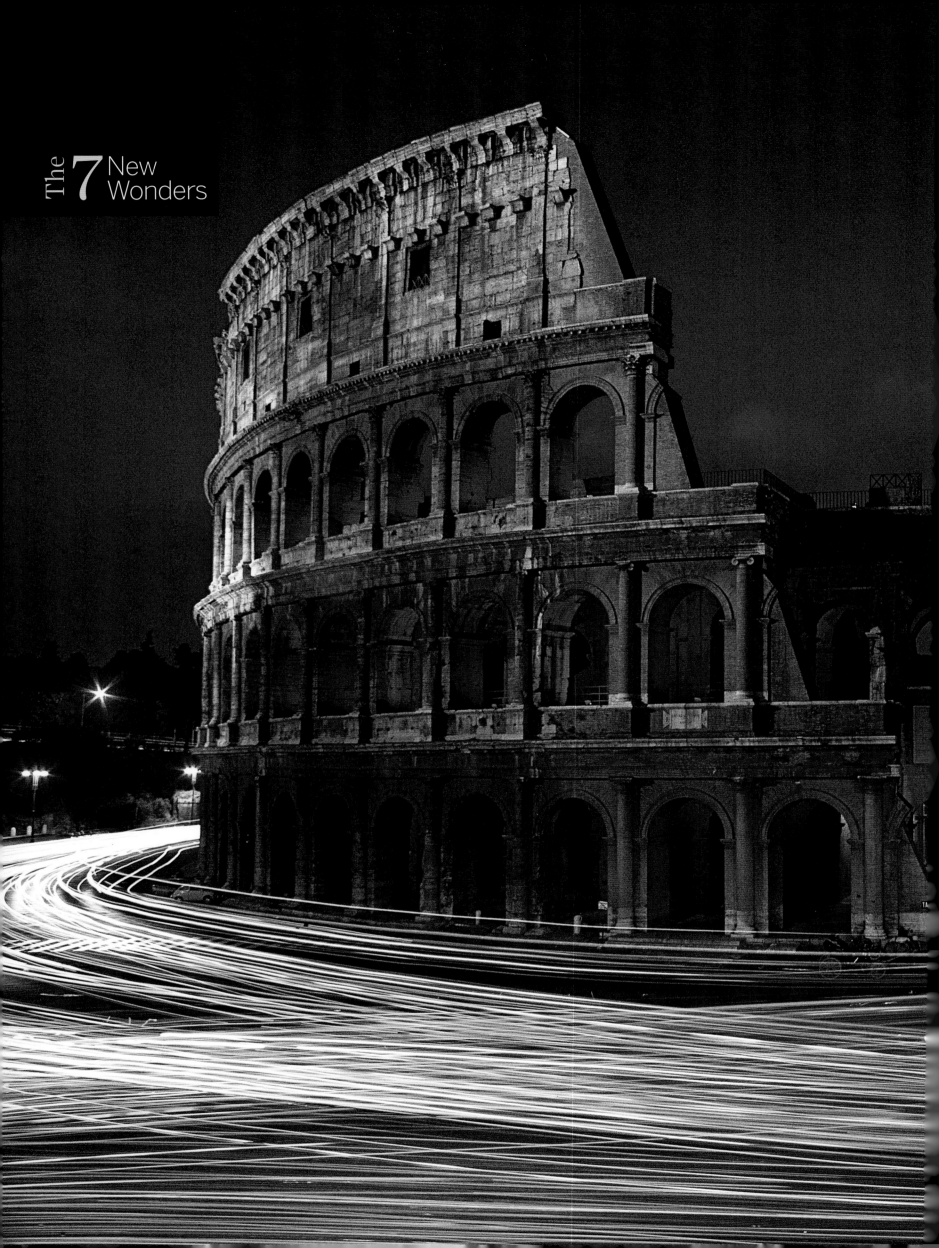

The Colosseum

As mentioned in our introduction, this most awesome of arenas was often cited as more worthy of inclusion on the sanctioned list of Wonders than some of the original seven. Now, thanks to a 21st century online ballot box, Rome's stunning stadium is officially given its due.

Work on the Flavian Amphitheatre, as it was originally called, was begun about A.D. 72 by the emperor Vespasian on the site of a villa that had belonged to Nero. (A nearby 100-foot statue that Nero had erected to himself, known as a colossus, led to the Flavian's popular name, the Colosseum.) Sitting on a foundation 42 feet deep, the walls rose 159 feet around an ellipse 615 feet long and 510 feet wide. The infrastructure was made of brick, concrete and tufa, and the exterior facade was fashioned from blocks of travertine limestone. As the quarries for the travertine were located a dozen miles outside Rome, and since 3.5 million cubic feet of travertine were required, the logistical problems alone were Sisyphean.

There were 80 entrances: 76 for ticket holders, two for gladiators and two for the emperor. At least 50,000 spectators could attend, and one of the many practical achievements of the building was that the crowd could be evacuated in just five minutes.

Vespasian's son Titus dedicated the building in the year 80, setting off a 100-day series of events. Early shows at the Colosseum were often headlined by clashes between different species of animals, but soon the action became increasingly outré. The morning often began with mock, comic sparring, which gave way to wild animal events that culminated in the afternoon with humans pitted against animals or against one another. Trained fighters would battle to the death or occasionally be permitted to live if the warrior had done something special that pleased the crowd. Rome being a pagan state, Christians along with slaves and criminals were fodder for gladiators.

The entire day's menu was served up with music from flutists, trumpeters, drummers and even a hydraulic organ that kept the death fights humming—until the Colosseum's gladiators finally hung up their swords and shields in the year 404.

A time exposure of traffic whizzing by on a lovely evening in Rome reveals that a grandeur born in the classical era is for all the ages. If this Wonder must be in ruins, it is a delight that the ruins are of such perfection.

The enigmatic statues were placed mainly on the perimeter of the island, always facing inward. This fallen fellow lies as the rampaging Easter Islanders left him and all his brethren. The distant statues in a neat row are a conceit of modern man.

Easter Island

One of the most remote inhabited islands on earth, Easter Island lies more than 2,000 miles from the shores of both Chile and Tahiti. It was settled in about A.D. 400 by Polynesians who, legend has it, were led by a chief named Hotu Matua, the Great Parent. When these early people arrived, their new home was lush, with giant palms useful for making boats and houses. By the time their descendants were through, Easter Island would be a hellhole. Here, an entire culture was victim to an obsession.

For some reason, beginning in the year 1000 and increasingly until 1600, the islanders became engaged in the construction and siting of statues, seemingly to the exclusion of anything else. They used volcanic tuff to carve at least 887 statues called *moai,* the largest of which was nearly 72 feet long. These moai were human forms, with exaggerated noses and ears. Because the islanders left no written record and but a flimsy oral history, there is no way to hold an informed opinion as to their purpose. In any case, simply carving these moai was not enough: A third of them were transported around the island and placed on *ahu,* ceremonial platforms that stood an average of four feet high. Moving the moai was a tremendous undertaking—the heaviest of them weighed 82 tons.

Archaeologist Jo Anne Van Tilburg and others believe that the islanders used palm trunks to move the statues. This deforestation proved critical to the culture's decline. With the disappearance of trees, topsoil was washed into the sea, leaving the inhabitants with no way to raise crops; nor could they build boats to catch fish. Inevitably, the social order collapsed, and in its place came civil war and cannibalism. And in what must have been particularly frenzied activity, the moai were toppled by the Easter Islanders themselves. (Those standing today are the product of recent archaeological restoration.) A passion in an isolated land led to obsession and madness, thence to extinction.

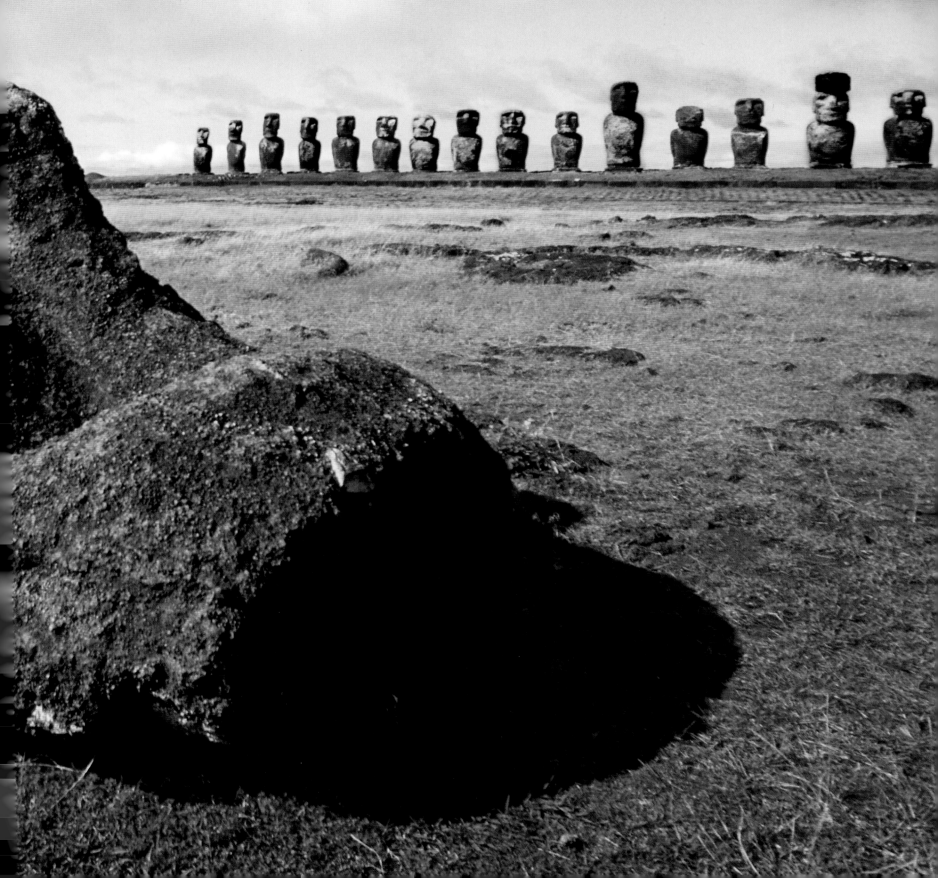

7 Amazing Runners-up

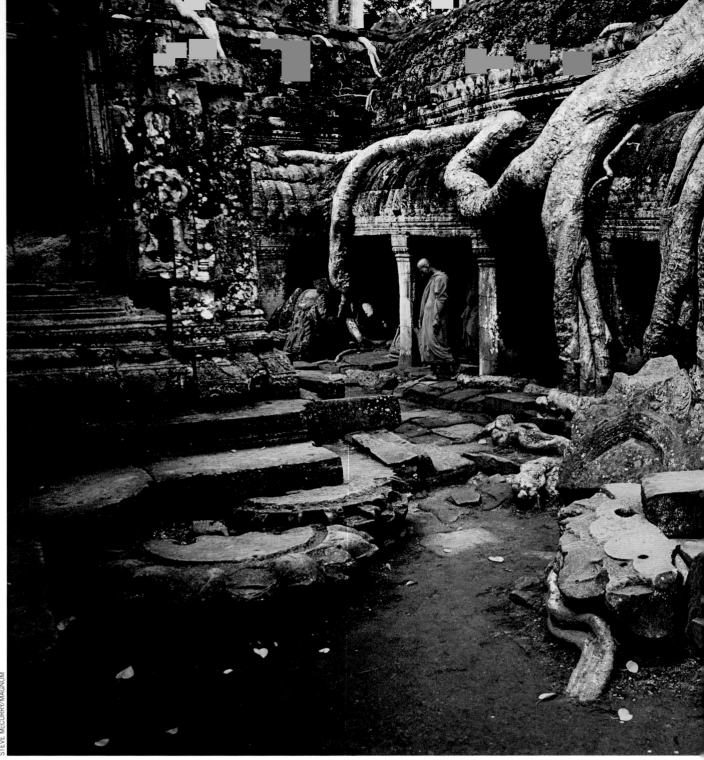

Angkor Wat

As we have already seen and will see again in these pages, humankind is spurred to phenomenal gestures by religious passions. Man has created spiritual iconography of a size that is barely to be believed, as well as tremendous houses of worship. The complex of temples at Angkor in Cambodia, and particularly the well-preserved Angkor Wat, which was built in the first half of the 12th century in honor of the Hindu god Vishnu, is second to none in its grandiosity and splendor.

Angkor was the capital of a Khmer kingdom in southeast Asia that extended from Vietnam to China. Beginning in the early 9th century and continuing for more than 400 years, the Khmer kings built over 100 stone temples, the remains of which astonish us today. In some sections of the city, the structures, if not actively attended to, became engulfed by encroaching forest. But Angkor Wat escaped this fate, partially because a surrounding moat kept the jungle somewhat at bay, and partially because, unlike some of its brethren temple complexes, it was never totally abandoned by its flock.

Angkor Wat means "city temple," and the temple proper was intended by King Suryavarman II as the principal house of worship in his state. The glory of Angkor Wat was captured by Antonio da Magdalena, a Portuguese monk who, upon visiting in 1586, became one of the first to let the Western world know of its existence: "[It] is of such extraordinary construction that it is not possible to describe it with a pen, particularly since it is like no other building in the world. It has towers and decoration and all the refinements which the human genius can conceive of."

In contrast to some of the other ancient man-made Wonders of the World, whose principal purpose in the present day is to serve as a tourist draw, Angkor Wat remains active as a place of worship. However, it is no longer dedicated to Vishnu. By the 15th century, it had transitioned from Hindu to Buddhist use, and monastics are still in residence today.

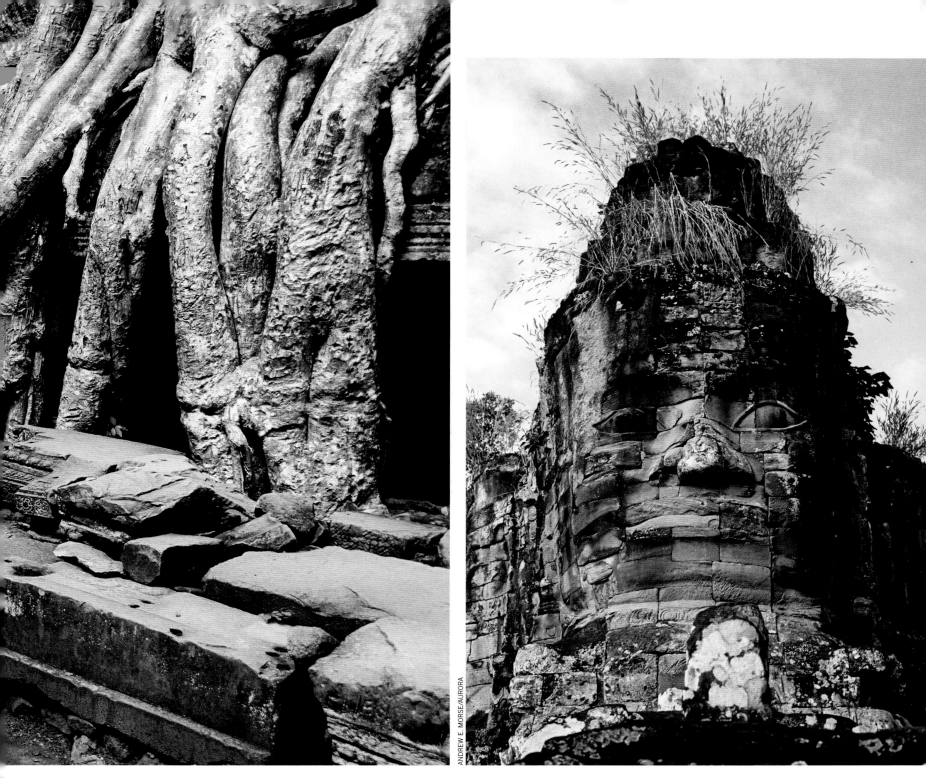

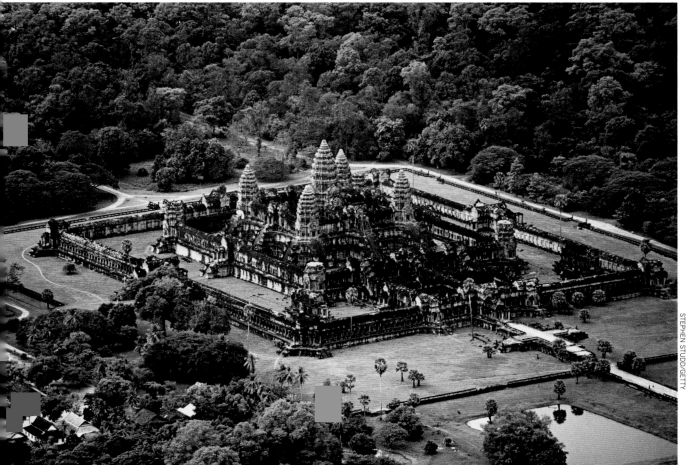

Above, left: The jungle has obviously encroached somewhat at Angkor Wat, but it has not engulfed the buildings here as it has others elsewhere in the Angkor precincts. Above: For instance, a giant carving of a face in the Bayon Temple has become overgrown. Left: One reason Angkor Wat has been able to keep the jungle at bay is a surrounding moat.

7 Amazing Runners-up

The attainments of ancient Greece, when placed in the context of the times, perhaps mark the apex of human civilization, and the highest point in Athens itself is reserved for the Acropolis. There are four surviving structures, including the Parthenon, which can be seen from a great distance.

The word *akropolis* is Greek for "high city," and the assemblage of buildings atop what is known as the "sacred rock" in the center of Athens is elevated indeed, and in its magnificence elevates us all. Crowned by the Parthenon temple, the Acropolis is the ultimate symbol of the glory of Golden Age Greece.

As we gaze upon it today, we do not see many remnants of the original Acropolis. That complex, including the Older Parthenon, which was still under construction at the time, was destroyed by Persian invaders in 480 B.C. Within 20 years, rebuilding was under way by order of Pericles, ruler of Athens during the Golden Age. The gifted architects Ictinus and Callicrates drew plans for the new Acropolis; the nonpareil sculptor Phidias joined the team. The key buildings that we know today—the Propylaia, the Erechtheion, the temple of Athena Nike and, of course, the Parthenon—were built in this period. The north side of the Acropolis was given over to the Olympian gods and goddesses and bygone Athenian cults, while the south side belonged to Athena, who was honored in various buildings and artworks as patron of the city, as goddess of war, as goddess of manual labor and as a symbol of victory.

The buildings were not only grand but durable, and through the centuries, they were used in myriad ways. When Christianity swept the land, the temples were converted into churches; in the 6th century A.D., the Parthenon itself was rededicated to the Virgin Mary. During the Middle Ages, the Acropolis became a fort. For two and a half centuries beginning in 1204, the Propylaia was the official residence of the Frankish ruler, and during the long reign of the Ottoman Empire (1456–1833), it was the headquarters of the Turkish garrison. The Parthenon was serving as a munitions depot when it was bombed and ruined by the Venetians in 1687. The Greeks reassumed control of the Acropolis during their war of independence in the 19th century, and these rightful owners have exercised dominion ever since.

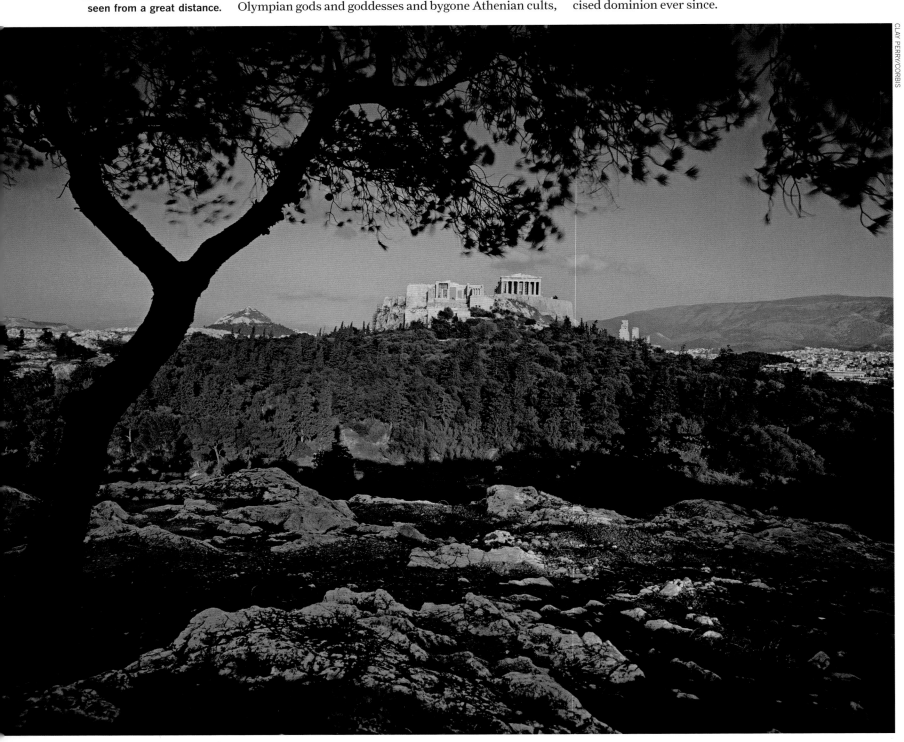

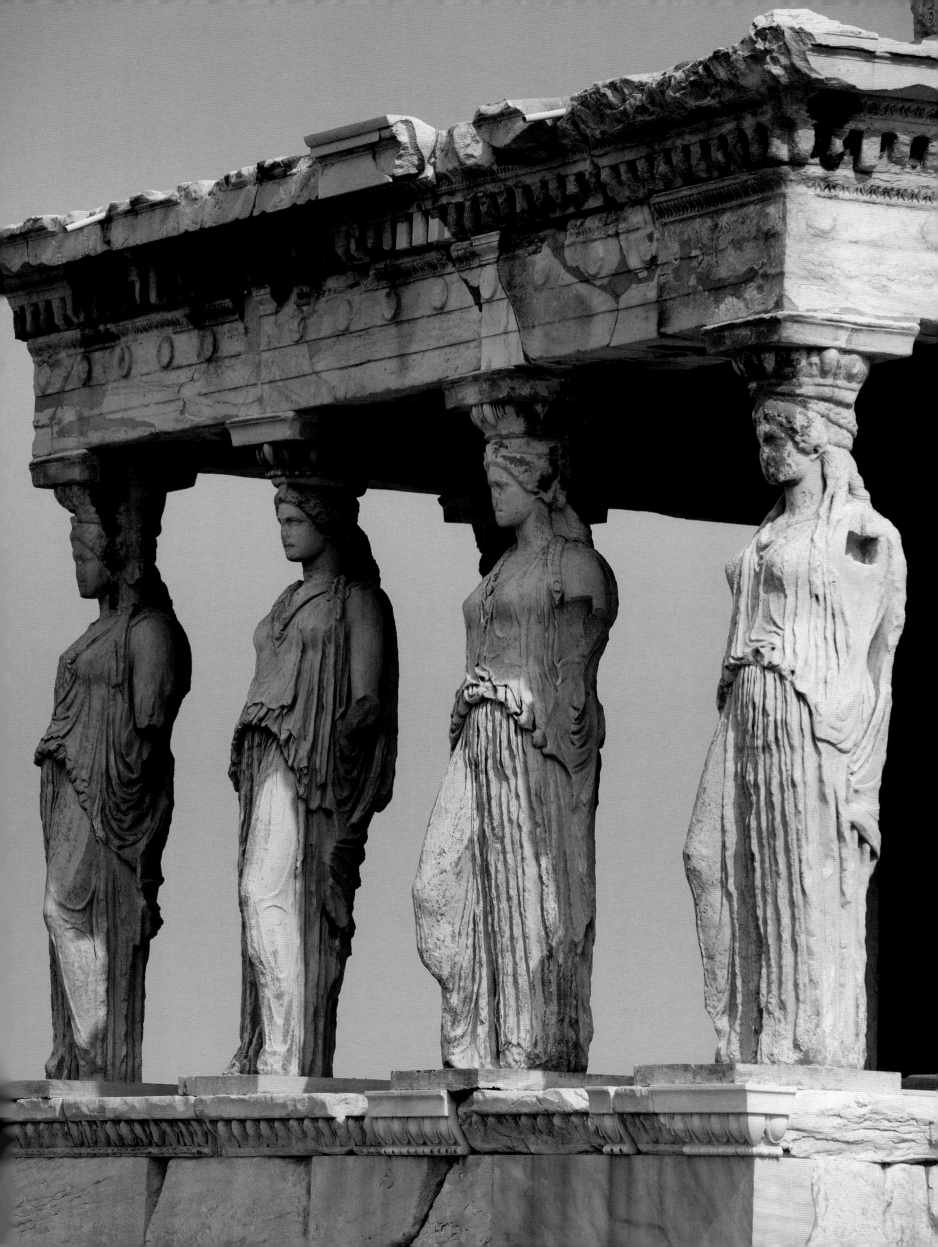

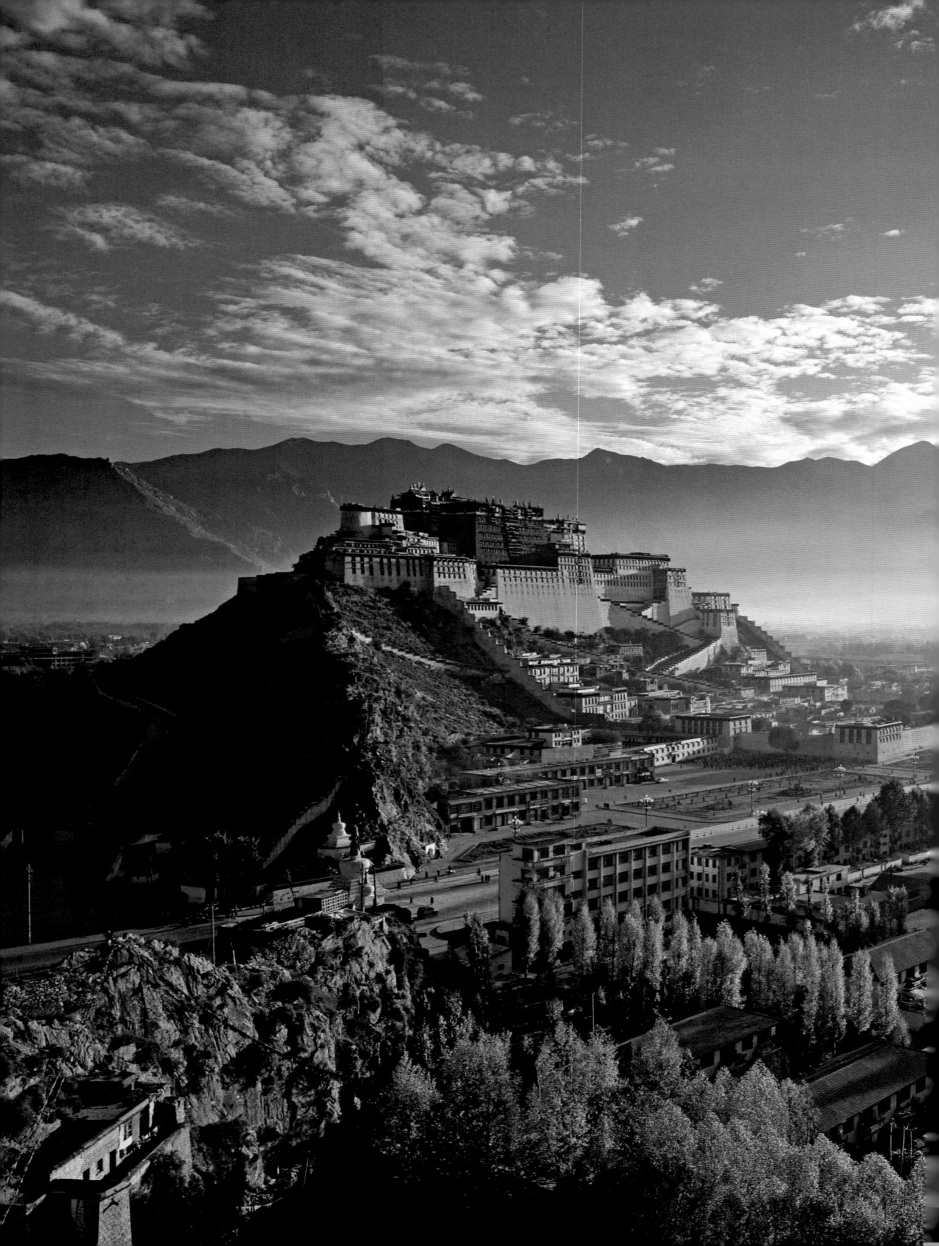

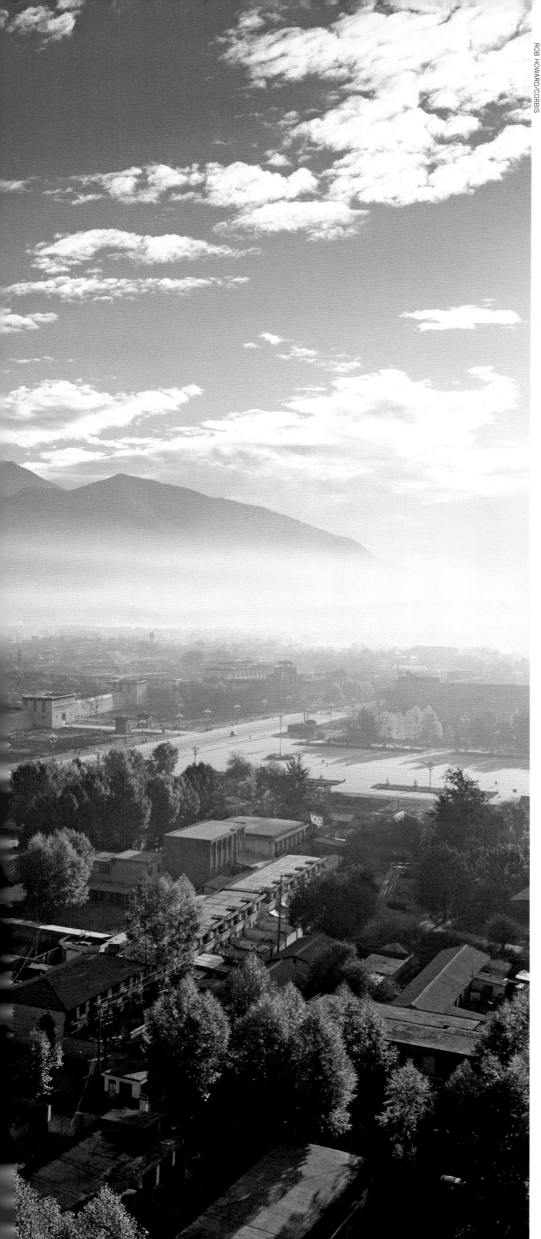

In the minds of Tibetan Buddhists (if not the Chinese authorities), the Potala complex is divided into the secular (the White Palace) and the sacred (the Red Palace). The whole of it includes more than a thousand rooms with exceptional murals, carved columns, and statues and decorations ablaze with gold, silver, pearls and other gems.

The Potala Palace

What Angkor once was to Hindus, what the Acropolis meant to the polytheistic Athenians, and what the Vatican, which we will visit next, still represents to Roman Catholics, the Potala Palace was (and defiantly still is) to many Buddhist followers of the Dalai Lama. This greatest monumental structure in all of Tibet sits at the summit of Marpo Ri (Red Hill), looming mightily over the Lhasa valley and radiating spirituality—radiating it even though the Dalai Lama is no longer in residence and the Chinese have converted the palace to a museum.

We have employed football fields earlier in our book as an effective measuring device, and we do so again, probably not for the last time: The palace is more that four football fields long east to west, and nearly that long north to south. This most imposing complex is in a most rarefied locale. Buildings begin at 12,100 feet above sea level and climb to 13 stories; on the top floor a person is majestically a thousand feet above the valley floor. The Potala houses some 200,000 statues (that's not a typo) and 10,000 shrines (that's not, either).

The Great Fifth Dalai Lama, Lobsang Gyatso, ordered construction begun in 1645. As with the Acropolis, the project took nearly half a century to complete. Since the Dalai Lama's role was always to be a governmental as well as spiritual leader, the palace was built for administrative as well as religious purposes.

For centuries, relations with China were fine. In the Saint's Chapel, the holiest shrine in the temple, there is an elaborate inscription written in the 1800s by the Tongzhi Emperor of China, calling Buddhism the "Blessed Field of Wonderful Fruit." The emperor's 20th century successors, as rulers of Communist China, thought differently, and sections of the palace were damaged as a result of Chinese bombardment during the 1959 invasion. That year, the 14th Dalai Lama was spirited into exile in Dharamsala, in northern India, and his presence in the Potala Palace has been but a memory ever since.

His presence, perhaps . . . but his spirit lives there still.

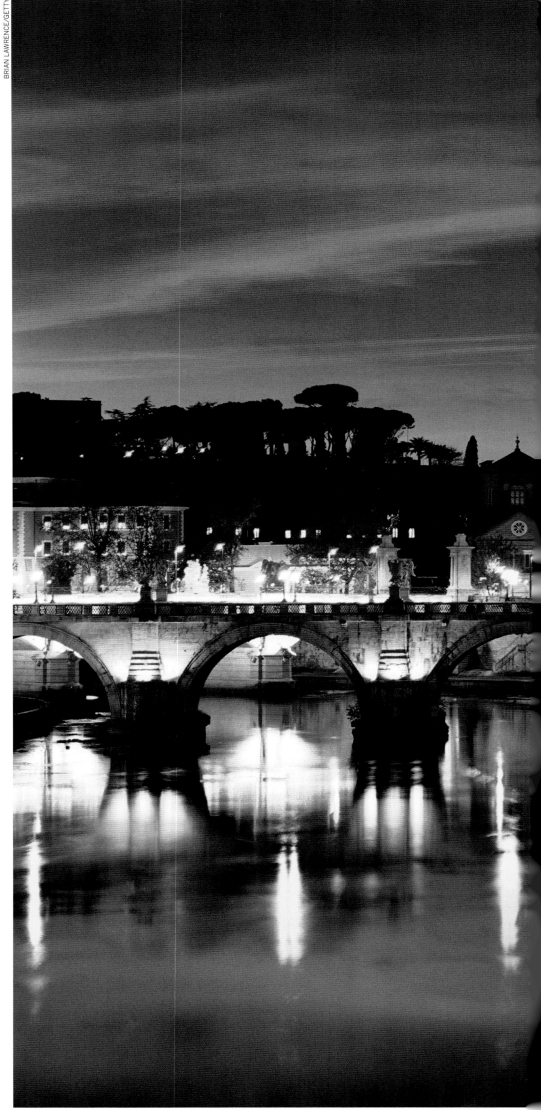

The dome of St. Peter's shimmers at twilight, as do the waters of the Tiber River. Jesus designated the apostle Peter as the first leader of his movement: "Upon this rock"—namely Peter—his church would be built. The literal rock, where Peter would be put to death and the religion would rise, was in Rome.

The Vatican

Roman Catholicism has a flock of more than a billion faithful. It is, of course, dedicated to the life and teachings of Jesus Christ. But it is headquartered not in the Holy Land, where Christ sermonized and was martyred, but in Rome, where Vatican City, an enclave of barely more than 100 acres, exists as a sovereign state separate from the Italian capital.

Early on, Christianity's very existence and then its rise in Europe were plagued by mortal troubles with Roman authority—and so, the fight was centered largely in Rome. When the tide of this religious movement spread throughout the empire, and Constantine I became the first Christian emperor in the 4th century, Rome naturally became the religion's home base.

On the very spot where his predecessors had ordered Christians put to death, Constantine allowed the building of a great church. The 4th century St. Peter's Basilica would last more than a thousand years and would be replaced in the 16th century by an even grander cathedral, also named for Peter, designed in part by a local artisan of some small repute—a fellow named Michelangelo Buonarroti.

The basilica's awesome dome represents Michelangelo's second most famous creation at the Vatican. The first is, in the modern era, part of "the museums."

The Vatican Museums are a series of interlinked galleries, apartments and chapels. Room after room of marvels rolls out as you walk this symphony of buildings. The sublime sculpture in the Gallery of the Candelabra, the vivid cloths in the Gallery of Tapestries, the exquisite vases in the Etruscan Museum, the brilliantly colored ancient maps in the Gallery of Maps, and all the paintings, paintings, *paintings*: Caravaggio, Leonardo Da Vinci, Van Dyck—a host of crucifixions, resurrections, last suppers and glorious battle scenes. Paintings . . . And statuary! In St. Peter's there is Michelangelo's "Pietà," of course, and in the Museu Pio-Clementino, there are 53 galleries of Greek and Roman sculpture to pass through before arriving at the transcendental Sistine Chapel.

Yes, Michelangelo is represented everywhere throughout the Vatican, but his ceiling here is a masterwork beyond comprehension. The secular as well as the religious cannot help but be moved by the majesty of this Wonder within a Wonder.

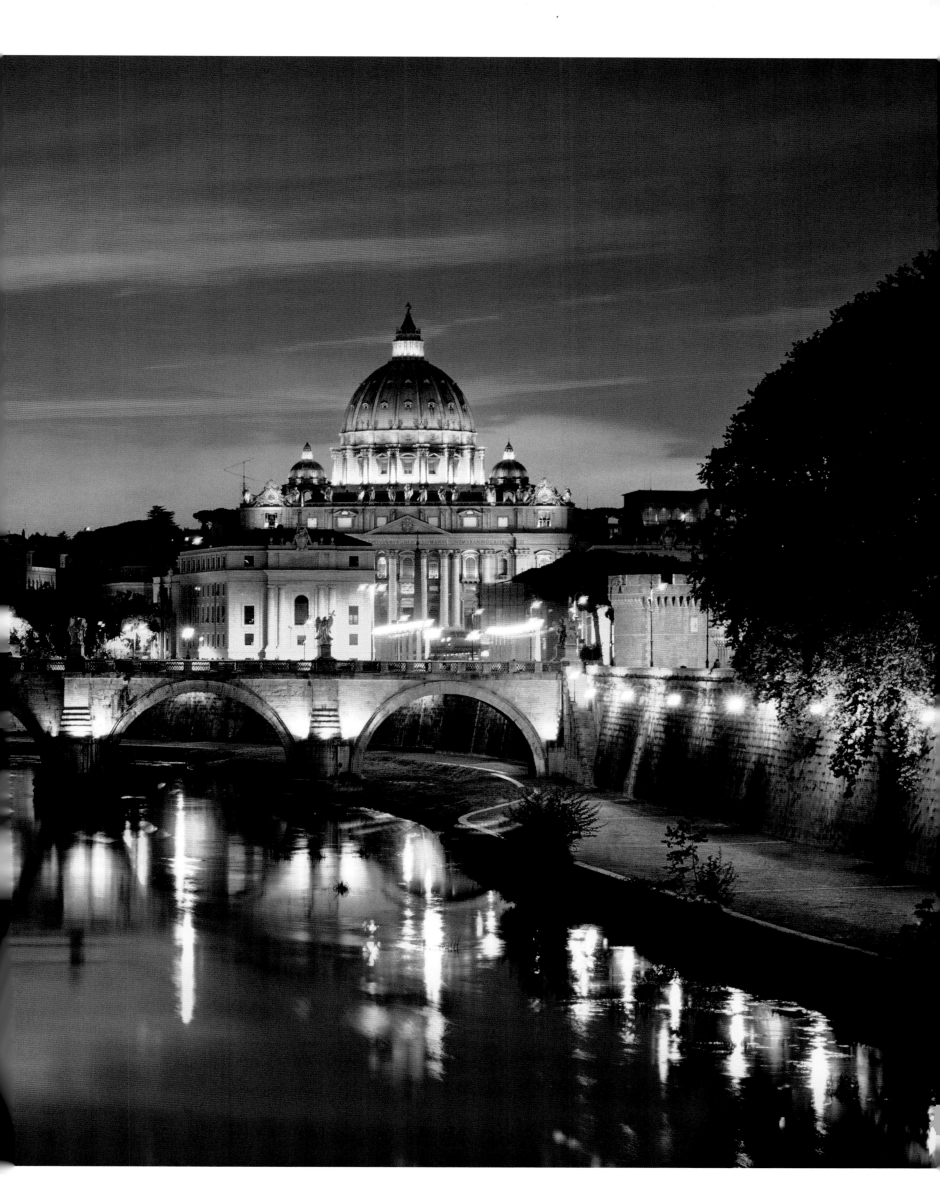

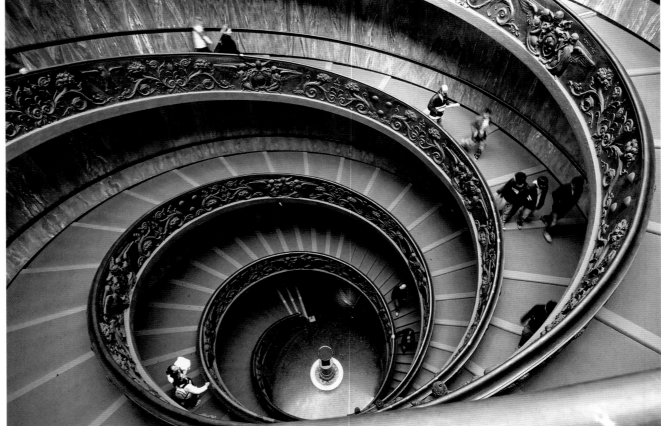

Scenes inside the sacred city: Tourists climb a spiral staircase in the Vatican Museum; bishops listen as Pope Benedict XVI says mass in St. Peter's in October 2008; and light streams through windows in Michelangelo's dome, gracing the basilica with a holy glow.

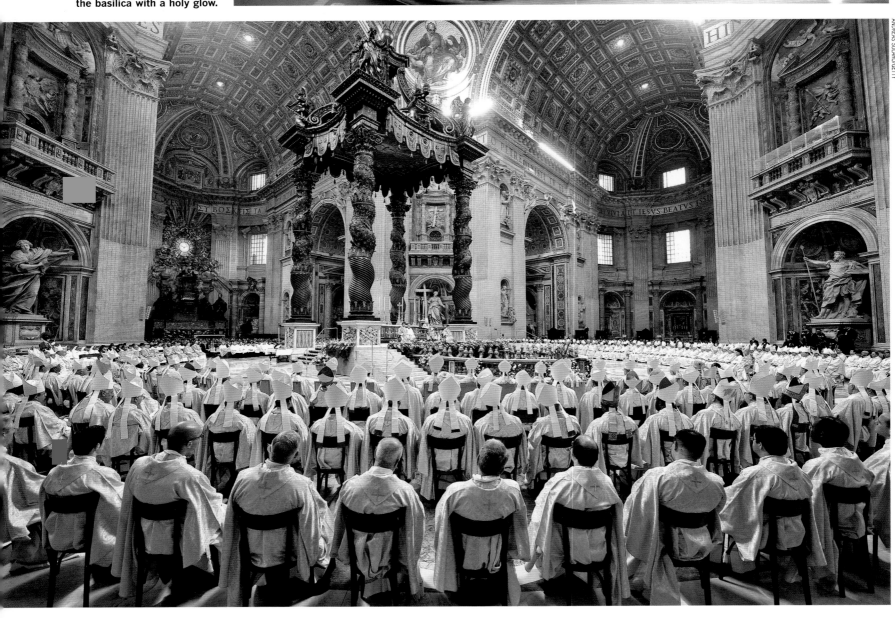

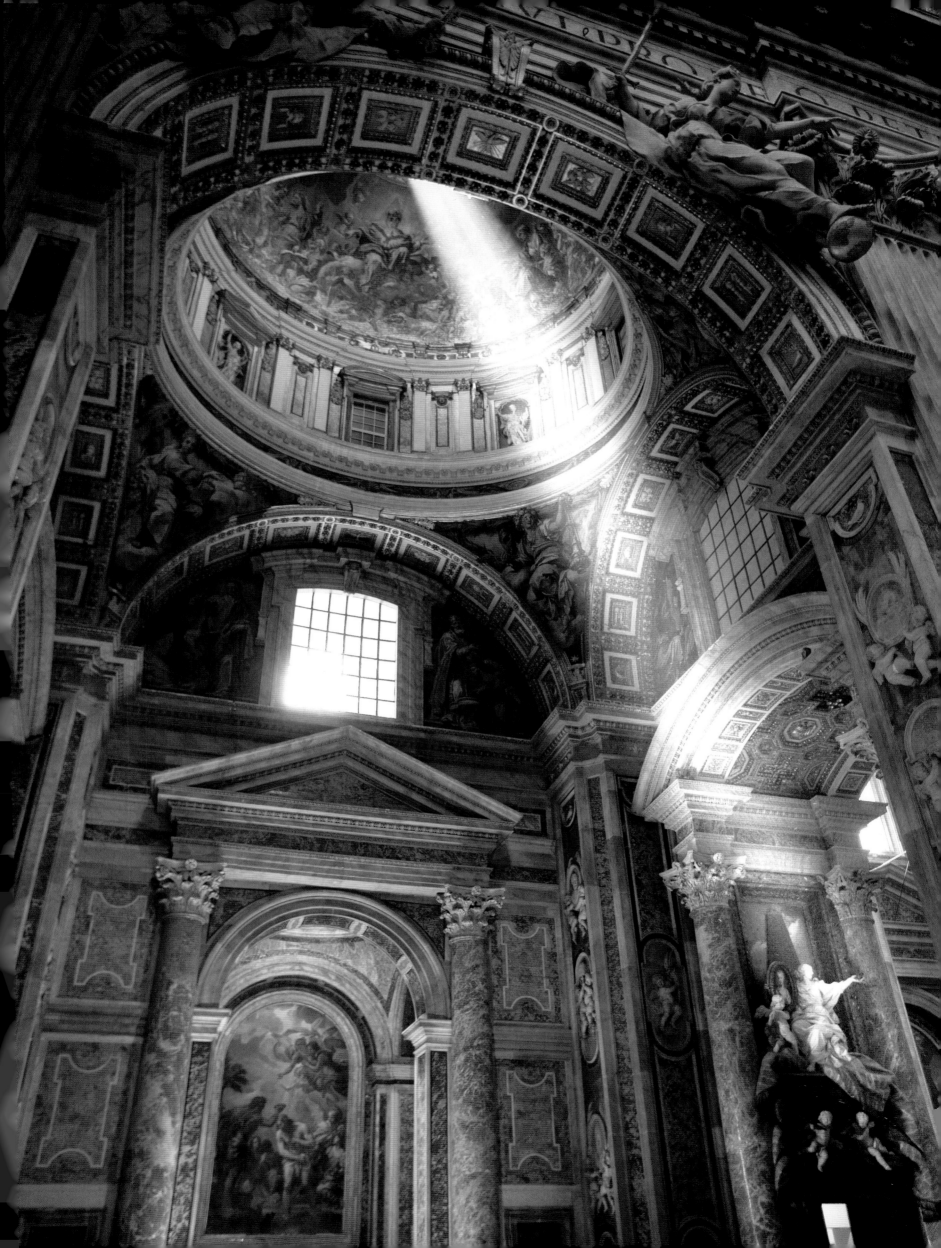

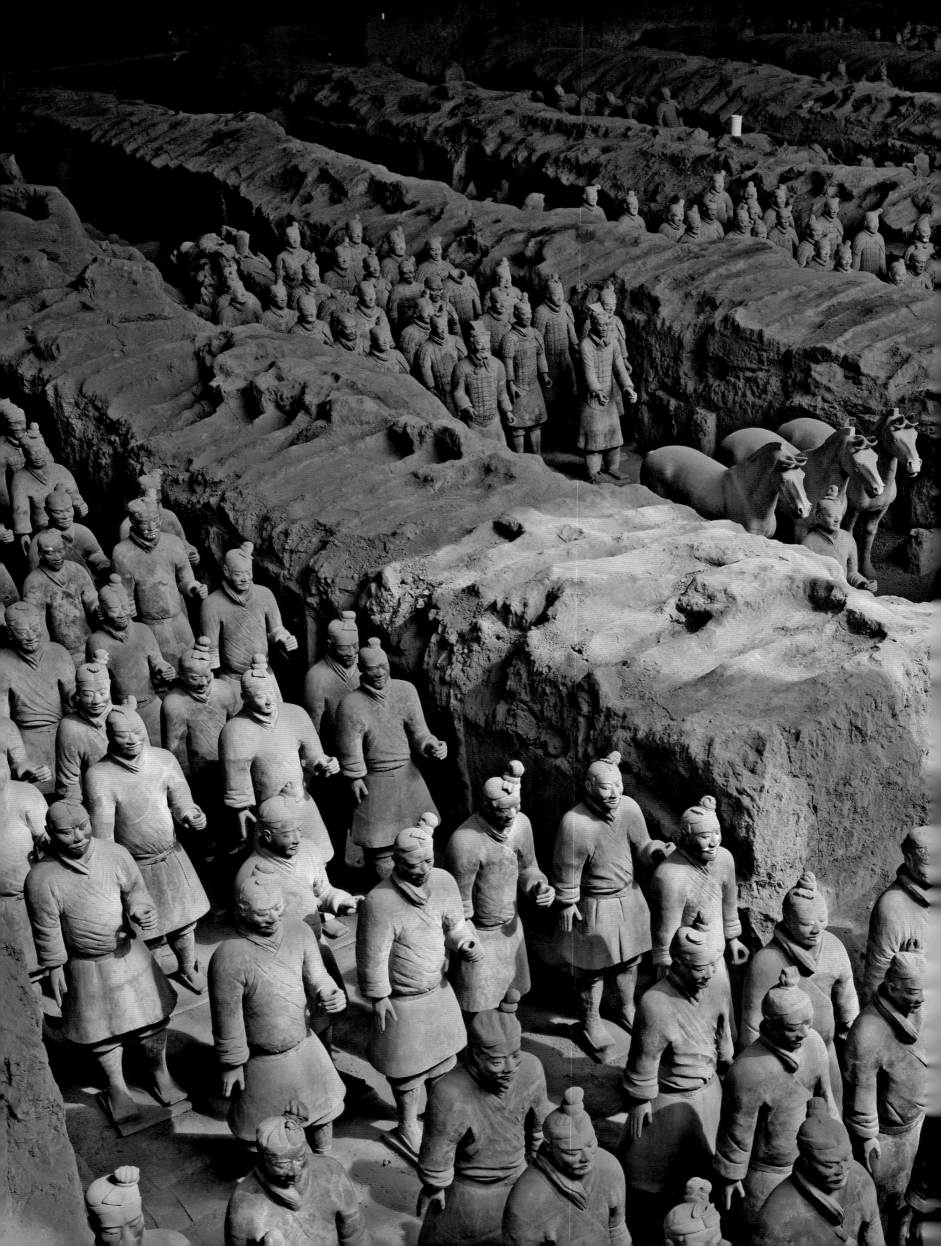

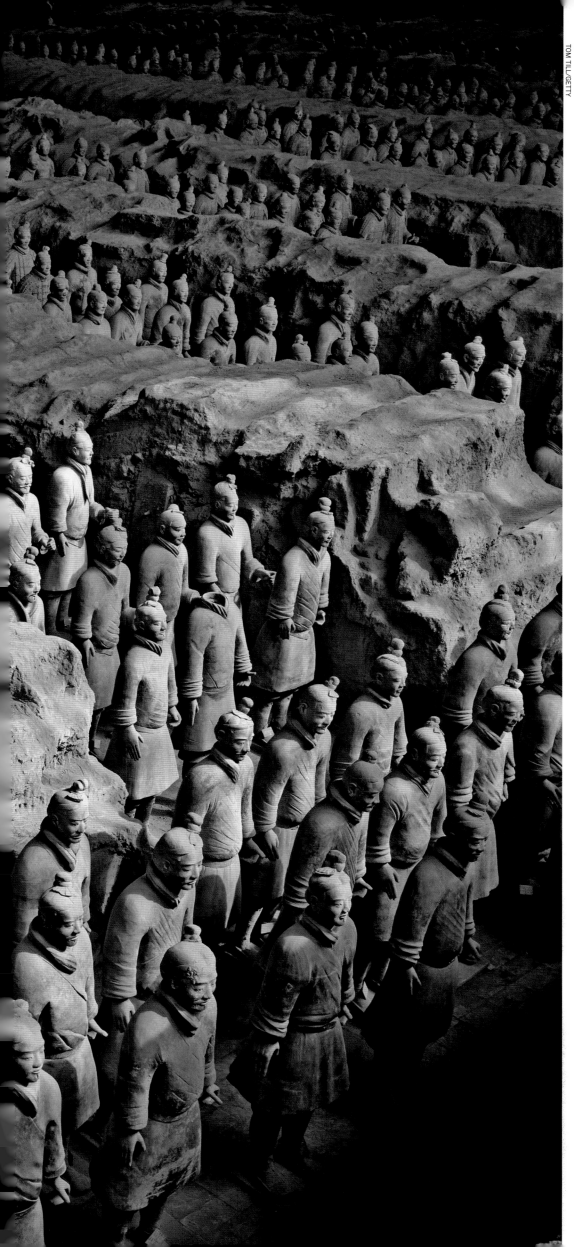

The soldiers were created 2,200 years ago. They were arranged with their backs to the emperor and are poised to enter combat as necessary. Looters through the years took the weaponry from these loyal troops, and today they seem less fierce.

7 Amazing Runners-up

The Terra-cotta Army

With the ancient tomb in Halicarnassus and the Taj Mahal, we have already visited a couple of pretty wild mausoleums. But wait until you get a load of this: The "mausoleum precinct," wherein dwell the remains of Chinese emperor Qin Shi Huangdi and those of his thousands of life-size terra-cotta soldiers, is nearly 25 football fields long by 10 wide. It is veritably, as it has been called, a "city of death."

The First Emperor of Qin was born Ying Zheng in 260 B.C. and was 12 years old when he assumed power over his precinct in a factionalized China. By brutal force, he united the country in 221 B.C. and at that point renamed himself Qin Shi Huangdi. He would live another decade, and his dynasty would soon thereafter be replaced by the Han. But well before his demise, Qin had begun making elaborate preparations for the afterlife, and if his expectations were accurate, he is a happy and well-protected ex-emperor today.

He was barely a teenager when he ordered work to begin on the huge necropolis in 246 B.C.; construction would continue for the remainder of his life. His own tomb in the center of the precinct was to be more than 500 by 500 yards in dimension and in the realm surrounding it would be an enormous protecting army of soldiers fashioned from the terra-cotta clay indigenous to the region: a virtual re-creation of life as the emperor liked to live it day by day. An estimated 8,000 men— infantry and officers included—were made in the kilns, as well as 130 horse-drawn chariots and 150 more cavalry horses; these were placed in pits around the tomb. Archaeological excavations have been ongoing since the mid-1970s.

As that last fact indicates, the terra-cotta army was a largely secret Wonder for more than two millennia, and it is only we moderns who have gaped at this most extravagant mausoleum. And as we have pondered it, one thing primarily has become clear. If, say, the other two mega-tombs that were visited earlier in our book were built for love, this one is a testament to power and one man's fierce desire to keep hold of it even after death.

Stonehenge

That Stonehenge hasn't claimed a place on the "official" list of Wonders seems absurd since, as much as any other entry in this volume, Stonehenge excites a sense of wonder in people. Everything about it is delightfully uncertain (well, almost everything, as we'll see). Where did it come from? Who created it? Why? When? Armies of archaeologists and engineers, historians and ethnologists have tried to answer these questions, not always with complete success.

The word *Stonehenge* has an Anglo-Saxon meaning of "hanging stones." The composition began on the Salisbury Plain in southern England around 3100 B.C. when a ditch with a diameter of 320 feet was excavated, likely by Neolithic people using deer antlers. Evidence of such a primitive implement suggests the obstacles yet to be faced by all of Stonehenge's creators. This construction, now often referred to as Stonehenge I, was in use for five centuries before being abandoned.

Stonehenge II, commencing about 2100 B.C., saw the site dramatically altered. About fourscore bluestone pillars, as heavy as four tons apiece, were set in two concentric circles;

the arrangement seems never to have been completed and was later dismantled. The bluestone had likely been sourced from the Preseli Hills in southwest Wales, 240 miles distant. That would be quite a schlep today with a heavy rock; then, it must have been truly grinding.

About a century later, Stonehenge III presented a further transportation challenge. Although the quarry was a mere 20 miles away, the task was even more daunting as it involved moving sarsen stones as long as 30 feet and weighing up to 50 tons. Not content with simply building another ring, 97 feet across with a horseshoe shape inside, it was deemed necessary to top the circle with sarsen stones too.

In subsequent years, several other devilishly complicated structures were assembled. The purpose of each of them remains open to innumerable interpretations, though one constant theory about Stonehenge has lately been confirmed: In all of its manifestations, it has been, as well as a place of ritualistic worship, a place of burial.

By the way, the popular notion that it was built by Druids has been discarded.

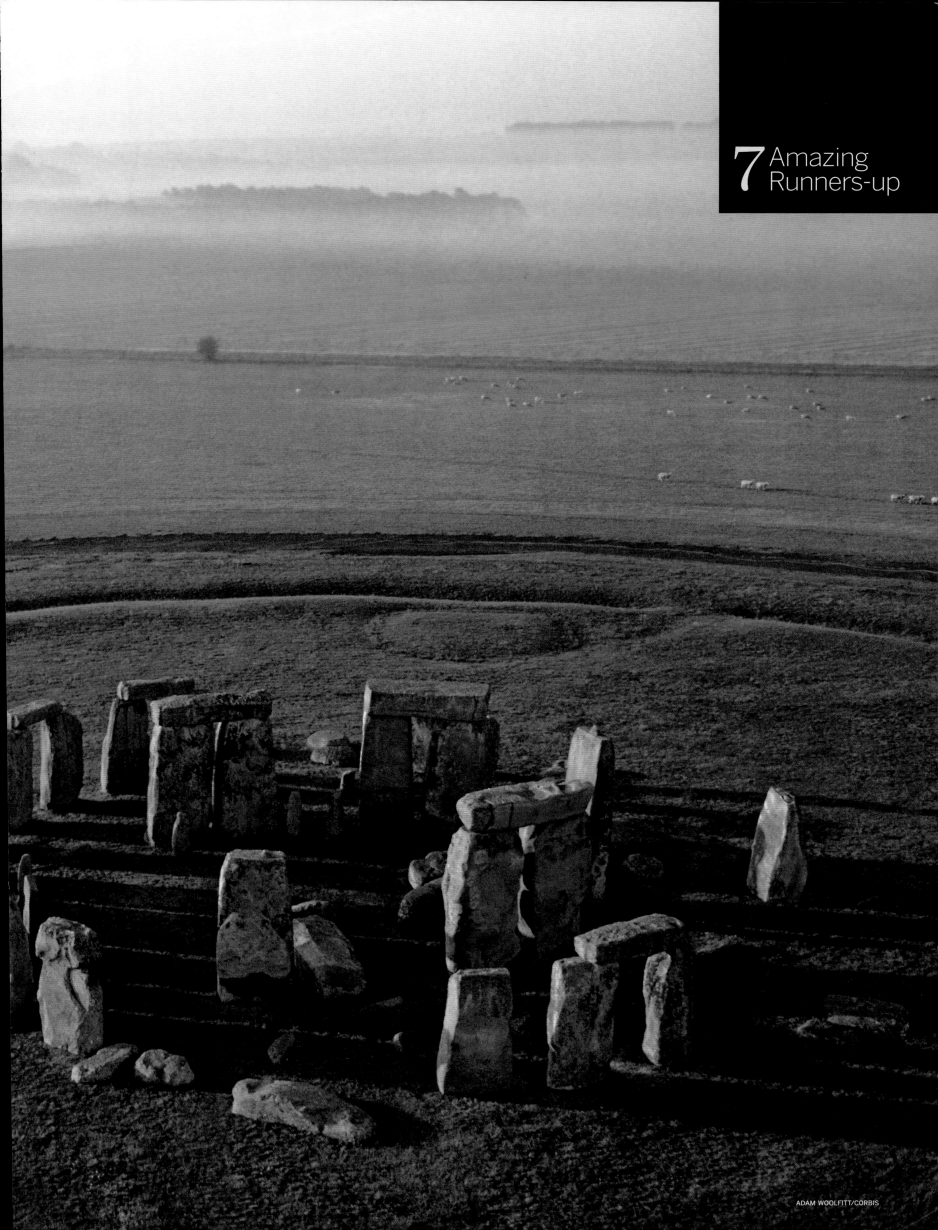

Wonders of Today

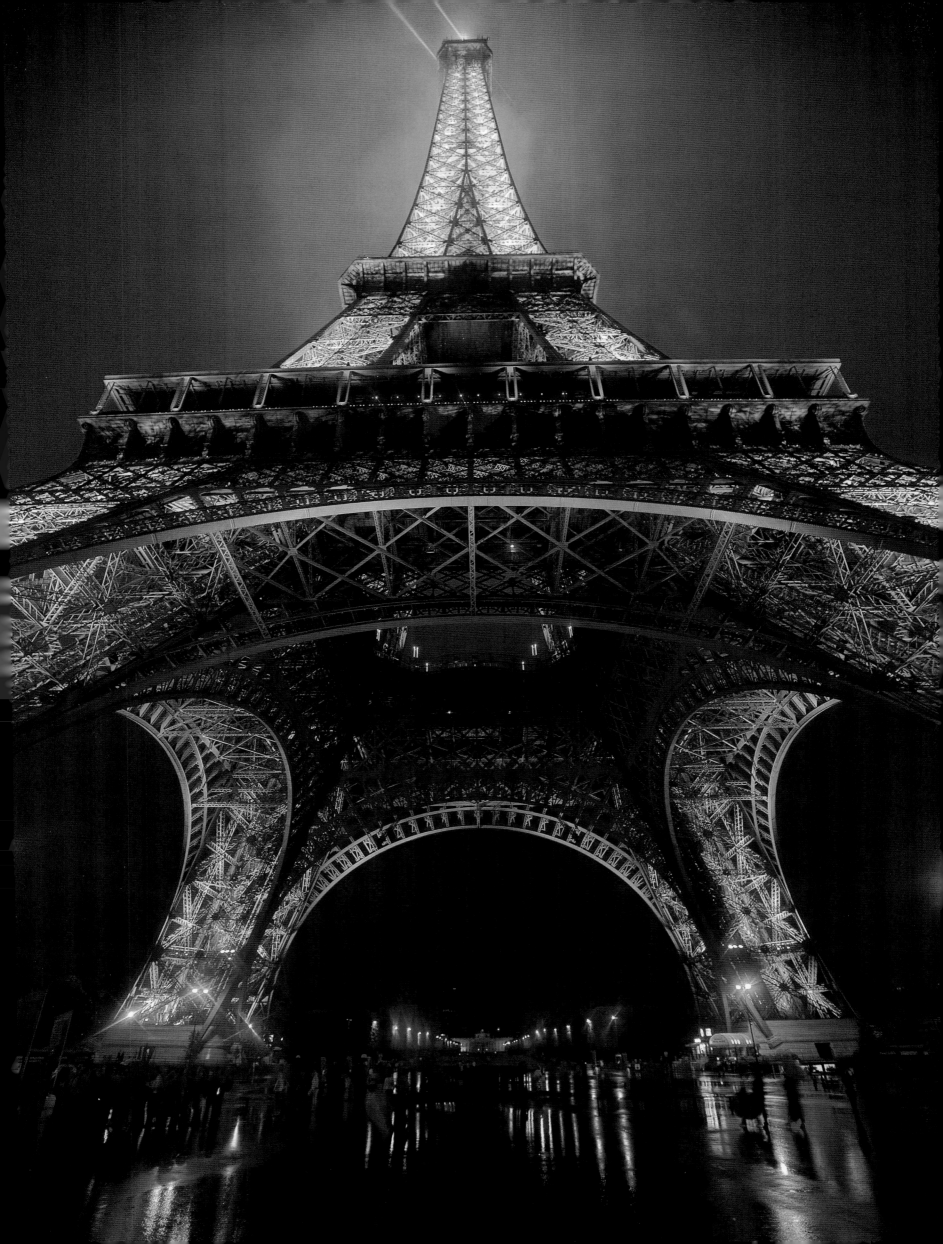

Wonders of Today

The Eiffel Tower

It can be argued that no city has such a signature building as Paris does in its Eiffel Tower. You glimpse it, and immediately Gay Paree is summoned to mind: romance, flair, a cosmopolitan je ne sais quoi. And yet, Parisians themselves were hardly unanimous in their affection for the structure when it was built, and once nearly had it torn down.

It rose as a centerpiece of the Paris World's Fair of 1889. The eminent engineer Gustave Eiffel was given the project; he served as both architect and structural engineer. At the time, a petition with the signatures of 300 influential citizens, including members of the cultural elite like Guy de Maupassant and Emile Zola, was presented in objection to the immense tower. One critic saw "stretching out like a black blot the odious shadow of the odious column built up of riveted iron plates"—a description that's even livelier in its native French. It is worth noting: The Parisian naysayers were not alone. Eiffel had first presented his plans to the city fathers of Barcelona for their Universal Exposition of 1888, but they considered the prospective tower bizarre and turned it down.

At nearly a thousand feet in height, the tower was the world's tallest building until 1930 (and remains Paris's tallest today). It was built with 15,000 pieces of iron and 2.5 million rivets. To protect against rust, 50 tons of paint are used, and in the present day the tower must be repainted every seven years. One thousand, six hundred and sixty-five steps lead to its top, and it has only had two purposes: as an observation tower and as a broadcasting tower. (Well, today there are two restaurants, including the luxe Jules Verne at 410 feet on the tower's middle level, but the argument that it is largely an empty emblem is hard to refute.)

There was a move to erase the Eiffel Tower in 1909; it survived only thanks to its role in the broadcast of telegraphy. A radio and TV antenna would make use of the tower in the decades to come. What once saved the building now seems its most prosaic raison d'être.

In the City of Light, no monument outshines the tower. Each evening, 20,000 twinkling bulbs are triggered during an hourly five-minute show—a show that was halved in 2008 from a 10-minute production in order to send a message far and wide that Paris was going "green." The lights make up what is prettily called the tower's "diamond dress."

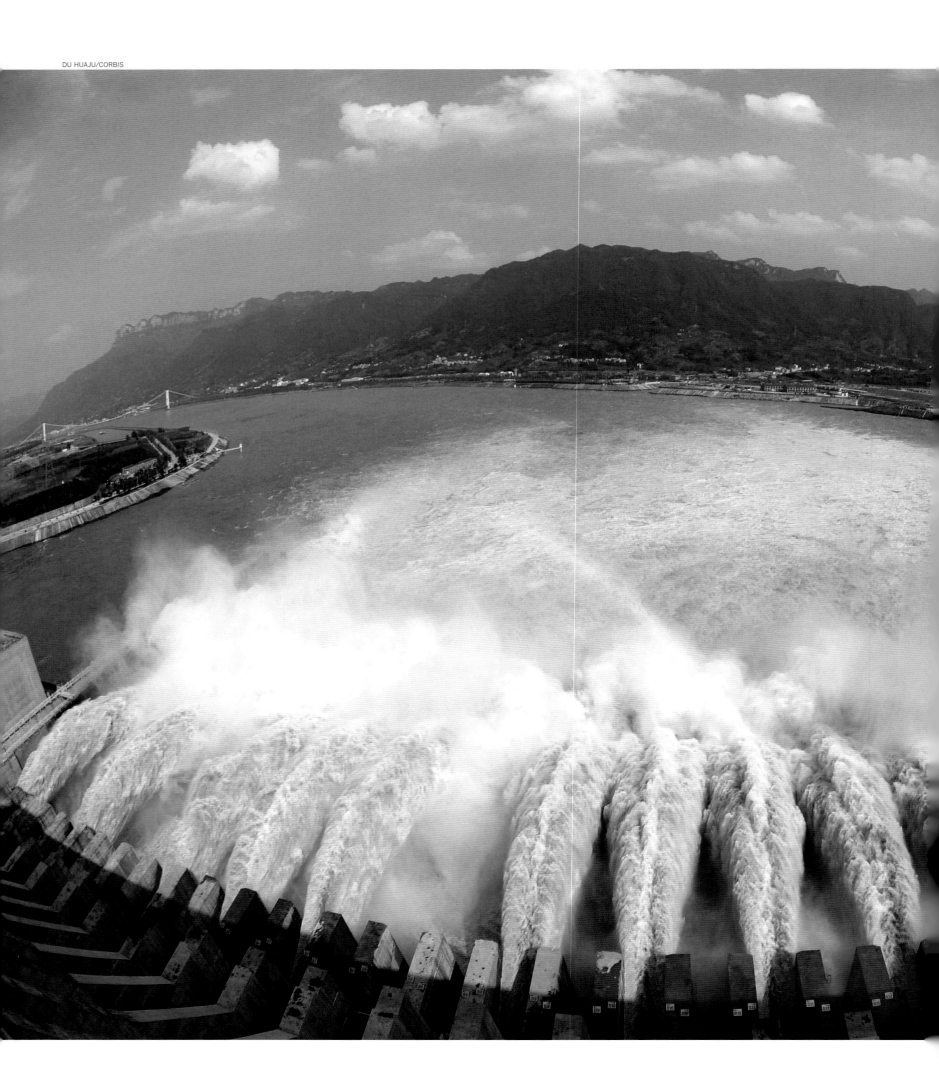

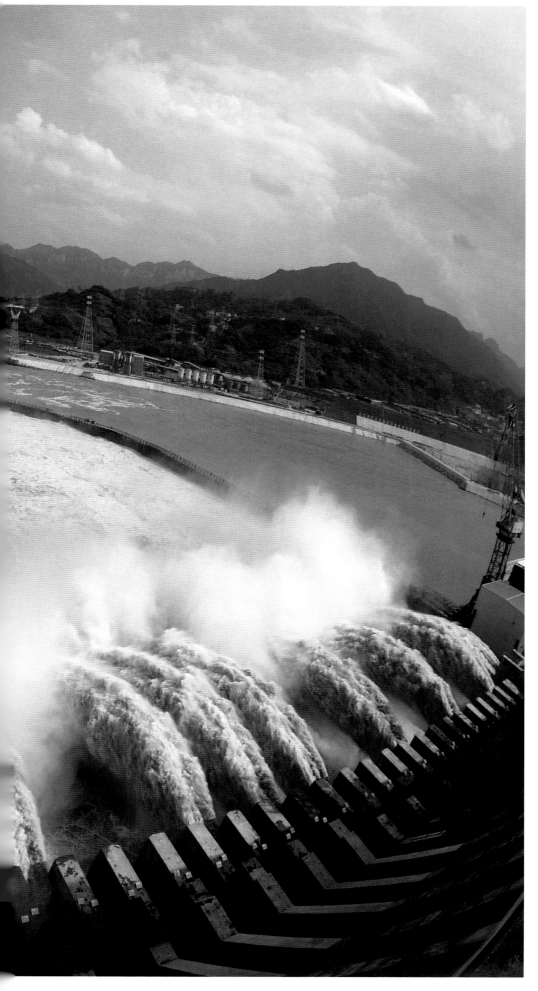

In July 2007, sluices are opened at the Three Gorges Dam in Yichang, in central China's Hubei Province, to divert flood water. The dam successfully controlled a huge flood crest on the Yangtze River that summer.

The Three Gorges Dam

In 1919, Sun Yat-sen gazed upon the Three Gorges section of China's enormous Yangtze River and proposed a dam that would be the gigantic equal of the setting. The idea was revisited in the subsequent decades, but wars or other distractions got in the way. Then, in 1992, Premier Li Peng submitted a proposal for such a dam to the National People's Congress. The plan passed by the slimmest margin in the legislature's history. Maybe the dissenting congressmen knew something.

Environmental issues have plagued the project from the get-go. On September 25, 2007, after nearly 13 years of backbreaking construction on the estimated $39 billion initiative, senior Chinese officials predicted a "huge disaster . . . if steps are not taken promptly." Within two weeks, the town fathers of Chongqing chimed in: They would need to relocate 4 million people (4 million *more* people; the total moved was already 1.4 million) living in at-risk areas because of environmental havoc wrought by the dam. At the time, Professor Lei Hengshun of Chongqing University, a specialist in the Three Gorges ecosystem, told *Time* magazine, "Now it's a good time to review the problems that have arisen before a larger flooded area brings an even bigger impact on the tributaries." He knew that stopping the dam was impossible but hoped risks could be lessened "as long as the government is able to deal honestly with the situation."

The government says it has done this, and the Three Gorges Dam is scheduled to come fully online in 2009.

And here we pause to discuss (defend?) our inclusion of this construction in our book. Should it have been excluded for its controversy?

Was, to return to an original Wonder, the pharaoh's Great Pyramid a "good" thing for the people of the time? Clearly not.

Was the Eiffel Tower, which we just visited, a wise expenditure of funds at the outset? Many thought not.

Because the Three Gorges Dam is such the biggest dam ever—7,661 feet long, 331 feet high, 377 feet wide at its base, more than 51 million cubic yards in volume, nearly seven times that of the runner-up—it is, whether grandly or grotesquely, a Wonder.

Wonders
of
Today

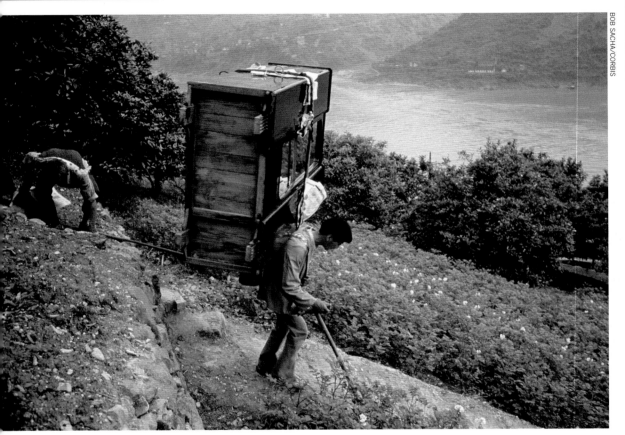

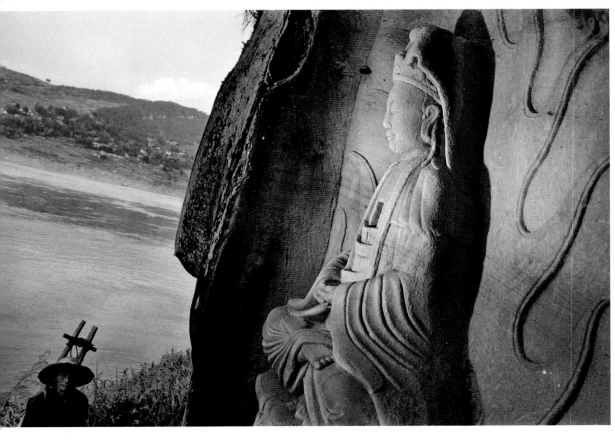

The pain behind progress: A villager in Hubei Province (top, left) carries a wedding armoire down a mountainside to the river in preparation for his family's relocation, necessitated by the dam. At left is one of the Buddhas that were carved into rock cliffs near Zhongxian in the 16th to 17th centuries. Their purpose was to watch over boatmen who were about to navigate difficult stretches of the Yangtze. When the dam project is finished, their assignment will have ended as they will be under water. Above: Artifacts and entire towns began to be lost years ago, as the 2003 submerging of the Xiayan Temple, which had been celebrated by 7th century Chinese poets, proves.

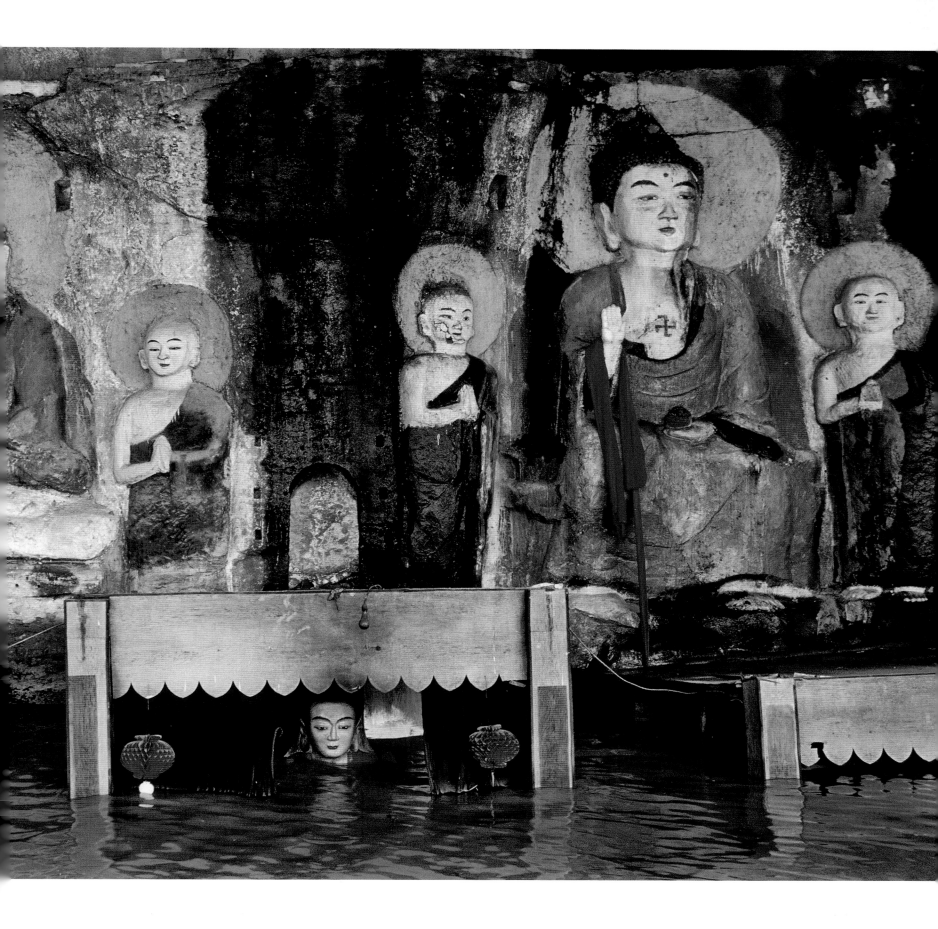

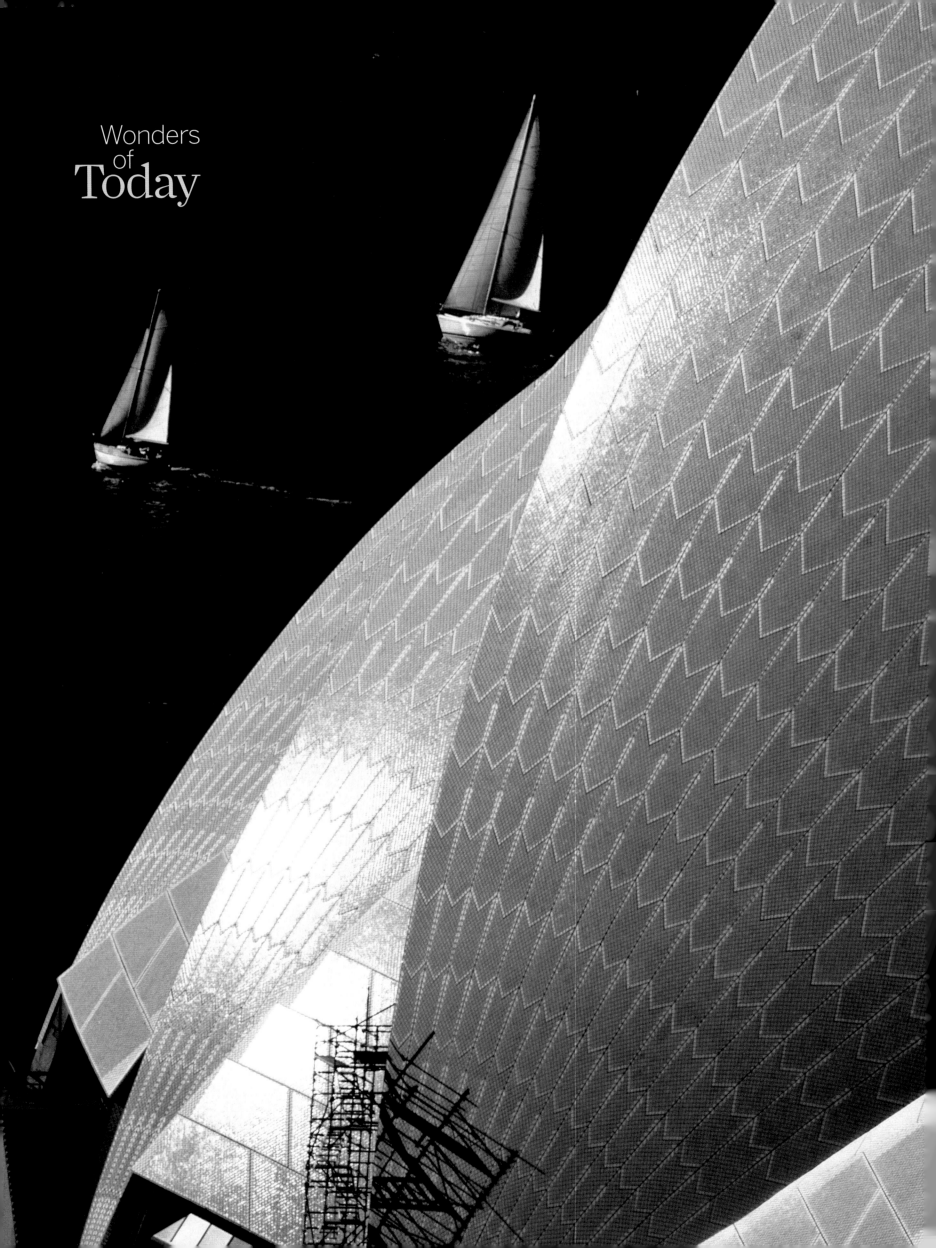

The Sydney Opera House

The gleaming jewel of Australia's glittering Oz of a city, the Sydney Opera House has been regarded as one of the world's great architectural specimens since it opened in 1973. But the hosannas sung at its dedication followed decades of wrangling, controversy, setbacks and all other manner of Sturm und Drang—sort of the cultural counterpart of the Three Gorges Dam contretemps.

The man who won the commission to design the edifice in 1957, the 38-year-old Danish architectural wunderkind Jørn Utzon, resigned in 1966, although he had earlier relocated his entire practice to Australia in order to oversee the storm-tossed project. The Opera House was finally completed a full decade after the original projection date, with a budget overrun of (get this!) 1,400 percent ($102 million eventually spent after an initial estimated cost of $7 million). It was dedicated on October 20, 1973, by Elizabeth II, Queen of Australia (and, by the way, England). There was a thunderous performance of Beethoven's Ninth Symphony and an all-time fireworks show. The Opera House was deemed an instant and smashing success. All was forgiven. Well, not quite all: Jørn Utzon was not invited to the ceremony.

Most striking about the Opera House once everyone had calmed down and come to assess it rationally were the "sails": gigantic precast concrete shells that seem to leap from Sydney Harbor like gamboling whales or dolphins. Their million-plus tiles, shining white in the Down Under sun, gave the antipodes a contemporary face, a signature, a world-class identity.

We at LIFE are in the business of telling stories in pictures, but pictures don't do justice to the immensity of the Opera House, which is hardly just an arena for opera. There are two main halls, five theaters and an equal number of rehearsal studios, plus four restaurants and six bars, in its four and a half acres. Its energy supply could power a town of 25,000 people.

As it is, it fuels Australia's national pride.

It may be the most famous roof in the world, and it is certainly among the most extraordinary. In it are 2,194 precast concrete sections weighing as much as 15 tons and held together by more than 200 miles of tensioned steel cable. Laid over this are 1,056,006 ceramic tiles covering a surface area of four acres. The tiles, specially made by the Swedish tile company Höganäs, clean themselves whenever it rains.

It's easy to make fun of Biosphere 2 as a kind of bizarre white elephant in the arid Arizona highlands. But put to proper use, the place can produce some solid science. Below: Technicians in Biosphere's "ocean" are placing calcareous algae in jars during an experiment that hopes to determine how increases in atmospheric CO_2 reduce the amount of calcification in coral and algae. If data gathered in the desert ultimately helps in efforts to stabilize the planet's threatened coral reefs, Biosphere 2 will certainly have had the last laugh.

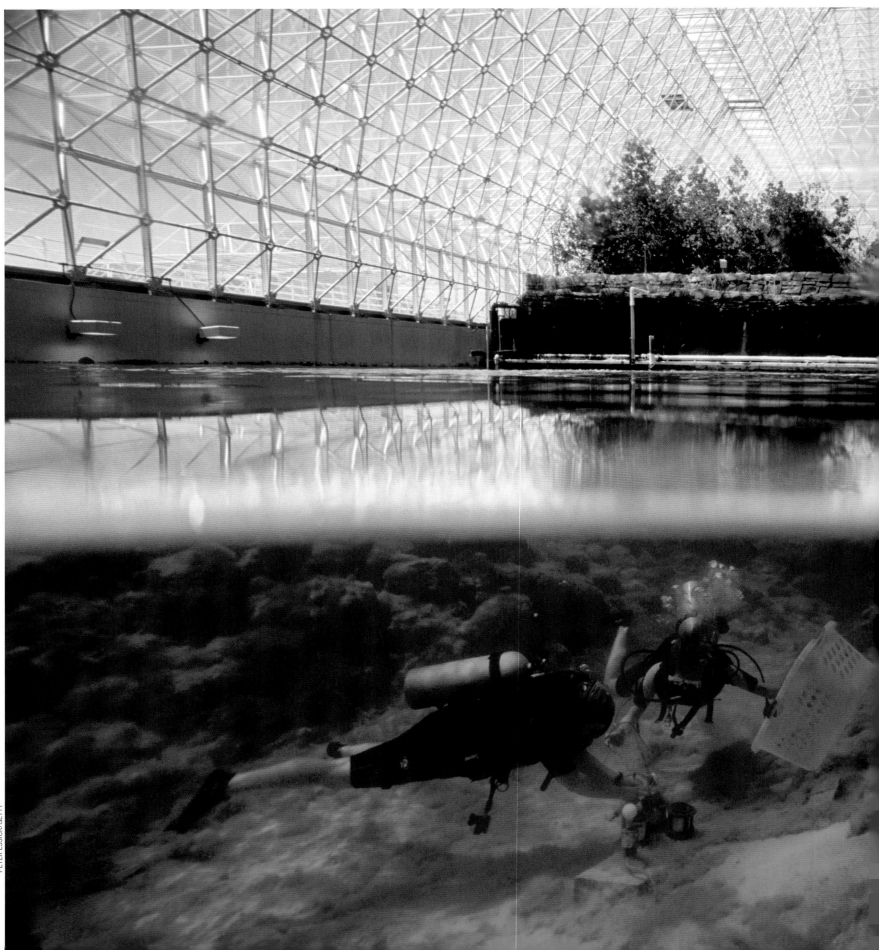

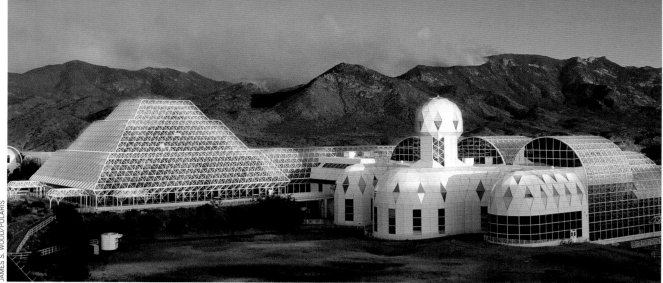

JAMES S. WOOD/POLARIS

Biosphere 2

There never really was a Biosphere 1. Well, actually, according to the folks originally behind Biosphere 2, there was and still is. They considered the earth and its environment to be Biosphere 1, and their sprawling 3.15-acre glass-enclosed ecosystem in the Arizona desert was therefore Biosphere 2. This name game was just one of the many things about this scientific (or pseudo-scientific?) enterprise that seemed too clever by half.

Built in the late 1980s with $150 million of Texas oil magnate Edward Bass's money, the giant terrarium was indisputably an engineering marvel. Covered with 6,500 plates of high-performance glass, the structure is airtight, with mammoth air conditioners and heaters in constant operation to keep the interior environments stable. Those environments include a nearly 3,000-square-yard farm, a 2,000-square-yard rainforest, an "ocean" with a coral reef, wetlands, grasslands and a desert. There was housing inside, since the original intent was to pioneer an effective system for space colonization.

In an experiment, eight men and women shut themselves in on September 26, 1991, and embarked on a two-year "voyage." Things did not go well. The oxygen began to thin, eventually to a level approximating that of air at 18,000 feet of altitude. Two supplies of pure oxygen were pumped in from outside to keep the project going. While bananas in the rainforest did well, other crops failed, and each crew member's diet was restricted to 1,750 calories per day. Crankiness ensued; before a year was out, the group had split into two tense factions. The researchers endured the two years, but after they emerged, rail thin, details of their ordeal became widely known. As *Time* magazine reported, "[T]he veneer of credibility, already bruised by allegations of tamper-prone data, secret food caches and smuggled supplies, has cracked . . . The two-year experiment in self-sufficiency is starting to look less like science and more like a $150 million stunt."

That was then, this is now: After a sale of the facility, management was assigned, in 2007, to the University of Arizona, which will use the Biosphere as a laboratory to study climate change and other environmental issues. The big glass folly has finally found its mission.

The Empire State Building

We have already visited in these pages a couple of buildings that were once the world's tallest—the Great Pyramid, which held the title for 43 centuries, and the Eiffel Tower, which did so for 41 years. On the pages immediately following we will see the reigning champ, Burj Dubai. Some might argue that any deposed skyscraper no longer qualifies as a world-class Wonder, but we disagree with that thinking. The Empire State Building in New York City was a Wonder when it was completed in 1931, and it is a Wonder still.

We are not alone in that opinion. In 1996 the American Society of Civil Engineers, having conducted a worldwide survey, issued their list of seven Modern Wonders and retained the Empire State Building, rightly acknowledging that it remained "the best-known skyscraper in the world, and was by far the tallest building in the world for more than 40 years." The ASCE added pointedly: "The building's most astonishing feat, however, was the speed in which it rose into the New York City skyline.

Construction was completed in only one year and 45 days, without requiring overtime. Ironworkers set a torrid pace, riveting the 58,000-ton frame together in 23 weeks, while just below them, masons finished the exterior in eight months as plumbers laid 51 miles of pipe and electricians installed 17 million feet of telephone wire. The building was so well engineered that it was easily repaired after a bomber crashed into it in 1945. The precise choreography of the operation revolutionized the tall-building construction industry."

Civil engineers are wont to gush over 58,000-ton frames and 17 million feet of wire, but a factor equal to the technological achievement in the building's fame has been its aesthetics. At its dedication, Depression-era masses cheered (and were cheered), and nothing in the intervening decades has served to diminish the tower's charisma and luster.

The Empire State Building remains the world's iconic urban tower, a skyscraper's skyscraper.

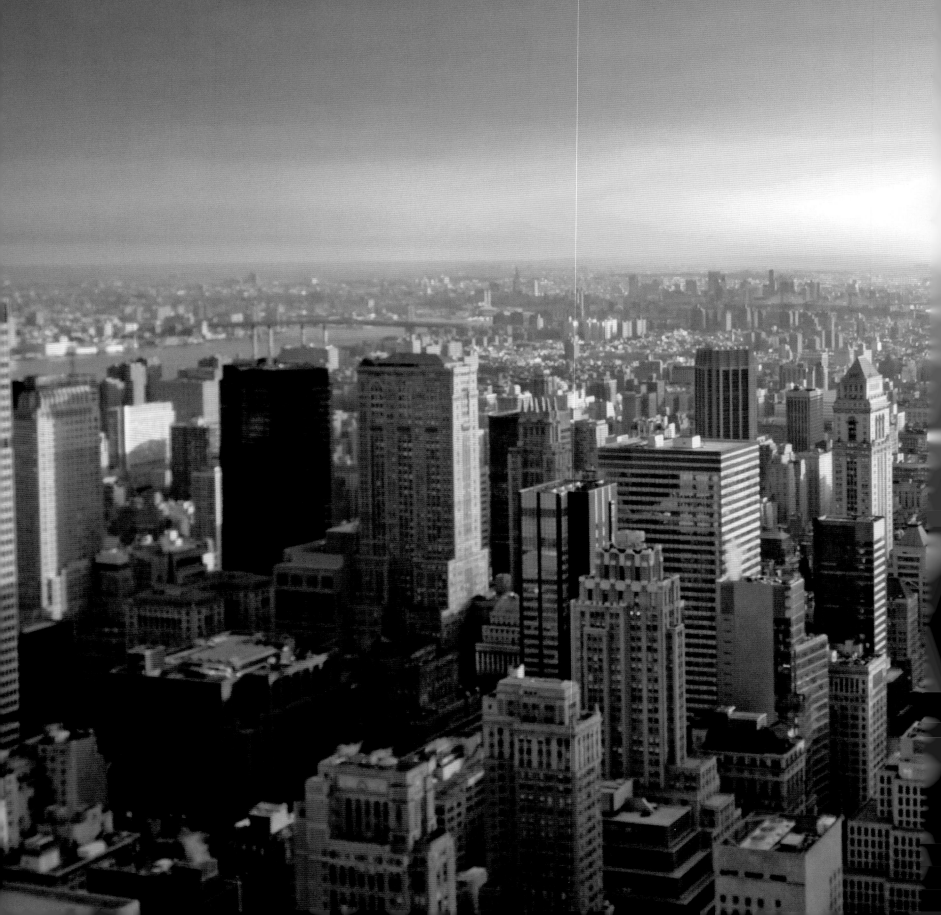

On a March day in 2008, the majesty of this
venerable Wonder is well illuminated in a photograph
taken from the observation deck at Rockefeller
Center, 15 blocks to the north. Of course, for more
than three decades, this vantage included in the
distance the Twin Towers of the World Trade Center,
which were destroyed on September 11, 2001. Until
the Towers' replacement structure is finished, the
Empire State Building is again Manhattan's tallest.

TONY SAVINO/CORBIS

Wonders of Today

On June 20, 2006, skeletal Burj Dubai was but a dream in the desert (below), but by January 4, 2009 (opposite), the still-unfinished skyscraper had risen to more than 890 yards in height and had already claimed the first of its several hoped-for titles.

When Khufu had his tomb built by the Nile, there wasn't really any kind of global competition to create the world's tallest building, but by the time the Empire State Building topped its midtown neighbor the Chrysler Building in 1931, there sure was. These days, the bragging rights are so important to some folks, there are rules concerning what's what. The Chicago-based Council on Tall Buildings and Urban Habitat is the arbiter, measuring buildings to the structural top, the highest occupied floor, the top of the roof and the tip of the spire or flagpole. Emaar Properties, which is developing Burj Dubai (Dubai Tower) in the United Arab Emirates, has made clear its aspiration to be numero uno under all four criteria.

The building, which is in the final stages of construction, is already the world's tallest. On July 21, 2007, as the skyscraper passed 1,680 feet, Emaar Properties quickly issued a statement: "Burj Dubai is now taller than Taipei 101 in Taiwan, which at 508 metres has held the tallest-building-in-the-world title since it opened in 2004. Burj Dubai has now reached 141 storeys, more storeys than any other building in the world."

By the end of 2008 the tower stood at 2,559 feet, and when it is complete the spire's tip will be 2,684 feet above the ground. The building is expected to have 162 habitable floors—fully 52 more than the present champ, the Sears Tower in Chicago. It must be noted: Those "final" statistics are estimates made by close observers of the project. Burj Dubai's construction manager is keeping actual goals close to the vest, lest other builders get wind of the plans and adjust their aspirations upward.

Some things are known for certain: The lower 37 floors will be a luxury hotel; floors 45 through 108 will have 700 private apartments; most of the remainder of the building will be given to corporate offices. There will be an outdoor swimming pool on the 78th floor and an indoor-outdoor observation deck on the 124th.

Burj Dubai, when finished, will claim at least one more title: world's fastest elevator. This will rise or fall at just about 20 yards per second. Khufu would have loved it.

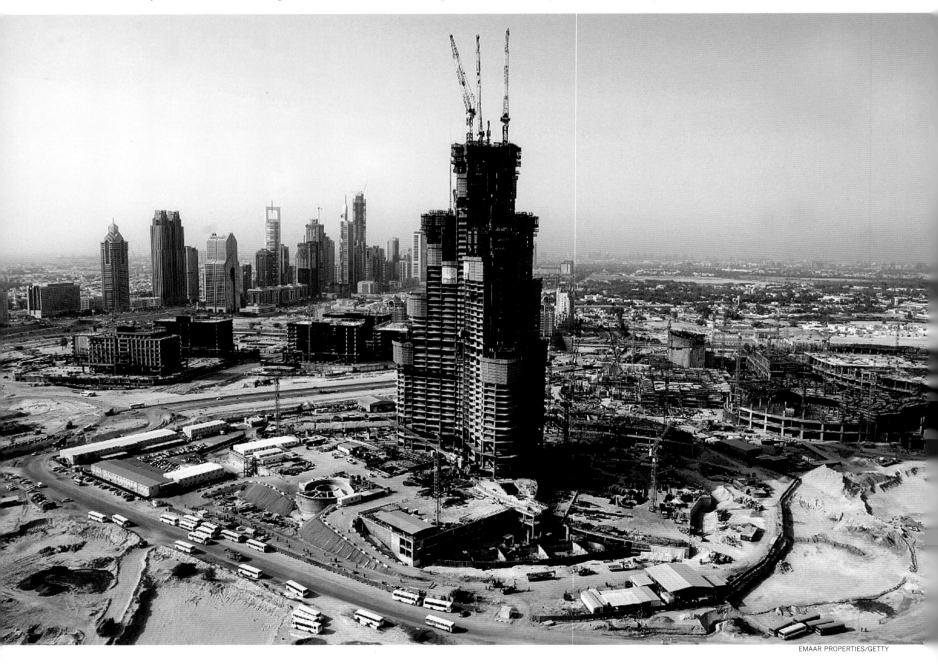

EMAAR PROPERTIES/GETTY

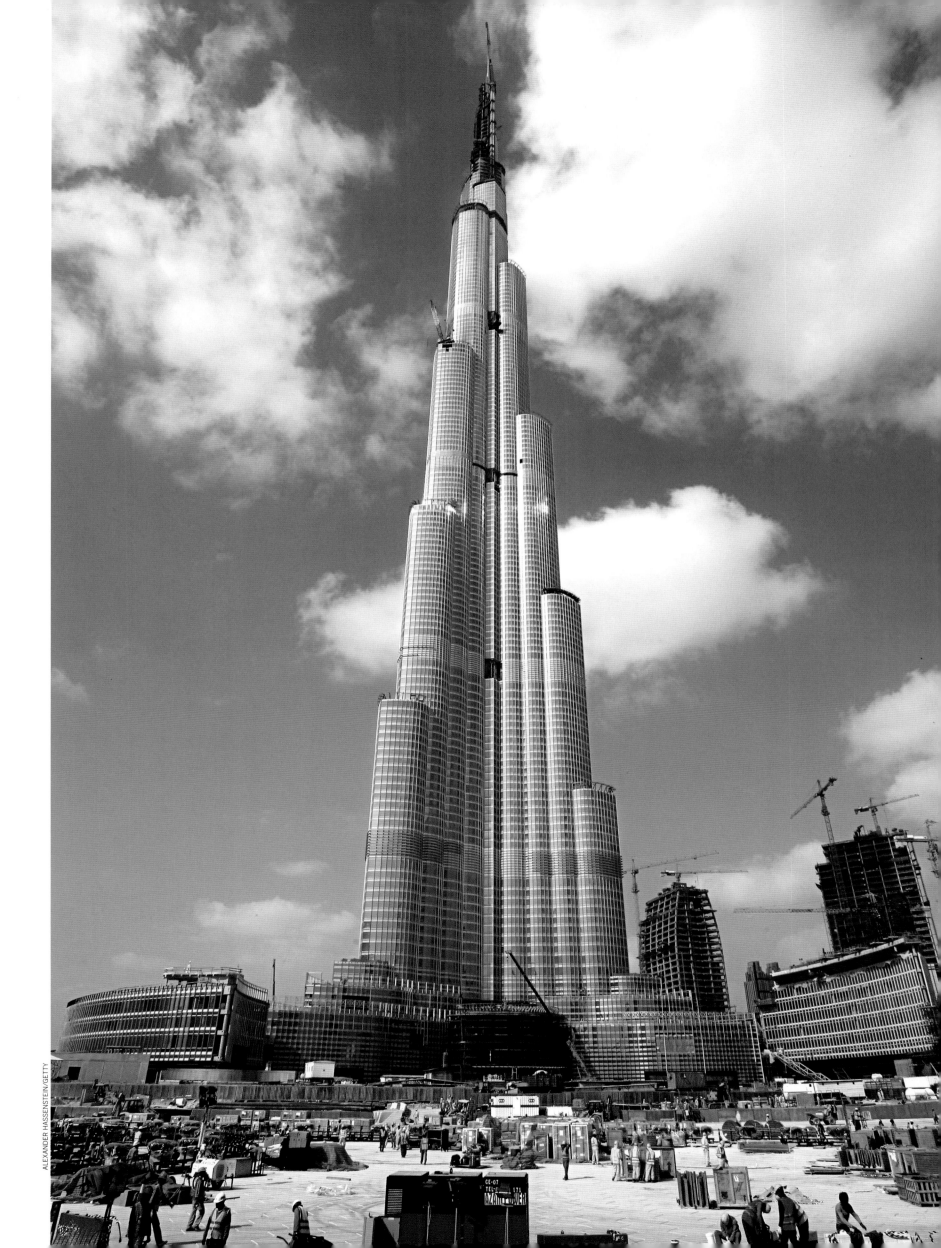

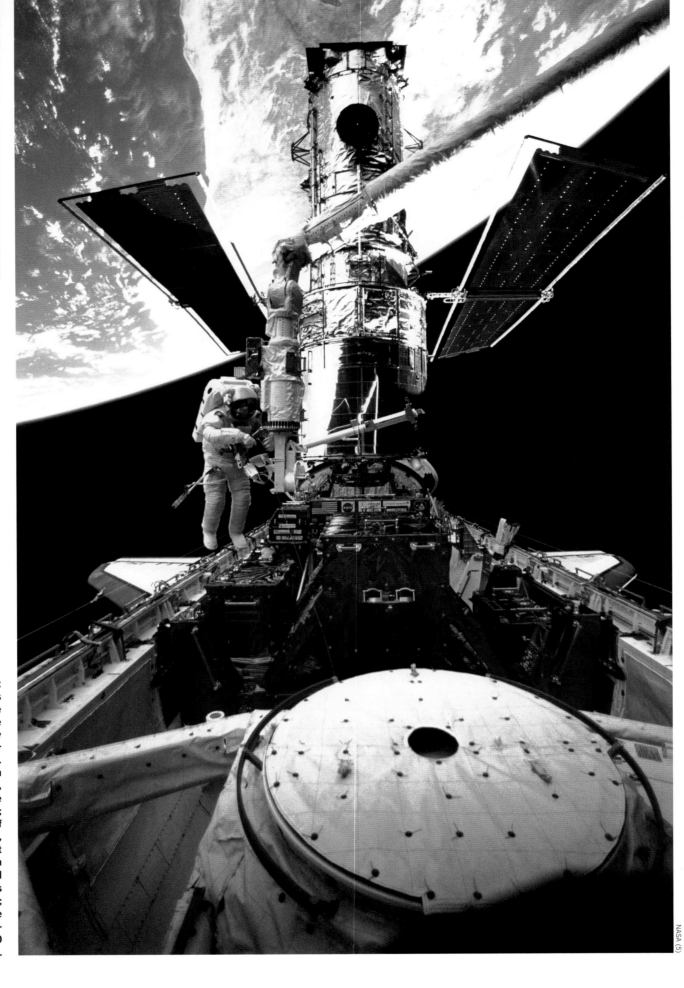

On February 15, 1997, astronaut Steven Smith performs maintenance on the telescope during a space walk. Opposite are four of the Hubble's nearly a million pictures, made after Smith's due diligence. Clockwise, from top left: An image issued on June 7, 2005, showing a star exploding in the Large Magellanic Cloud region; a November 13, 2008, view of a newly discovered planet, Fomalhaut b, orbiting its parent star some 25 light years from our solar system; the Pencil Nebula, about 815 light-years distant, as seen in 2003; approximately a third of the Cone Nebula, part of a large star-forming complex that is 2,600 light-years away, from 2002.

NASA (5)

The Hubble Telescope

Edwin Hubble was a lawyer-turned-astronomer who, in the 1920s, made discoveries that were instrumental in changing the way mankind thought about its place in the universe. Peering into space through telescopes at the Mount Wilson Observatory in Southern California's San Gabriel Mountains, Hubble found that distant clouds of light in the universe were in fact galaxies not unlike the Milky Way, where Earth resides. Suddenly, the possibility that there might be situations elsewhere that approximated our own increased exponentially. Hubble also

determined that the farther a galaxy is from our planet, the faster it is moving away from us. This led to the concept of the "expanding" universe, which in turn was the basis of the Big Bang theory—the postulate that the universe began with a burst of energy 13.7 billion years ago and has been growing ever since.

Dr. Hubble clearly knew how to wield a telescope.

So when it came time for NASA to name what would be the world's first space-based optical telescope, it had a historical candidate in Edwin

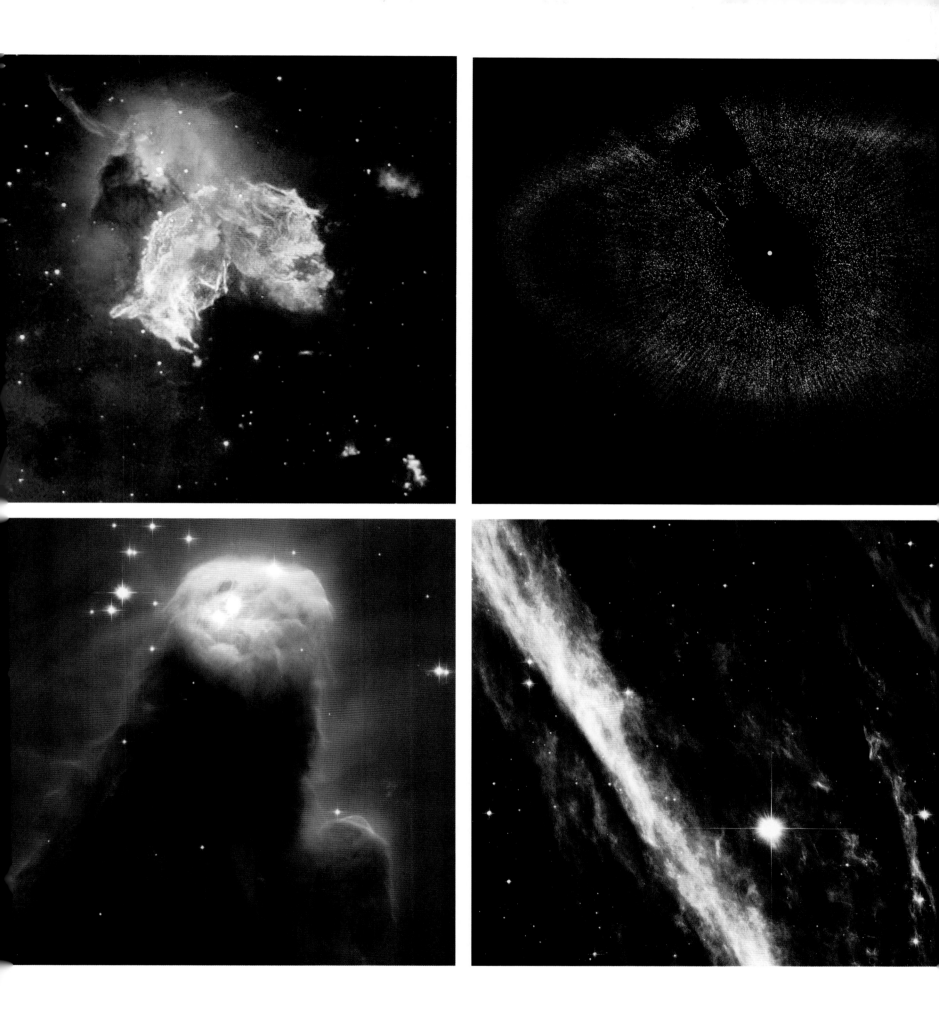

Hubble, who had died in 1953. The 43.5-foot, 24,500-pound, $1.5 billion instrument was borne aloft by the space shuttle *Discovery,* then launched into orbit on April 24, 1990. It was deployed the next day, and has been sending back data that has thrilled scientists and pictures that have fascinated all of us ever since.

The Hubble is just about the size of a school bus, and that's a nifty way to envision it: driving around the planet once every 97 minutes, 353 miles above the surface, keeping its eyes not on the road ahead but, rather, on the sky above. This bus is fueled by the sun, whose rays are caught by two 25-foot solar panels and distilled into the required 2,800 watts of energy.

Why put a telescope into space? Because such a device, afloat above the distorting effects of the earth's atmosphere, could provide unprecedented deep and clear views of the universe. During several servicing missions since its launch, the Hubble has been fixed and upgraded with new equipment, and is still doing its work ably as it nears its 20th birthday.

Sailboats ply the waters of San Francisco Bay as the Golden Gate Bridge looms above the mist. Chicago is the Windy City and San Francisco has been called, if a bit less famously, Fog City. Just so: In the Bay Area's unusually cool summers, a billowing white cloud is produced on a regular basis by a combination of sea spray, wind and Central Valley heat. By late August, the densest of the fogs thin, and a highlight becomes a low-lying stream of white pouring through the Golden Gate, with a lovely blue sky above. It's a trademark image almost the equal of the bridge itself.

DONOVAN REESE/GETTY

The Golden Gate Bridge

The "bridge that couldn't be built" was an appellation bestowed, in 1937, upon a bridge that had in fact already been built. The product of Depression-fueled gutsiness and hope against hope, the Golden Gate Bridge was at once a marvel and a miracle. It was not only the longest suspension bridge in the world, it was also the first to span the mouth of an ocean harbor. And, on top of it all, it was beautiful.

As opposed to many other outsize U.S. construction projects of the 1930s, the Golden Gate was not conceived of as simply a means to utilize a dormant workforce or energize a local citizenry. In fact, efforts to build the bridge began in the '20s, when things were still roaring and the world generally seemed to be the bee's knees. In 1928 six counties in northern California came up with a proposition and began floating it; in 1930, after the stock market had crashed but before the full ramifications had set in, voters approved a $35 million bond to give the bridge a go. Engineer Joseph Baerman Strauss drew up a design that looked as improbable as it did fantastic, and with many doubters catcalling from the sidelines, work was begun on January 5, 1933.

The construction, as had been the case across the country with the Empire State Building, was superfast, taking only a tad longer than four years. The result was phenomenal. With twin towers rising 746 feet apiece and spans supported only by cables (the bridge's two principal cables contain 80,000 miles of steel wire, enough to circle the earth thrice), the bridge was built to sway as much as 27 feet in winds of up to 100 mph. The entire 1.7-mile length was painted international orange to complement the surroundings of scenic San Francisco—yet one more serendipitous decision in a long series of them. Today, the Golden Gate, which along with the Empire State Building was one of two "older" Wonders retained by the American Society of Civil Engineers on its list of seven Moderns, is the signature landmark of the City by the Bay.

Wonders of Today

Below: On December 1, 1990, diggers celebrate the historic meeting of the French and British tunnel teams and the first ground-based connection of England with the European continent since the Ice Age. Bottom: The lorry terminal in Folkestone in Kent, on the British side. Below, right: Chunnel-bound hyper-fast Eurostar trains in London's St. Pancras Station.

Of all the world's massive construction projects undertaken near the end of the previous millennium, one effort unquestionably qualifies as a Wonder—not least as it answered a centuries-old dream, that of uniting England with the European continent. We speak, of course, of the 31-mile Channel Tunnel, affectionately known in Britain, France and the wider world as the "Chunnel."

Work on what would finally become an estimated $21 billion project was begun in 1988. Huge tunnel-boring machines as long as 240 yards each went to work on both coasts. With a capability of clearing 250 feet a day, the machines met in the middle in remarkably short order: just under three years.

DAVID GILES/PA

JASON HAWKES/GETTY

LEWIS WHYLD/AP

In looking at a project that displaced three times more earth and rock than the building of the Great Pyramid in Egypt, the folks at the American Society of Civil Engineers were breathless when citing the Chunnel as one of their Modern Wonders: "[I]t rolls infrastructure and immense machinery into an underwater tunnel system of unprecedented ambition." The ASCE went on to describe three concrete tubes *plunging* into the earth at Calais, on the French coast, then *burrowing* "through the chalky basement of the English Channel. They reemerge at Folkestone, behind the white cliffs of Dover. Through two of the tubes rush [trains] traveling close to 100 mph . . . Maintenance and emergency vehicles ply the third tunnel, between the rail tubes. Meanwhile, machines are always at work, turning the Channel Tunnel into a living, intelligent structure." A quick piece of evidence to support this last vivid metaphor: The tubes are multichambered, and pistons open and close ducts to relieve air pressure that builds ahead of an onrushing train.

The Chunnel was an instant success: In its first five years of operation, 28 million passengers and 12 million tons of freight were transported through it. If it was a miracle of engineering, it was also something of a cultural miracle, for it got Britain and France working together—sharing, as if the best of friends!—on a daily basis.

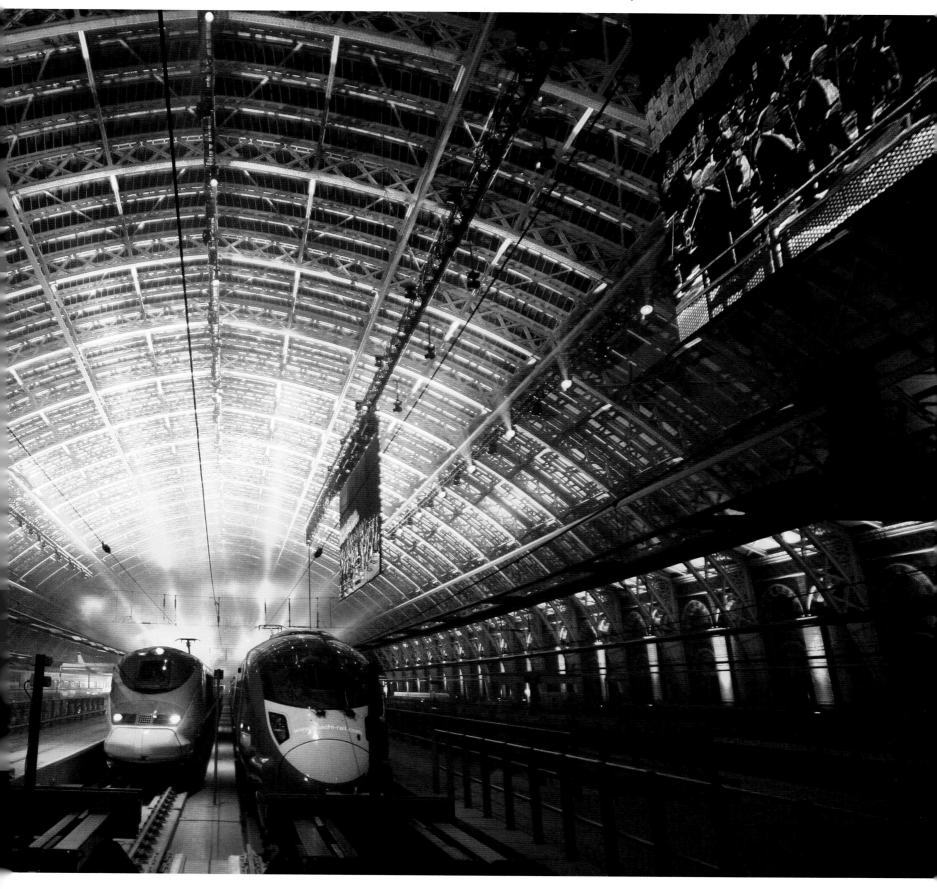

The International Space Station

I f the original gang behind Biosphere 2 seemed to be playing
around with life in outer space, the scientists and engineers
involved with the International Space Station are engaged in
very serious business—engaged, in fact, in the largest and most
complex international scientific project in history.

Assembly of this research facility, which is traveling at
17,210 mph as it orbits the earth, began in 1998 and is slated to be
completed in 2011. As of 2008, it was already the largest space
station ever built, and when finished it will measure 356 feet
across and 290 feet long. It will be powered by the sun's energy,
harnessed by two thirds of an acre of solar panels.

The goals of the space station are stated plainly by the people
behind it: "Research in the station's six laboratories will lead to
discoveries in medicine, materials and fundamental science that
will benefit people all over the world. Through its research and
technology, the station also will serve as an indispensable step in
preparation for future human space exploration."

The station, which is expected to be operative at least
through 2016, is clearly a scientific and engineering Wonder, but
it is also a Wonder of international accord. While economics was
a driving factor in bringing nations together to build the thing, it
is nonetheless true that cooperation on the project has been
great. Led by the United States, the International Space Station
draws upon the resources of 16 nations—the others are Canada,
Japan, Russia, Brazil and 11 nations of the European Space
Agency—and by the end of 1999 some 500,000 pounds of compo-
nents for the station had been built at factories around the
world. The manned spacecraft that service the station are pri-
marily the U.S. Space Shuttle and Russian craft, but astronauts
who have spent time on the station have come from 15 partner
countries. Thanks to the Russians, the station has been visited
by half a dozen space tourists as well. The cost to punch your
ticket to the orbiting outpost: a cool $20 million.

A sense of scale can be discerned from this photograph, taken March 12, 2008, of the Space Shuttle Endeavour, with the planet Earth in the background, preparing to dock at the International Space Station. The enormous orbiting lab truly seems like something yanked from George Lucas's imagination.

This has long been, and continues to be, a work in progress. Near right: In March 1946, Netherlanders repair breaches in the dikes made not only by the winter gales but by bombing during World War II. Below: In May 1984, workers are dwarfed by huge sheets of seabed mattresses rolled in gigantic drums, indicative of the many different strategies at play in the North Sea. Far right: The Oosterschelde Dam in Zeeland.

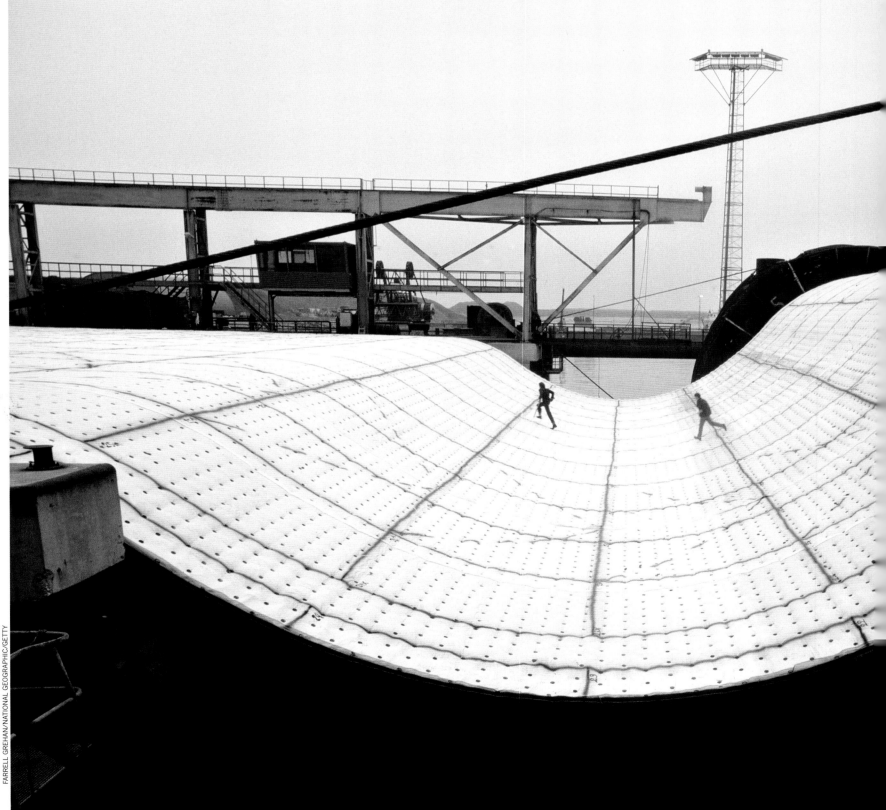

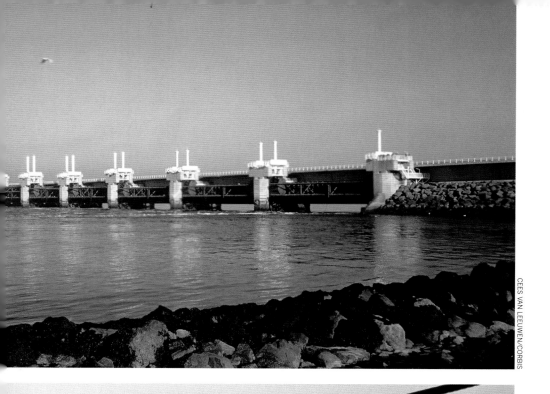

CEES VAN LEEUWEN/CORBIS

The North Sea Protection Works

As we know, young Hans Brinker held back the North Sea by plugging a leak in a dike with his finger and thus saved his country, the famously low-lying Netherlands. To keep the ocean at bay today requires an extravagant network of dikes, barriers, floodgates and other water-manipulating devices. Two conclusions: The North Sea Protection Works, which has bent but never broken, is a marvelous machine; and . . . that Hans must have been quite a lad.

Much of the Netherlands lies below sea level, and the Dutch have always used dams to protect fields and, indeed, themselves. (Were this not the case, half of the country would be washed over daily by the tides.) By the 20th century, new technologies were becoming available to combat storm surges that overwhelmed existing structures; a devastating storm in 1916 was a catalyst for action.

The North Sea Protection Works is a system of structures and strategies put in place during the remainder of the 20th century. It began with a 19-mile-long dike that closed the Zuider Zee, a tidal inlet that was subsequently drained, resulting in a half million acres of new farmland. In 1953 the "storm of the century" hit, but the dike, 100 yards thick at the waterline, held. The southwestern Netherlands, however, was wrecked by the storm; nearly 2,000 people and hundreds of thousands of animals were killed. So new action was demanded, and in the decades since, the Delta Project—dikes, dams, gates and channels—has been added, and in 1997 a barrier was built to protect Rotterdam.

The magnitude of the North Sea Protection Works has been compared with that of China's Great Wall, and its technological sophistication was likened to that of the first lunar landing. Analogies are useful, but they obscure one point: The complex system is wholly unique, a testimony to its many designers and to the will of the Dutch people to undertake a civil engineering project on the most monumental of scales. It is as daring and tenacious and brave as . . . well, Hans Brinker.

Mount Rushmore

Doane Robinson of the South Dakota Historical Society had an idea for boosting tourism in his state: How about we get someone to carve statues of western heroes like Buffalo Bill and Lewis and Clark into the Black Hills? In 1924 he contacted the prominent American sculptor Gutzon Borglum, who had been influenced by Auguste Rodin while studying in Paris. Borglum became entranced but wanted to work on a national scale. George Washington came to mind. After the city that was named for our first President got involved, with Congress authorizing the Mount Rushmore National Memorial Commission in 1925, President Calvin Coolidge insisted that two Republicans and a Democrat be part of the assemblage. Abraham Lincoln seemed a natural (even though Borglum was a card-carrying member of the Ku Klux Klan), and Thomas Jefferson, too. Theodore Roosevelt brought things into the 20th century. "The purpose of the memorial," said Borglum, "is to communicate the founding, expansion, preservation and unification of the United States with colossal statues of Washington, Jefferson, Lincoln and Theodore Roosevelt."

So the fact that Roosevelt had proclaimed an earlier Borglum statue "first-rate" had absolutely nothing to do with TR's nomination? Perhaps not. In any event, the hero of San Juan Hill was in.

The carving of Mount Rushmore—accomplished with dynamite, jackhammers, drills and chisels—began on October 4, 1927, and finished shortly after Borglum's death in 1941. But during those 14 years, only six and a half years of work was done. Weather often intervened; also money kept running out and hiatuses were called. The project, which displaced 450,000 tons of rock and resulted in four distinctive 60-foot heads that can be seen 60 miles away—the biggest sculpture anywhere in the world—finally cost $900,000.

The largest single private donation to the effort was $5,000, made, interestingly enough, by a lawyer from New York City—one Charles E. Rushmore. He had been in the Black Hills back in 1885 to check on some property titles for an eastern mining company. At one point, he had asked his guide, the prospector Bill Challis, the name of that impressive mountain over there.

"Never had any," said Challis. "But it has now. We'll call the damn thing Rushmore."

And so, with his contribution to the project, Rushmore was investing in his own immortality.

In an unusual vantage on a July morning at 6:39 a.m., George Washington and, less prominently, Thomas Jefferson— half of Rushmore's Fab Four—bid adieu to the setting moon. If and when the Crazy Horse monument, which is being blasted out of a different Black Hills mountain, is ever finished, Rushmore will be by far the smaller of the two.

The Millau Viaduct

Here's another record-holder: the tallest vehicular bridge in the world. At a maximum height of 1,125 feet, this Wonder is definitely not for the vertiginous.

It was built in answer to a summertime dilemma: How could vacationers from northern Europe get to the southern coasts of France and Spain without suffering the grueling bottlenecks that routinely ensued? Planners theorized that if they could possibly build a bridge spanning the valley of the River Tarn, near Millau in the south of France, they could cut

something like four hours from the trip during the tourist high season. The noted British architect Norman Foster was retained to figure out how such a bridge could be built.

He worked on the project with structural engineer Michel Virlogeux. Their idea was to place seven concrete pylons or piers at intervals across the valley, and they would support tall masts that would keep an eight-span roadbed aloft. The viaduct roadway, which would come to weigh 36,000 tons, would be 8,100 feet long—more than a mile and a half's worth

This (left) looks like a truly harrowing drive, but fret not: The photograph was produced using a fish-eye lens. Seen in the distance are the city of Millau and the Black Limestone Plateau. Below: The viaduct on December 16, 2004, the day it opened for traffic—making holiday travelers very happy indeed.

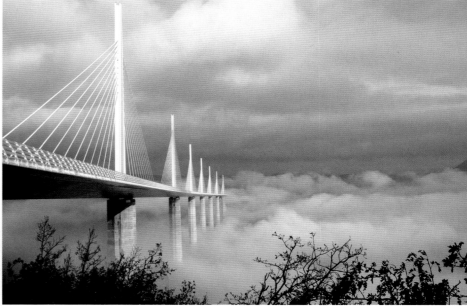

of hellacious, high-flying, heart-stopping driving.

Construction began on the bold, even audacious project in October 2001 and would take three years. The pylons, which range in height from 250 feet to 810 feet, depending on the depth of the valley at each interval, were assembled on site from sections weighing 60 tons apiece. Atop each pylon, beginning at the roadbed, was secured a 290-foot mast weighing approximately 770 tons. Eleven metal cables, each made of between 55 and 91 high-tensile strands woven together, stretched down from the masts in either direction to support the roadbed.

More than 110,000 cubic yards of concrete were used in all, and the total weight of the bridge came in at 320,000 tons.

Then-president Jacques Chirac presided at the ribbon-cutting on December 14, 2004. By the following summer, as many as 50,000 vehicles per day were gliding over the Tarn Valley on a bridge unlike any that had come before it. For these vacationers, the old saw had come true: Getting there was half the fun.

Wonders
of
Today

The National Stadium

The first triumph of the 2008 Olympic Games in Beijing was registered by this stadium, the largest steel structure in the world and an arena of colossal aspiration. The Chinese organizers wanted symbolism, functionality and breakthrough modernism represented in their National Stadium, and they got all of this in spades.

In April 2003 these officials sat down to choose from among the plans of 13 finalists in a design competition. Those of a team that included the Swiss architecture firm Herzog & de Meuron, Arup Sport, and the China Architecture Design and Research Group—plus a Chinese artistic consultant—were selected. Clearly Asian design elements, as can be seen in everything from ceramics to palaces, were at play in the winning bid. "Why does a Chinese bowl or a Chinese

The stadium, which appears to be a steely gray by day against the often similar shade of the Beijing sky, shines by night. The arena actually comprises two independent structures, one existing within the other. A latticework frame stands 50 feet outside a concrete seating bowl, which is painted red.

window have this kind of pattern?" asked Li Xinggang, the lead architect of the Architecture Design and Research Group. "Maybe the Chinese people like things to appear in this irregular way, but underneath there are very clear rules. The Bird's Nest developed in this way." Li, who used the nickname that was instantly bestowed upon the design, added that when he saw his team's scale model next to those of his rivals during the competition, he said to himself, "We will win this."

They did, and ground was broken on December 24, 2003. In the next four and a half years, 110,000 tons of Chinese steel were put in place and up to 17,000 construction workers at a time toiled on the project. Yet the equivalent of only $423 million U.S. was spent. It is estimated that the stadium would have cost 10 times as much in the West.

On August 5, 2008, Nicolai Ouroussoff, in an architecture review for *The New York Times,* had these words for those attending the upcoming opening ceremony: "Expect to be overwhelmed . . . [T]he stadium lives up to its aspiration as a global landmark. Its elliptical latticework shell, which has earned it the nickname the Bird's Nest, has an intoxicating beauty that lingers in the imagination."

The more than 90,000 spectators who filled the National Stadium days later, and the millions more watching on television worldwide, cheered in agreement.

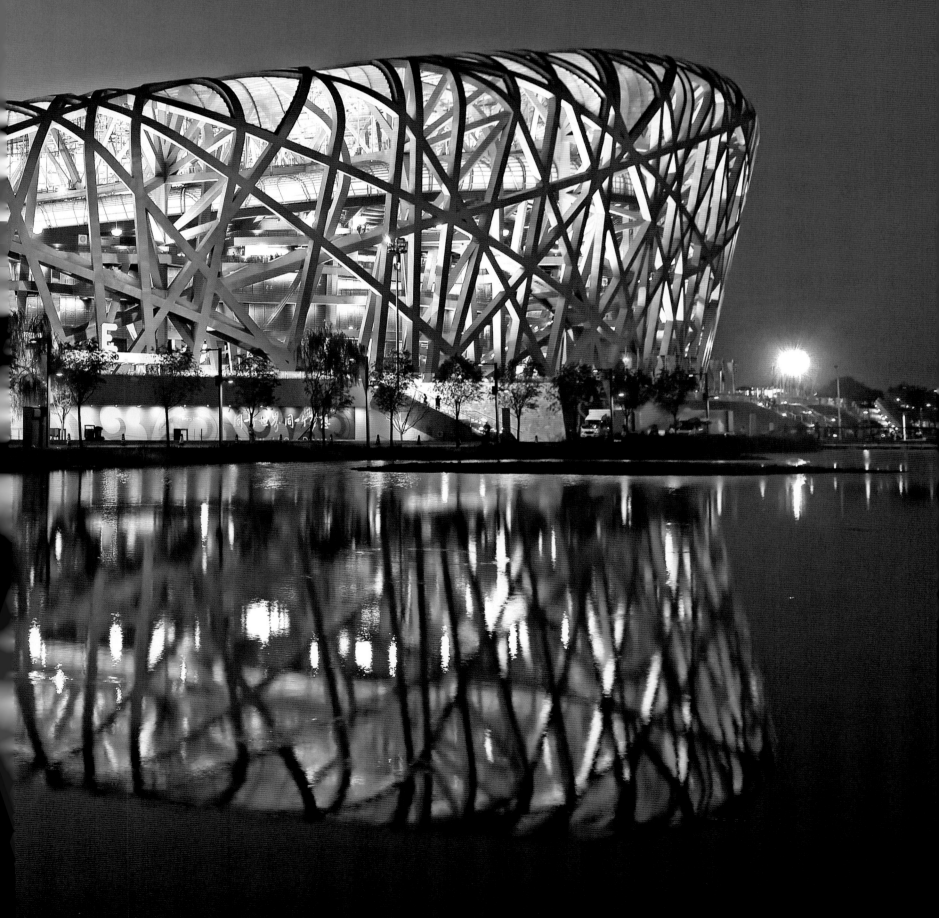

Nature's Wonders

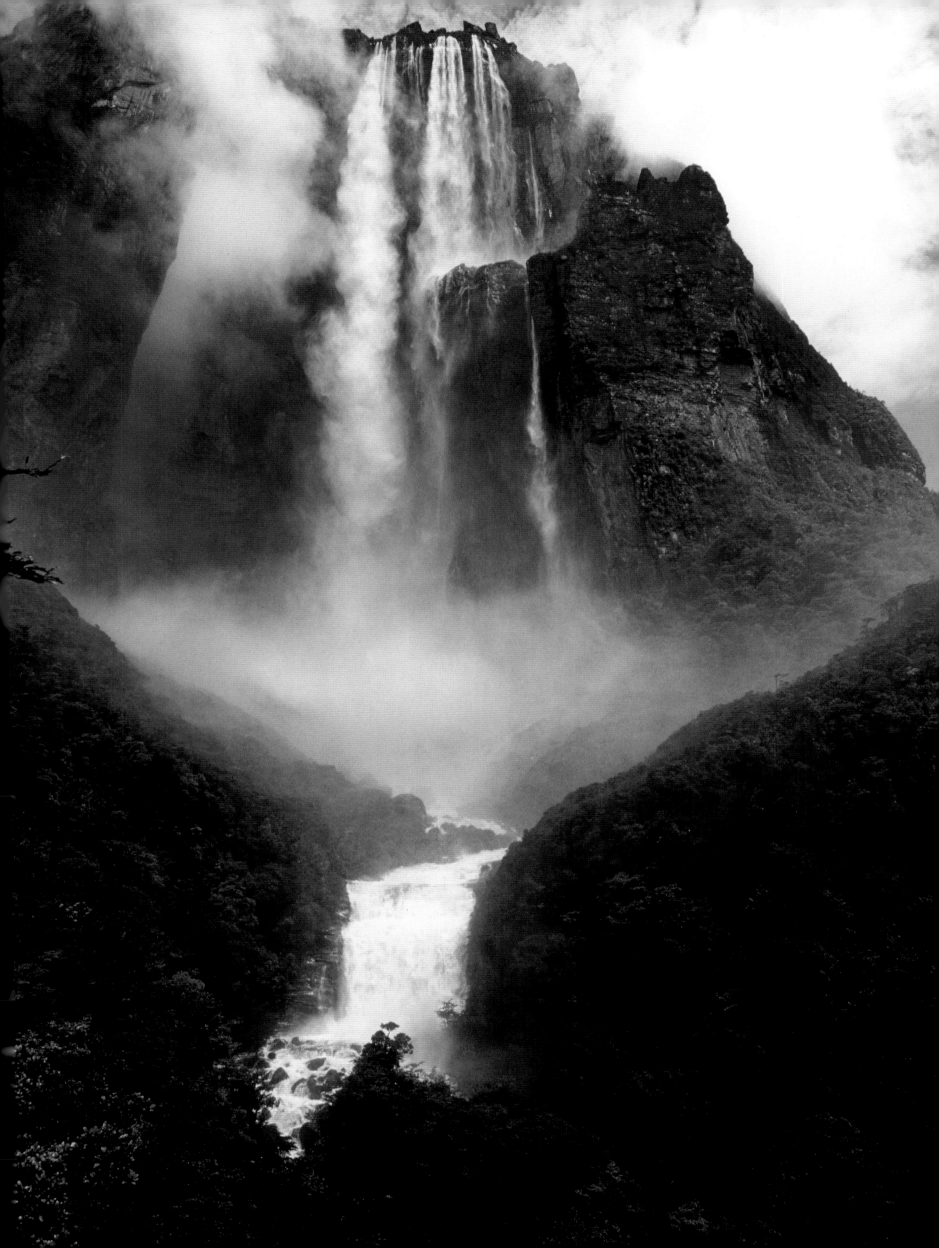

The Galápagos Islands

A visit to the storied Galápagos Islands calls to mind the power sweep of the old Green Bay Packers: You know what's coming, you try to brace yourself for it, but the experience overwhelms you nonetheless. In these isles, you are as one with strange creatures who do not fear you and carry on with their daily affairs—forming an animate, dreamy patchwork quilt of wildlife.

The 19 islands of the Galápagos lie 600 miles west of the South American country Ecuador. They are on the equator, yet are also in the way of cool, nutrient-rich currents; thus tropical forms coexist with cool-water species. Once known (for good reason!) as the Enchanted Isles, their remoteness has, at least in part, served to create a world with 27 reptiles but only one amphibian—a frog that has recently become established. The land mammals are limited to rodents and a couple of bat species.

The islands take their name from their 500-pound giant tortoises (the old Spanish word for tortoise is *galápago*). There are four-foot-long marine iguanas (like the ones we see here) that would look right at home on the set of a dinosaur movie, hundreds of them, drawing heat from the sun before disappearing into the water to munch on seaweed. Side by side with these creatures are animals of Antarctic origin, like penguins and fur seals. Seabirds are represented by the delightful blue-footed booby and the world's only flightless cormorant.

Charles Darwin famously visited this land in 1835 and noted: "[S]everal of the islands possess their own species of tortoise, mocking-thrush, finches, and numerous plants . . . that strikes me with wonder." This mutability of species helped the great man with his evolutionary theories. Ironically, however, there are scarlet crabs here identical to an Atlantic species from which they have been separated for perhaps 35 million years.

Clearly, the Galápagos are a one-of-a-kind place. With the careful management the islands have been receiving, they should remain for all time a Wonder among Wonders.

The delights that awaited Darwin were many and extraordinarily varied. They included marine iguanas such as these, climbing the rocks of Fernandina Island. In the ocean, this effective swimmer is content to graze on seaweed.

ART WOLFE/GETTY

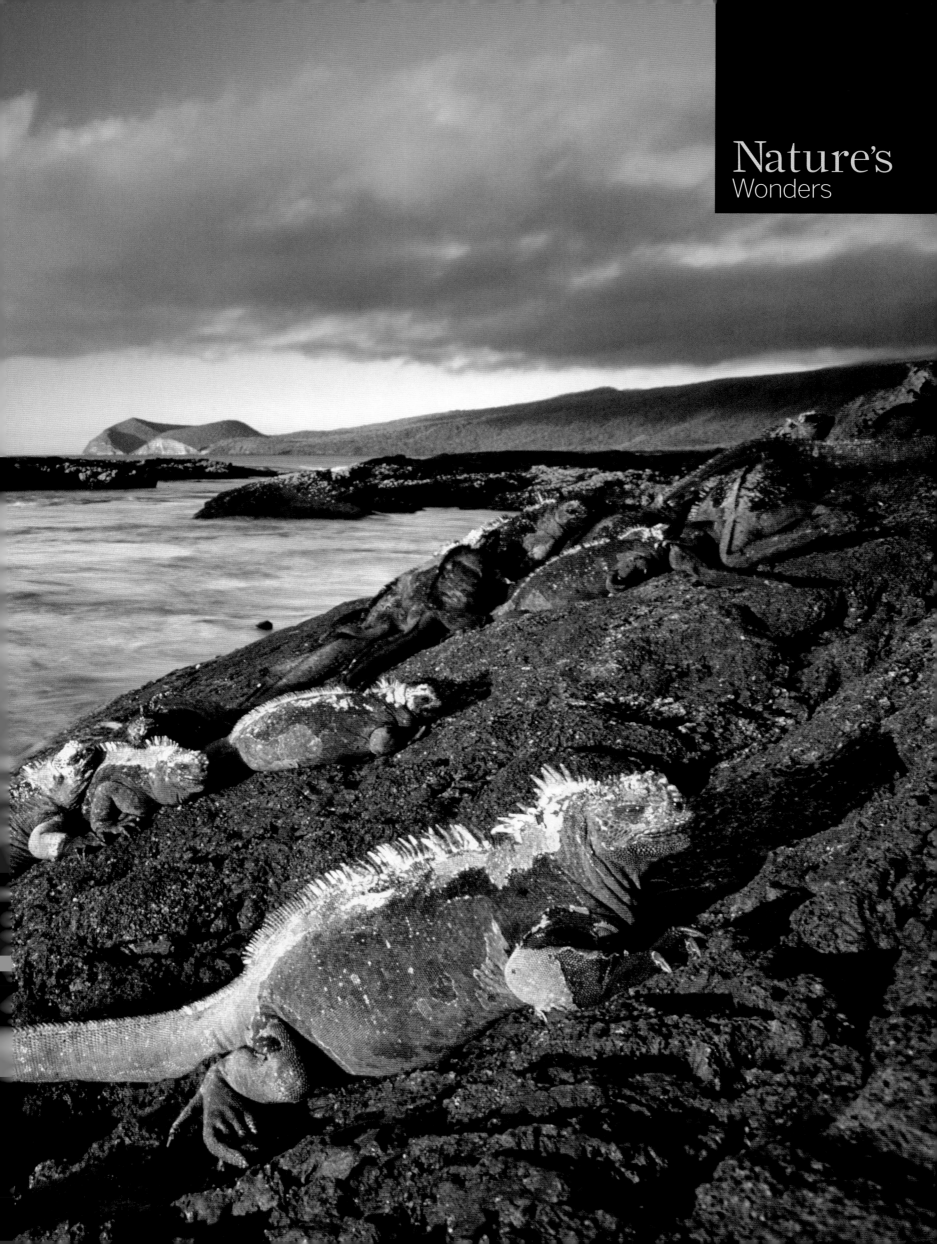

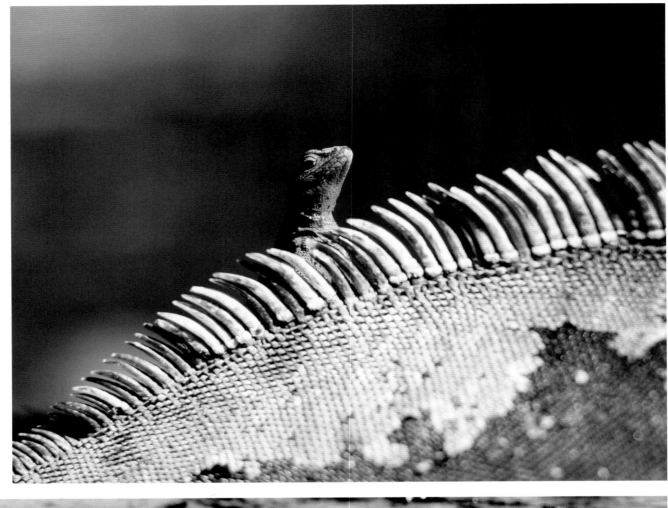

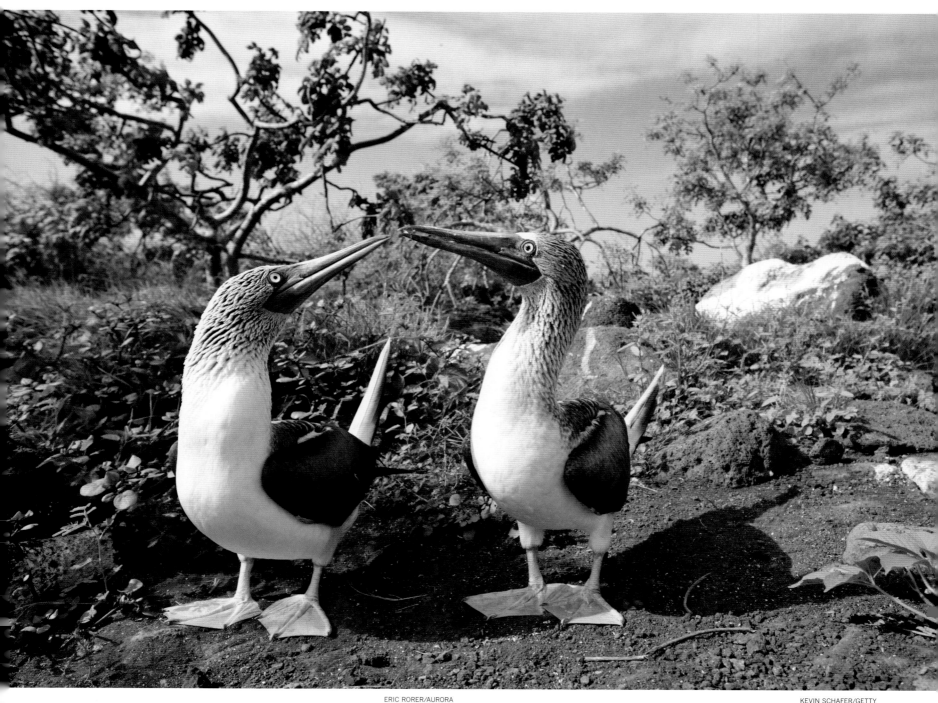

ERIC RORER/AURORA

KEVIN SCHAFER/GETTY

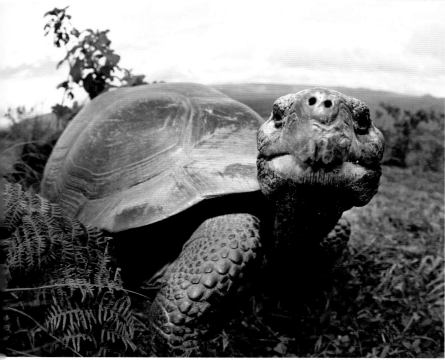

Members of the planet's most storied—and studied—menagerie, traveling clockwise from the opposite page, top: A lava lizard peers over the spiny hide of a marine iguana on Fernandina Island; two blue-footed boobies engage in a courtship display on North Seymour Island; a land iguana is on the march on Santa Cruz Island; a giant tortoise is ready for his close-up near the rim of the Alcedo Volcano on Isabella Island, which is particularly known for its population of these animals that can weigh more than 500 pounds and grow to six feet in length; brightly colored crabs scurry across tide pools on Fernandina Island.

Loch Ness

We will fess up immediately: This Scottish lake is considered by us a Wonder because of a quite probably fictitious monster that people have wondered about since time immemorial. But before we get to this possibly imaginary beast, let us state the case for Loch Ness as a pretty substantial and intriguing entity in and of itself.

It is a large and narrow body of water extending 24 miles in length and having a surface area of 13,952 acres. Nestled amidst the rugged mountains of the Northern Highlands of Scotland, it is extremely deep: Much of it has twice the depth of the North Sea, and the bottommost point of the loch is some 750 feet below the wind-tossed waves. Fed by seven major rivers, it contains more water than all the other lakes in England, Scotland and Wales put together. Remote, in a fierce landscape, it would indeed be a fine place for a monster to dwell.

And perhaps it is that. As long ago as the 6th century, Saint Adamnan wrote an account of Saint Columba, a former Abbot of Iona, "driving away of a certain water monster by virtue of prayer of the holy man." He also wrote of a man killed by "some water monster [that] had, a little before, snatched at as he was swimming and bitten with a most savage bite." Through the ages, other testimony accrued. Not all versions of Nessie looked alike; some were more serpentine than others, some resembled a horselike creature, some were said to be 20 feet long and others were twice that length. Of course, these discrepancies, along with sightings of multiple monsters, might indicate a breeding colony, which would certainly be necessary for the tale to be true. Otherwise, Saint Columba's monster would be impossibly old in the present day, a freshwater Methuselah.

A popular conception of the creature has described it as a marine reptile with a large body, flippers, a long neck and a small head, not dissimilar to a long extinct dinosaur, the plesiosaur.

So, then: the Natural Wonder in northern Scotland. Which is it? The wild and woolly lake itself? Or the wild and weird monster that dwells therein?

Your choice.

In the gloaming on September 11, 2008, the ghosts of Urquhart Castle peer out over the loch, whispering among themselves, "Where are you, Nessie? Show yourself, Nessie."

Beneath "the high noble arc of the cloudless African sky," the American hunter Stewart Edward White and his companions were walking, as he recalls it, "for miles over burnt out country . . . Then I saw the green trees of the river, walked two miles more and found myself in paradise." While he was the first to tell his countrymen of Serengeti, he was hardly the first to consider this lush plain of no fewer than 11,583 square miles in Tanzania and Kenya to be an African oasis of unsurpassed proportions and loveliness. The Masai people who had inhabited the area for millennia named it Siringitu—"the place where the land moves on forever."

This is one of the oldest ecosystems on the planet, with an interrelationship of climate, flora and fauna that has been essentially unaltered for

a million years. Twice that long ago, man entered the picture here in Olduvai Gorge and started to have his impact in the hunting, gathering, adapting, evolving, stalking, running and migrating rhythms of Serengeti.

The migration: It is a hallmark of this land. More than a million wildebeests and 200,000 zebras are on the move every October, traveling from the hills of the north to the plains of the south for the short rains of that season. In April they are spurred by heavier rains to head west, then back north. During the so-called Circular Migration, more than 250,000 wildebeests and tens of thousands of other herbivores (Serengeti is home to 70 species of larger mammals) will succumb to predation, exhaustion or other causes (40,000 animals are poached annually in regions surrounding

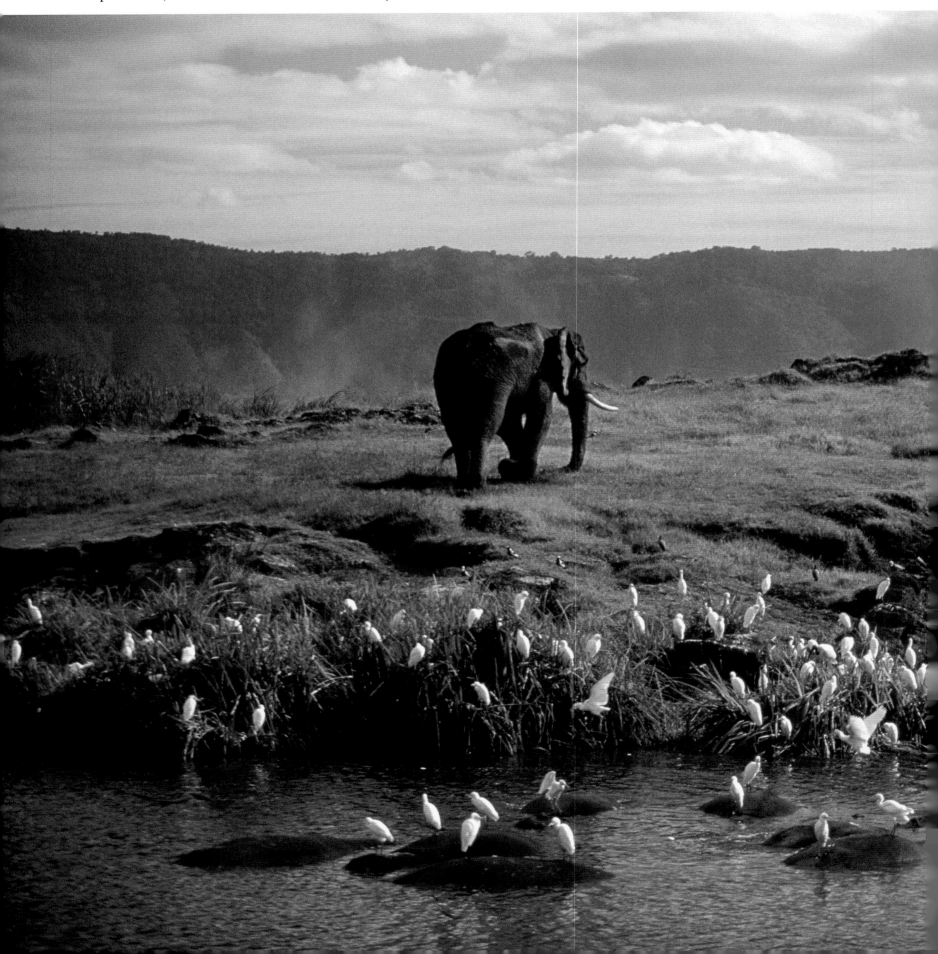

Serengeti National Park), but they will be back at it determinedly the next year. In the 1960s a barbed-wire fence was built to control the wildebeests. The animals promptly flattened it.

The Serengeti migration has been named one of the 10 Natural Travel Wonders of the World, but that almost serves to diminish the overall spectacularity of this place. The "Big Five"—buffalo, elephant, leopard, rhinoceros and lion—all call Serengeti home, as do the cheetah, giraffe, zebra, hippopotamus, jackal, mongoose, warthog and more than a dozen kinds of antelope besides the wildebeest. Among primates we have the galago, baboon and monkey. For all of these animals—and for us—the rolling grasslands provide an unsurpassed backdrop.

Nature's
Wonders

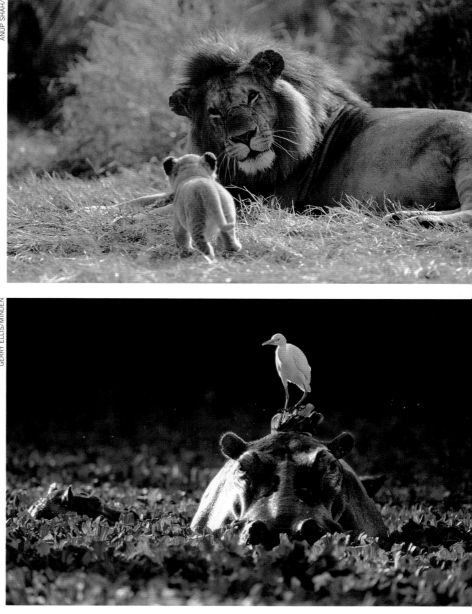

In the photo to the left, an elephant making its way through the Tanzanian landscape is evident in the extreme, as is a flock of cattle egrets. Now look more closely: Those gray humps in the foreground belong to hippos wallowing in a water hole. Above: A close-up of the big guy swimming in water lettuce, with his pal the egret again in attendance. Top: A male lion and cub.

ANUP SHAH/MINDEN

GERRY ELLIS/MINDEN

SHIN YOSHINO/MINDEN

Nature's
Wonders

In a view from the North Rim, low-lying clouds add drama to the always dramatic symphony of the canyon. For some Native Americans, this was not only a spiritual place, it was home: They built shelters near the Colorado River and in caves. The flow of the river is now controlled at the Glen Canyon Dam, which fronts an enormous reservoir, Lake Powell.

The Grand Canyon

Two billion years ago events conspired to begin crafting the incomparable Grand Canyon. What is today magnificent was born in tectonic mayhem as water, erosion and deposition—the formation of rock from various materials—converged. Then, 60 million years ago, two geologic plates collided and a huge plateau built of many sedentary layers was upthrust. Later still, the river that we now call the Colorado began carving into this block of sandstone, limestone and shale. The river was a sculptor's tool. "The Grand Canyon is carved deep by the master hand," wrote the 20th century botanist and author Donald Culross Peattie. "[I]t is all time inscribing the naked rock; it is the book of earth."

Two hundred and seventy-seven miles long, a mile deep and, at its widest, 18 miles across, this notch has a prime place in natural history and in the history of our nation. The first people to view the Grand Canyon were Native Americans who came to the region approximately 11,000 years ago. The first European to gaze upon the place, García López de Cárdenas, who in 1540 was part of Francisco Vásquez de Coronado's explorations of the American Southwest, misunderstood what his eyes were telling him. Conditioned to the scale of European gorges, he was certain that the wee river below was no more than six feet wide, and that the rocks down there were man-size at best. The Native Americans told him the river was mighty and the boulders massive. Nonsense, said the conquistador, and he and his men spent days trying to reach the river. They never did, and finally admitted the locals were right.

In 1869, Civil War veteran Major John Wesley Powell led a boat trip the length of the canyon, one of the most intrepid explorations in history. Having braved the rapids that constantly threatened his team with ruin, Powell exclaimed to his journal, "What a conflict of water and fire there must have been here! What a seething and boiling of the waters; what clouds of steam rolled into the heavens." He was more right than he possibly could have known.

n 1977 the submersible *Alvin,* which can take three people nearly 15,000 feet below the sea, was engaged in one of its amazing ventures, this time to explore a volcanic rift in the Pacific Ocean. As so often happens in the business of science, a "routine" exploration opened the door to another world, one bursting with entirely new forms of life in an ecosystem that itself was a novelty.

Deep-sea vents, also known as hydrothermal vents, are essentially geysers on the ocean floor. They often form on oceanic mountain ridges. Cold seawater slips beneath the ocean floor, is heated by volcanic rock and thrust upward through cracks, where it collides with cold water, forming a toxic, superheated plume. In the land of the plumes,

chimneylike structures composed of mineral deposits, primarily metal sulfides, arise. In this environment of extreme heat and bitterly cold temperatures, of powerful poisons and acute acidity—with intense underwater pressures that would crush most living creatures and a total absence of sunlight—an eerie world thrives, one apart from all others.

There is no plant life, only animals and microscopic organisms, and no photosynthesis, which had previously been considered by biologists de rigueur for all living things. Vent life is sustained by a process called chemosynthesis, in which microbes combine vent chemicals with oxygen. The animals dependent upon chemosynthesis represent a truly different kettle of fish. Some 300 species live near the vents, each of

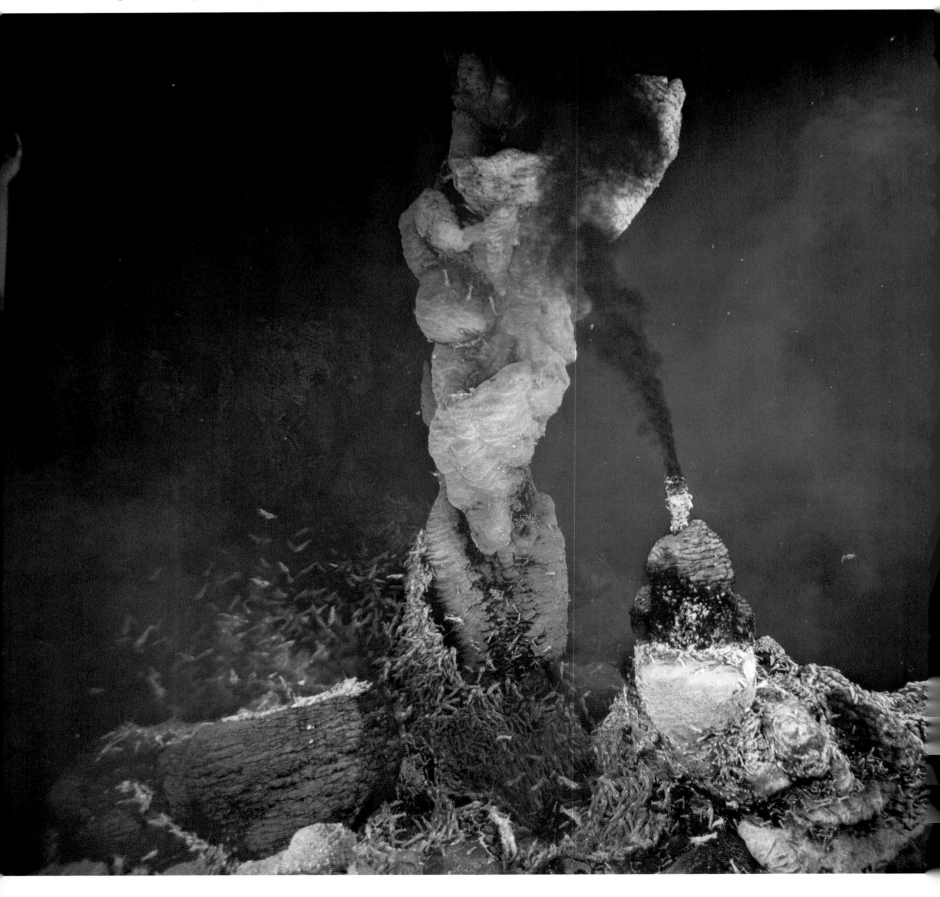

them needing the vents' ghastly ambience to survive. More than 95 percent of the known vent species are entirely new to science.

The vents and the life they nurture—snakelike creatures standing upright in long tubes, minute crabs, other crawly things—are collectively classified in our book as the Wonder. But there are deep-ocean fish in and around the vents that are even more bizarre: anglerfish, swallowers, eels and a species known in the oceanographic world as the "vampire squid from hell." These fish resemble ancient animals rather than anything else alive today. They possess, variously, radar, ferocious dental work and a supernatural talent for bioluminescence. Pleasant dreams . . .

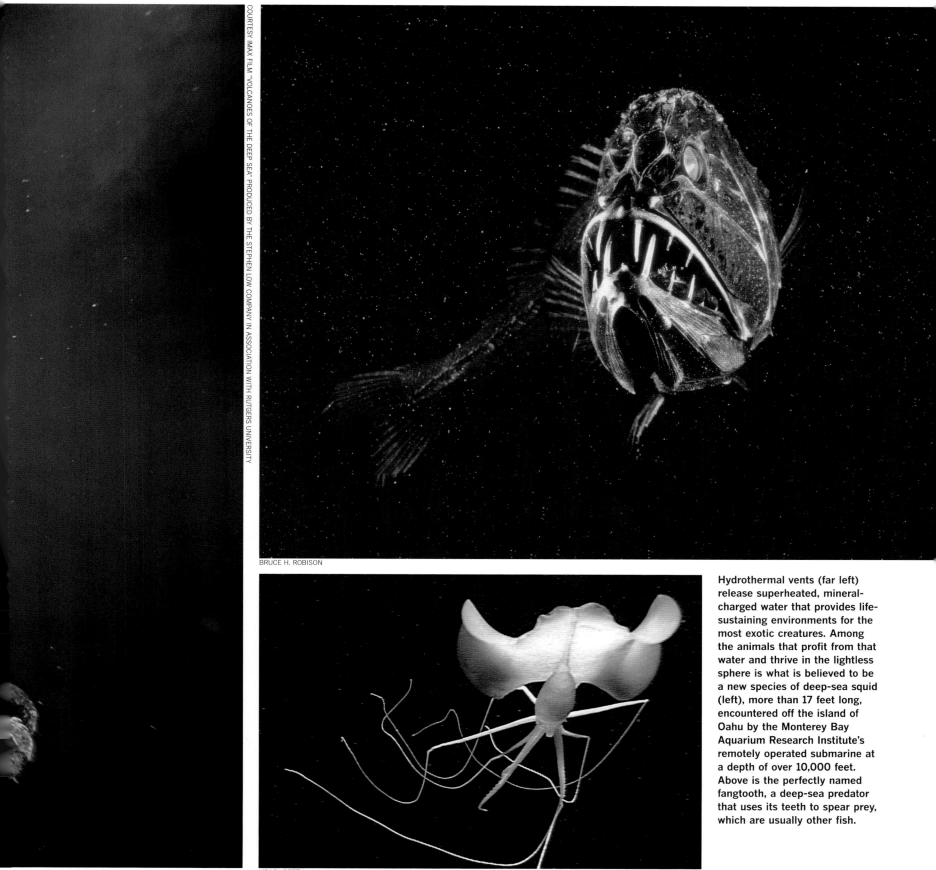

COURTESY IMAX FILM "VOLCANOES OF THE DEEP SEA" PRODUCED BY THE STEPHEN LOW COMPANY IN ASSOCIATION WITH RUTGERS UNIVERSITY

BRUCE H. ROBISON

MBARI/GETTY

Hydrothermal vents (far left) release superheated, mineral-charged water that provides life-sustaining environments for the most exotic creatures. Among the animals that profit from that water and thrive in the lightless sphere is what is believed to be a new species of deep-sea squid (left), more than 17 feet long, encountered off the island of Oahu by the Monterey Bay Aquarium Research Institute's remotely operated submarine at a depth of over 10,000 feet. Above is the perfectly named fangtooth, a deep-sea predator that uses its teeth to spear prey, which are usually other fish.

The Rock of Gibraltar

It's the most famous rock in the world, which is one reason for its inclusion here. It rises on the Iberian Peninsula, extending from the southern coast of Spain, and has been an iconic landmark since ancient times—it was, for centuries, considered the signpost of the edge of the known world. But well before man started to write his own dramatic history of Gibraltar, nature scripted a thrilling birth.

Picture it if you will: Two hundred million years ago, when Spielberg's Jurassic-period beasties were walking the earth, the African tectonic plate collided forcefully with the Eurasian plate. As the song says, "Something's gotta give." Gibraltar was upthrust, magnificently, and the Mediterranean was isolated from the Atlantic. The Mediterranean lake subsequently dried up, then the Atlantic burst through, creating the Strait of Gibraltar, the Mediterranean Sea and the signature sentinel, the Rock of Gibraltar, 1,398 feet above the crashing surf and as imposing as it was impressive.

It was of limestone, and so was (and became further) pockmarked with caves. Evidence indicates that Neanderthal man occupied some of the lower caves as much as 30,000 years ago: That's how long impressive Gibraltar has been significant. Its significance during the Golden Age of Greece and after was immense. Such as Plato saw it as the gateway to something . . . *else*. He placed the lost continent of Atlantis just beyond Gibraltar in the wider ocean. The Moors occupied Gibraltar for seven centuries, and a castle that was built at the beginning of that dominance, in 711, is extant in remnants today. So are underground passages, called the Galleries, dug by English soldiers under siege by the Spanish in the late 18th century. Even today, Gibraltar, which is linked geographically to Spain, is conjoined governmentally with Great Britain.

We have used the word *storied* earlier in our book. But to nothing does it apply as well as to Gibraltar. *Solid as the Rock of Gibraltar* is a phrase known by all to mean invincible. Those who have long lived on the promontory, who have long held it, even only who have long perceived it, understand the saying completely.

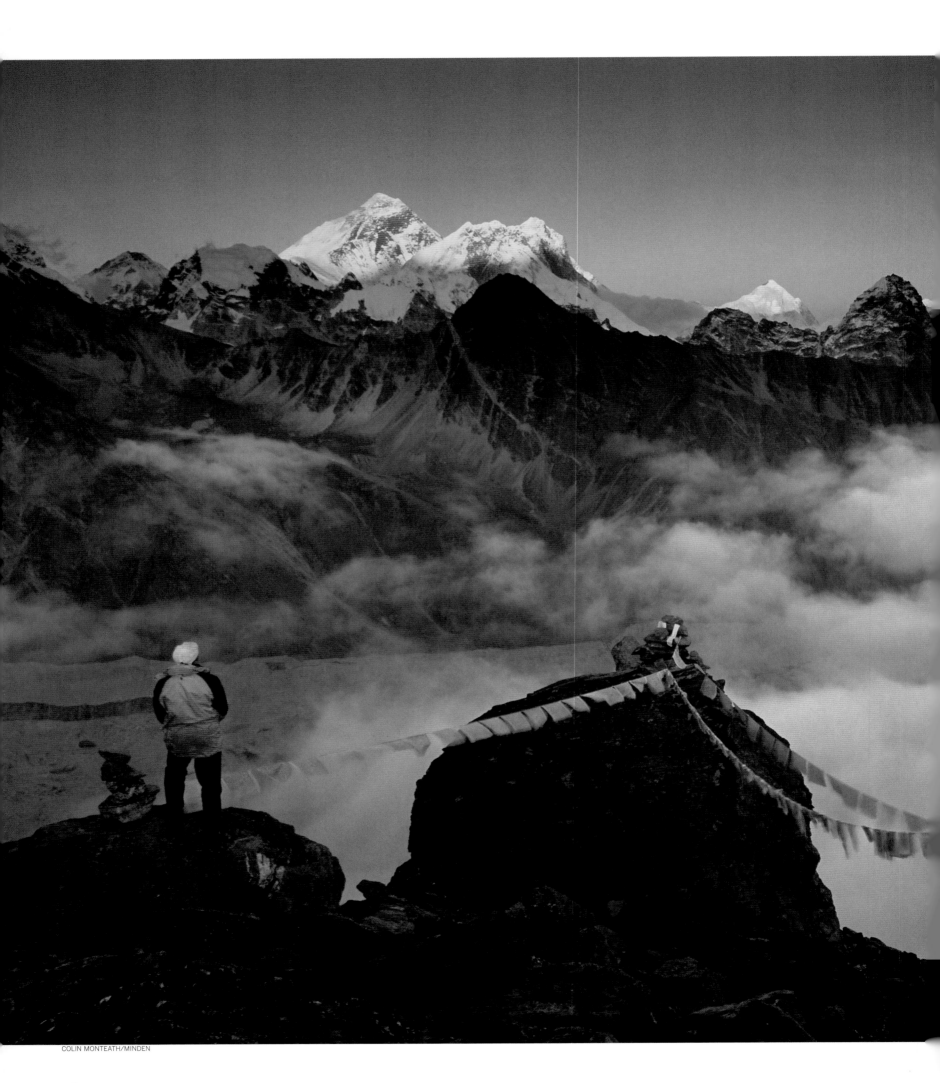

108

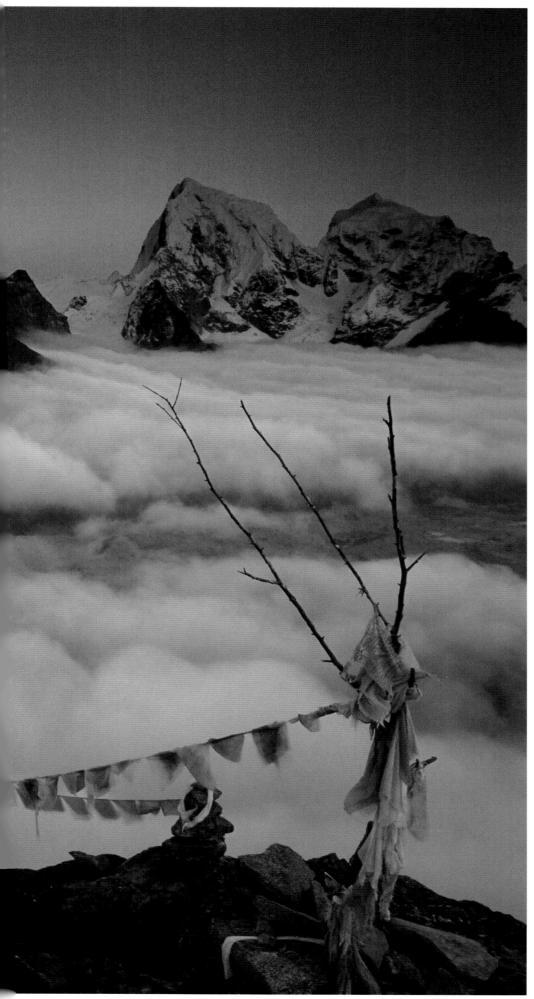

Nature's
Wonders

A mountaineer on Gokyo Ri enjoys a sunset view of Everest's glistening summit (left). It is astonishing to consider that this lesser but still formidable Nepalese peak, at 17,575 feet, doesn't come within two miles of Everest's height. And the big are getting bigger: The Himalayan Mountains are continuing to grow, and Mount Everest gains an average of 2.4 inches each year.

Mount Everest

The legendary British mountaineer George Mallory, who would die on the great mountain's slopes in 1924, said that he accepted Everest's challenge "because it is there." His response was at once elemental, ominous and thrilling—quite like the peak itself.

The story of the world's tallest mountain began 45 million years ago when the continent of India, moving northward, collided with Asia. Among the crash's ramifications was a mountain range that would become the world's highest. The people who eventually came to dwell to the south of those peaks bestowed upon them the name Himalaya, Sanskrit for "abode of snow." The attitude of that distant past held that the very highest of these mountains ruled over a mystical, spiritual realm. Chomolungma, the Tibetans called it, Mother Goddess of the Earth.

Much of the world knows the 29,035-foot-high mountain as Everest because in 1856, George Everest led a British mapping expedition to the region. He called it Peak XV, but others named it for him. After the scouting came the climbing: By the late 1800s, ascents were being made throughout the Himalayas, and men began wondering how to conquer Everest—how to overcome its avalanches, crevasses, bitter cold and relentless wind.

By 1953, when Auckland, New Zealand, beekeeper Edmund Hillary and his Sherpa climbing partner Tenzing Norgay were tapped by their British expedition to make a summit assault, there had been decades of failure and at least 13 lives lost on Everest. Hillary and Norgay succeeded, and they were world heroes by the time they reached base camp.

In their footsteps have trodden hundreds of others. Today, guides lead tours to the top, and there have been times when dozens have reached the summit on the same day. For his part, Hillary, who died in 2008, felt late in his life that this Wonder might be getting less wondrous. "I don't think a climber can get the same joy out of it as we did," he told LIFE in an interview commemorating the 50th anniversary of his triumph. "Those sorts of challenges simply don't exist anymore. We were born at the right time."

The Amazon

Here we refer to both South America's legendary river and its surrounding rainforest, interrelated and interdependent Wonders of extraordinary dimension and influence. The forest, at more than 2.1 million square miles, is the world's very biggest; the river, at 4,000 miles, is technically the second longest (to Africa's Nile) but is far and away the largest if we consider its entire watershed, number of tributaries and the volume of water borne to the sea. Consider: The Amazon by itself accounts for approximately one fifth of the water delivered to the oceans by all the world's rivers.

That massive outflow is, according to tradition, what caused the Amazon to be discovered by Europeans: A ship's captain was stunned to find that, 200 miles out to sea in the Atlantic, he was sailing in freshwater, and went to investigate. The first exploration of the river's entire length was made by the Spanish conquistador Francisco de Orellana in 1542. Among his less pleasant adventures on the river were attacks by tribes of female warriors. These reminded him of the Amazons of Greek myth, and the river was given a name.

The Amazon, which travels through six countries, has literally thousands of tributaries—17 of them are more than a thousand miles long each—and carries water from more than 40 percent of the continent's landmass. It is more than six miles wide in places, and seldom less than four. It is an immensity.

As is its eponymous rainforest, which is so big it affects the world's climate (and thus represents an environmental issue of enormous concern, what with the pressures of deforestation). While the river is home to some 3,000 types of fish—nearly a third of all freshwater species in the world, among them the ravenous piranha—the forest nurtures 300 kinds of mammals, and all sorts of amphibians, birds, reptiles and insects, along with thousands of plant species, including sheltering trees that form a canopy up to 200 feet high. Name an exotic, and the Amazon's probably got it. Snakes? Anacondas: We have anacondas. Want a big cat? We've got jaguars and ocelots. Of course, there are monkeys galore; for fans of winged things, there are colorful toucans with foot-long beaks and harmless but nevertheless fear-inducing vampire bats.

The Amazon: sine qua non.

Nature's
Wonders

Right: A scarlet macaw flies beneath the rainforest canopy bordering the upper Tambopata River in the Peruvian Amazon. Below: A stingray rests on the sands of the Rio Negro. Opposite: The emperor tamarin is a very funky squirrel-size monkey.

JOEL SARTORE/NATIONAL GEOGRAPHIC/GETTY

CLAUS MEYER/MINDEN

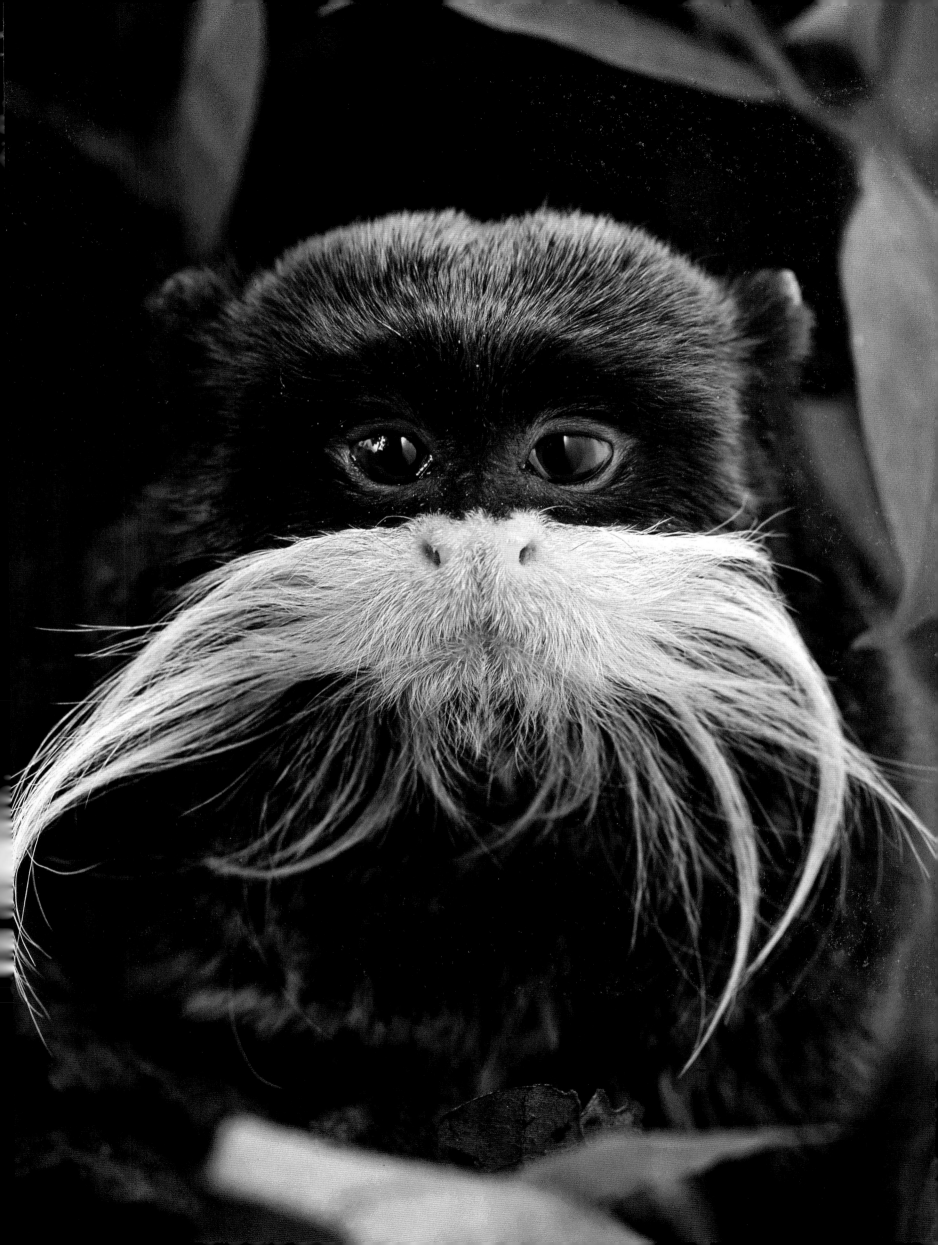

Lake Baikal

Take all the water from the five North American Great Lakes and pool it, and you still have less water than there is in Russia's Lake Baikal, the largest freshwater lake in the world by volume—a reservoir of fully 20 percent of the planet's entire freshwater supply. The maximum depth in Lake Baikal is more than a mile beneath the waves. Baikal is also considered the oldest lake in the world, with an age between 25 million and 30 million years. It sits in a Siberian locale at a relatively high altitude, nearly 1,500 feet above sea level. All of these singularities combine to lend Baikal its most remarkable aspect: an almost impossibly rich diversity of flora and fauna. The so-called Galápagos of Russia nurtures more than a thousand species of plants and at least 1,500 kinds of animals. Eighty percent of these species are endemic to Baikal and found nowhere else in the world.

If Baikal boasts nothing quite as strange as the horrible-looking deep-sea fish that haunt our oceans' thermal vents (page 104), there is

It will be unsurprising to learn that it gets mighty cold in Siberia in wintertime. Below are two hikers on the lake in March 2007. At left is a reenactment for a film made in Russia recounting the longest horse ride in history. In 1889 a Cossack named Dimitri Pechkov and his small horse, Serko, traversed from the Amur River to St. Petersburg—some 4,000 miles in less than 200 days. In the movie, Lake Baikal was a more than perfect stand-in.

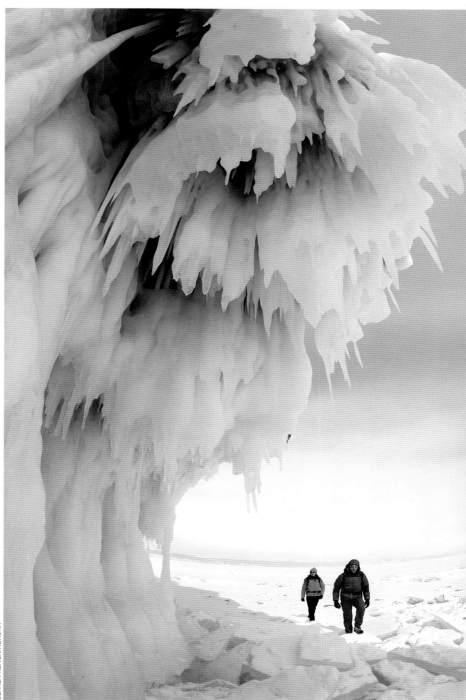

still strangeness to be found. Consider the two species of golomyanka, translucent fish that grow to just less than a foot in length and dwell between 700 and 1,600 feet down. They are also known as Baikal oil fish, as they quickly decompose in sunlight, leaving behind a patch of fat, bones and oil. It is estimated that there are more than 100,000 tons of these fish in the lake, and they would overwhelm the ecosystem were they not preyed upon by other animals. The good news is that they are the chief dietary staple of the Baikal seal, of which there are more than 60,000. This small pinniped, which grows to just over four feet long, is one of only three species of freshwater seals in the world and is the longest-lived of all seals, with females sometimes reaching 56 years of age.

No one is sure how the seal first got to Baikal, as the lake is hundreds of miles from the nearest ocean. Was there perhaps an ancient channel to the Arctic Ocean? This is only one of many mysteries attached to this remote, mysterious lake.

Nature's
Wonders

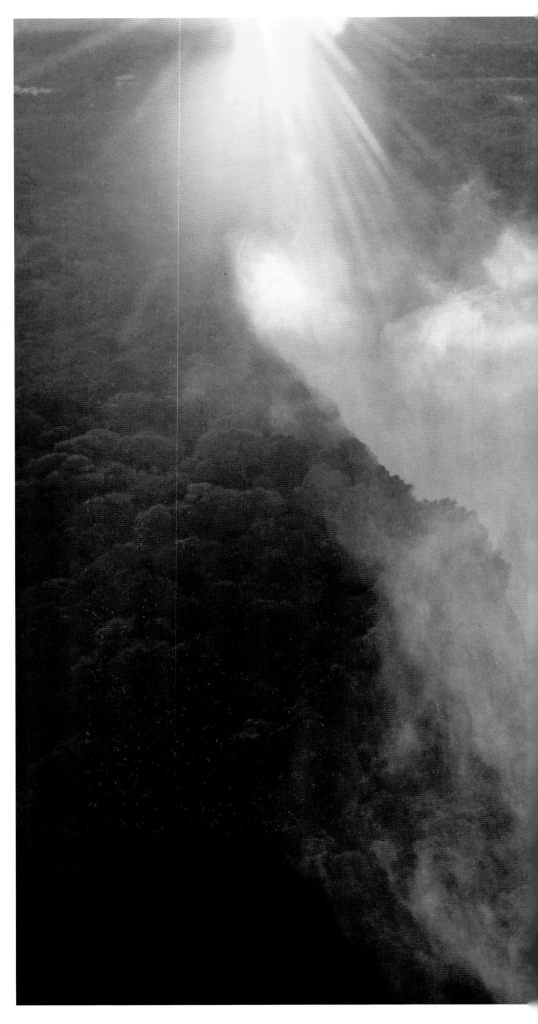

During the rainy season, from late November until April, the Smoke that Thunders rises above the waterfall on a near daily basis, occluding the Zambezi plain. Although Niagara Falls, for instance, has a higher annual average flow rate, the level of the Zambezi River is so impacted by Africa's weather in different seasons that Victoria holds the record for the highest single flow ever, anywhere.

Victoria Falls

As touched upon in the introduction to our book, large waterfalls impress in different ways. There is the ethereal wispiness of a high falls viewed from afar, its spray drifting and the sound of the river barely discernible in the breeze. Angel Falls, which we will visit shortly, and Yosemite Falls fit this bill. There is the dramatic tumult of long cascades over big rocks, such as those in raging rivers of the American West: the Tuolumne, the Snake. And then there is the thunder of a wide and mighty stream finding itself, suddenly, at a precipice, with no option but to plummet. The cauldron that is Niagara comes to mind. And even more—Victoria.

The Zambezi River has an easy time of it as it rolls Mississippi-like through south-central Africa. By the time it reaches the edge of a 350-foot-deep rift at the Zambia-Zimbabwe border, it is more than a mile wide, fat and carefree. Then its reverie is shattered. The Zambezi's flow is flung into the abyss and crashes toward Batoka Gorge in the world's largest curtain of water. Furious and frothing now, it is redirected to Mozambique Channel, thence to the sea. As the river tumbles, it throws off spray, and Victoria's hallmark characteristic forms above the cliffs: clouds of water and vapor that rise as much as a thousand feet in the air. *Mosi oa Tunya,* the locals called this phenomenon for centuries before the white man arrived: the Smoke that Thunders.

That white man was none other than David Livingstone, the famous Scottish missionary and physician tracked down, in 1871, by Henry Stanley ("Dr. Livingstone, I presume?"). Earlier, in 1855, Livingstone was exploring the Zambezi when natives took him to the falls. He wrote for the folks back home an effective metaphor, suggesting that if one imagines "the Thames leaping bodily into the gulf, and forced there to change its direction, and flow from the right to the left bank, and then rush boiling and roaring through the hills, he may have some idea of what takes place at this, the most wonderful sight I had witnessed in Africa." Livingstone, dutiful son of the empire, named that sight for Queen Victoria.

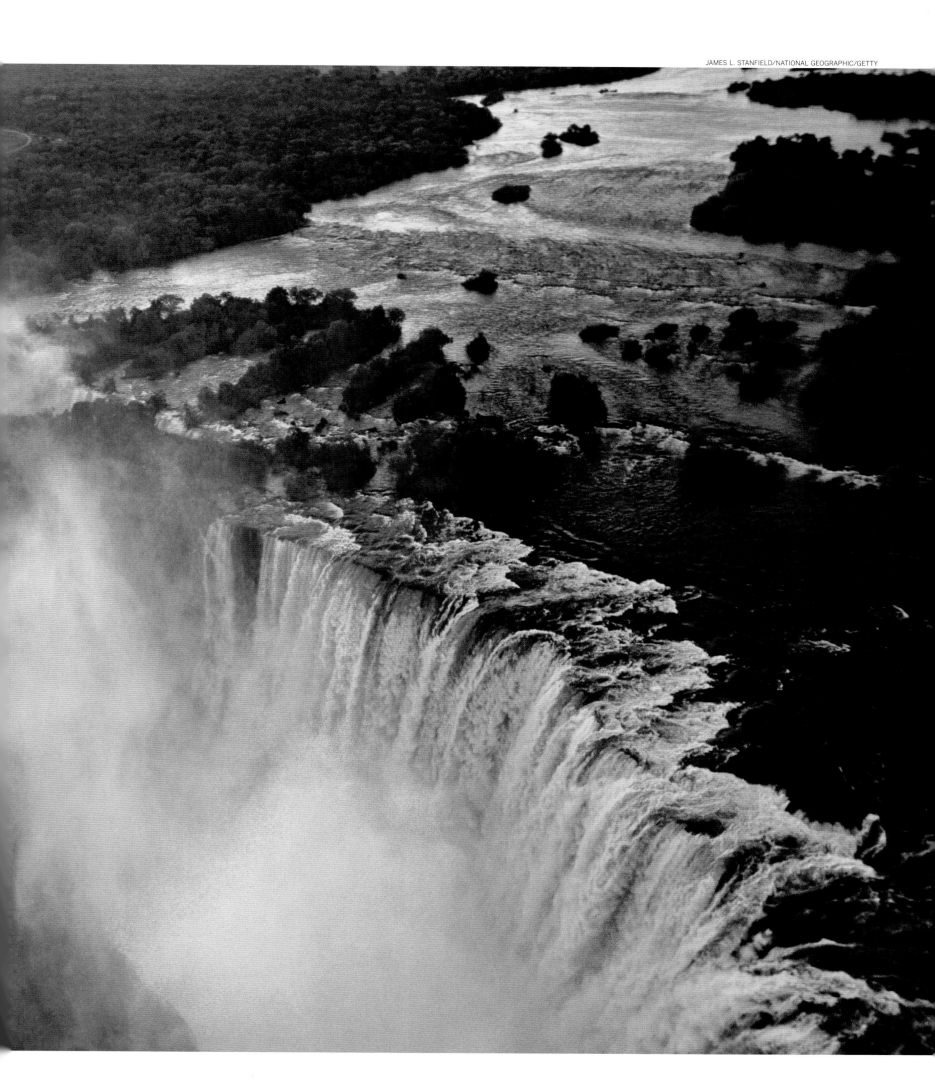

Yellowstone

More than 100 countries throughout the world now have national parks or reserves. But in 1870, when Congress created a park at the headwaters of the Yellowstone River, there were no others. Yellowstone would be an experiment. The question: Was exceptional land worth preserving, whether for its uniqueness or biodiversity or weirdness or whatever? The resounding answer, nearly a century and a half later, is yes.

Yellowstone was certainly unique, possessed of biodiversity and weird in the extreme when Congress set it aside for preservation way back when. There had been rumors for much of the 19th century—in fact, since the first white man happened upon the area in 1807—that there were strange and wondrous phenomena ongoing in a vast tract of land straddling the Wyoming and Montana territories. In 1870, Henry Dana Washburn, a former Republican congressman from Indiana and, before that, a general in the Union Army, led an expedition into the mysterious region, hoping to find the headwaters of the Yellowstone River. Washburn and his fellow travelers were not environmentalists by persuasion or philosophy, but they were so impressed by the lakes, valleys and particularly the geysers in the region that they concurred—with but one dissenter—when a member of their team, Montana judge Cornelius Hedges, suggested that the area be preserved as a park. After returning from their journey, during which they gave names to Old Faithful, Giant and Giantess, among several other geysers, the men pushed their referendum with lectures, editorials and articles, arguing not

A bison—which, along with the gray wolf and the grizzly bear, is counted as Yellowstone royalty—passes in front of Castle Geyser. It was named by the Washburn-Langford-Doane Expedition of 1870, and Nathaniel P. Langford wrote at the time: "A vent near it is constantly discharging a large stream of boiling water, and when the geyser is in action the water in this vent boils and bubbles with great fierceness." It is in such action once every 10 to 12 hours, erupting water to a height of 90 feet.

just from a tree-hugger's perspective but from that of a tourist agent. With the enthusiastic support of rail officials and concessionaires, they carried the day.

The park sits upon a 2,000-degree lake of molten rock, an underground pressure cooker 50 miles long and 30 wide. For at least a few million years, since magma burned a hole under Wyoming's ancient bedrock, Yellowstone periodically disgorged a small ocean of lava in eruptions hundreds of times worse than any recent volcanic explosion on the planet. Today, volcanic action heats rock beneath the surface, and this in turn creates all manner of thermal spectacle in thousands of steaming hot springs and hundreds of geysers, plus bubbling mud pots and fumaroles.

By the way, Yellowstone may blow one day. If it does, run.

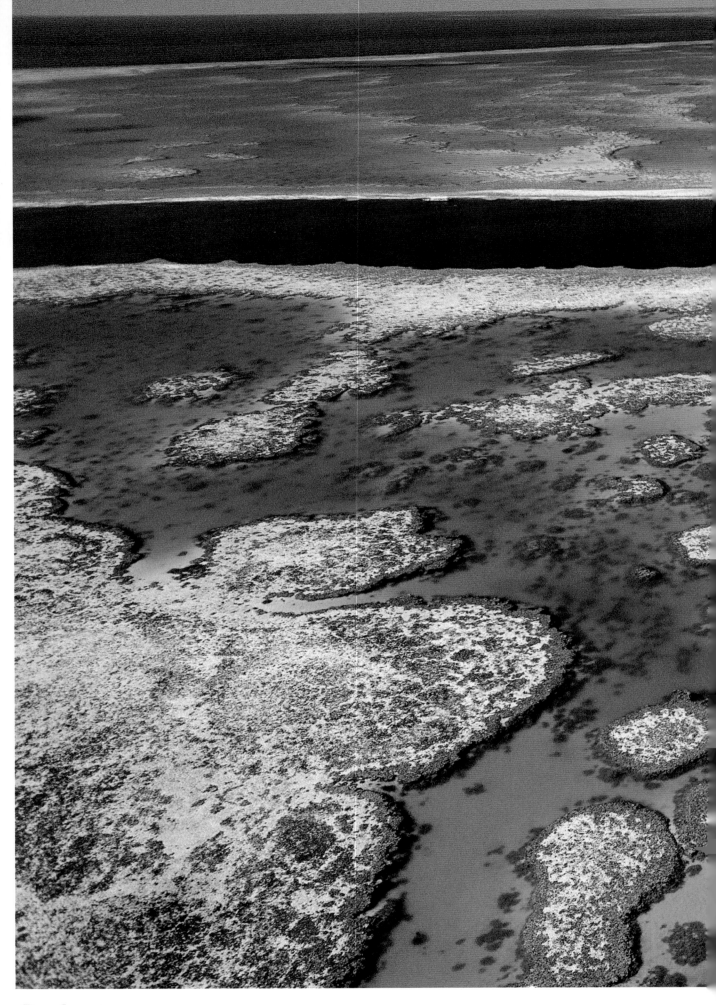

Nature's Wonders

Off Queensland, Australia, near the Whitsunday Islands, are two reefs, Hook and Hardy, separated by a 200-foot-deep tidal channel known locally as the River. The diving and snorkeling in the region are, as you might guess, beyond belief.

The Great Barrier Reef

This, as opposed to the Great Wall of China, is the Wonder that is a cinch to see from outer space. At more than 1,200 miles in length and covering more than 100,000 square miles in all (it's about half the size of Texas), the Great Barrier Reef, off the northeastern Australian coast, is as glorious to behold from afar as it is up close. It is by far the biggest of our Natural Wonders.

The reef is an often misunderstood entity. For starters: It's not one coral reef but an interconnected series of perhaps 3,000, ranging in size from barely more than an acre to 25,000 acres. It was long believed that the reef was as much as 20 million years old—not a far-fetched theory, given that relatives of modern corals developed as long ago as 230 million years—but new evidence indicates a birth date of approximately 600,000 years ago. In fact, the structure of the reef as we know it today, built upon dead reefs below, dates back only 6,000 to 10,000 years.

Regarding its bounteous animal population, the Great Barrier

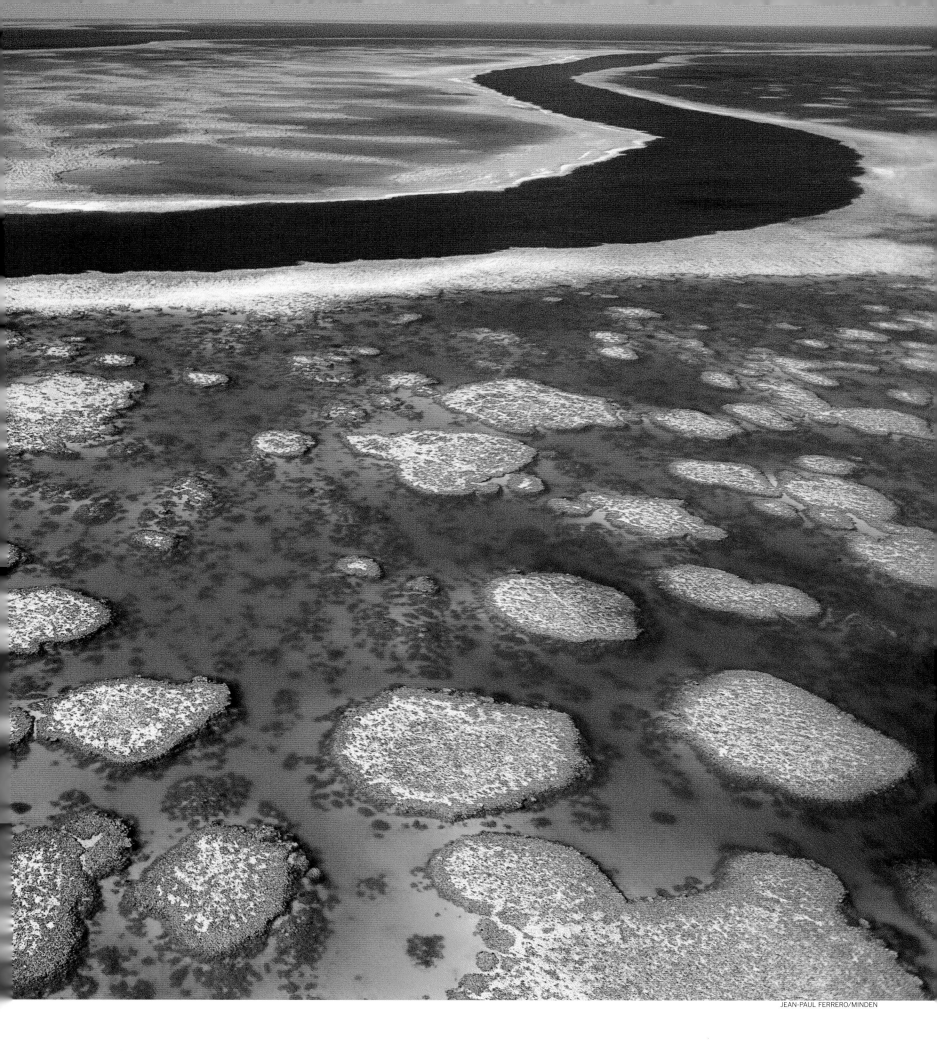

Reef supports more than 1,500 species of fish, 4,000 species of mollusk and 400 species of coral. That's right: The tiny, colorful specimens that make up what has been called the world's largest living organism are not plants but animals. Coral polyps and hydrocorals are smaller relations of jellyfish and sea anemones, crowned with colorful tentacles. They exist in colonies and become fixed by remnant algae, sponges and other decayed creatures. White coral indicates polyps that have died; the brilliant pastels that are the reef's hallmark show vibrant life.

As for the life of the Great Barrier Reef itself: It is being threatened by two tenacious predators: the crown of thorns seastar and man. The former is a starfish that can grow to nearly two feet in diameter and that has, since 1960, been eating away at parts of the reef. The latter may be warming the oceans with his industrial ways, perhaps allowing the crown of thorns to proliferate, and is surely polluting the seas, where a most delicate life-and-death balance is maintained. For now.

Nature's Wonders

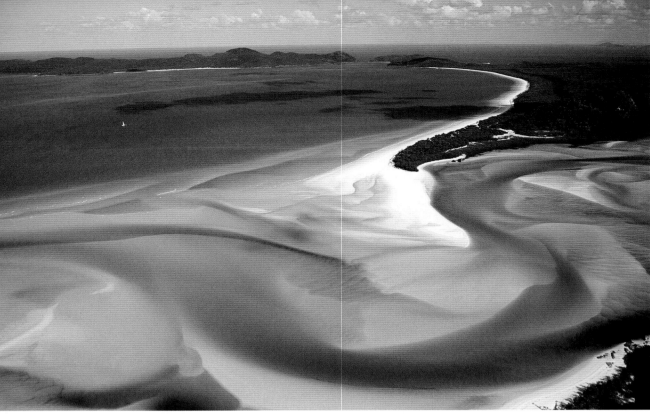

Top: The silica sand of Whitehaven Beach on Whitsunday Island, largest in a group of 74 isles and cays also called the Whitsundays, beckons human visitors. Just offshore dwell exotic denizens of the deep: a green turtle feeding on jellyfish (above); a cuttlefish (above, right); two clown anemonefish, upon which Disney's intrepid Nemo was based, swimming past a magnificent sea anemone (right); and, opposite, a venomous lionfish, whose fins can cause a diver great discomfort, and in extreme cases, death.

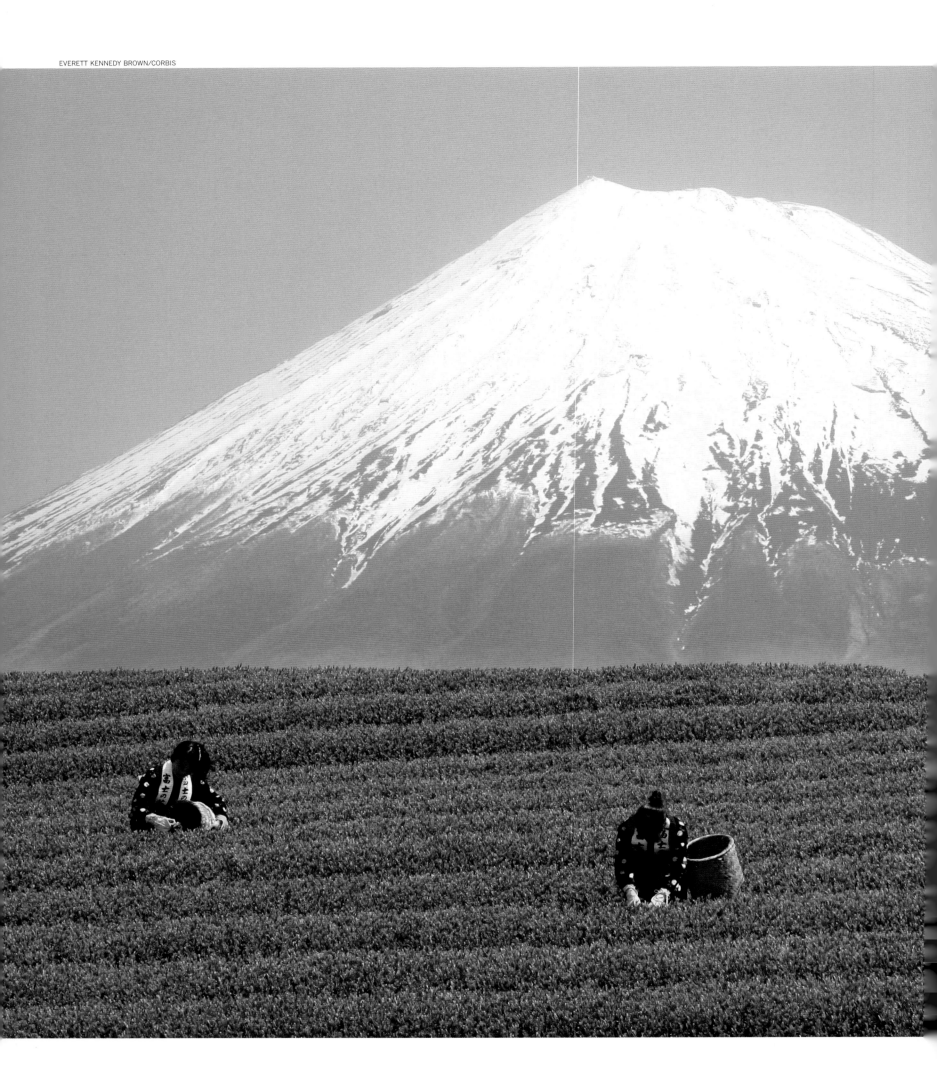

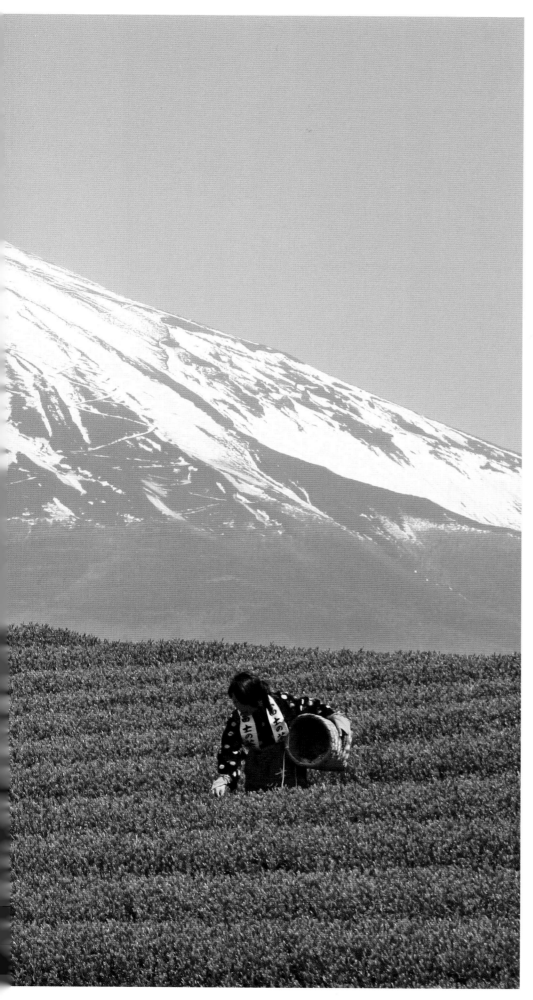

In spring, Japanese women, in traditional farmers' clothing, pick "first flush" tea leaves while Fuji looms in the background. Shizuoka province is Japan's primary tea region, producing 45 percent of the nation's yield, and first flush harvests in April and May account for 80 percent of the local farmers' income. When the young leaves have been picked, climbing season on Fuji is not far off.

Mount Fuji

At 12,388 feet, it is the tallest mountain in Japan but hardly among the tallest in the world. It is not by any means an impossible mountain to climb; thousands make the ascent each summer. It is unquestionably beautiful, but there are beautiful and distinctive mountains everywhere: the Matterhorn in the Swiss Alps, Kilimanjaro in Africa, Mount Rainier in Washington State. How, then, is Mount Fuji a Wonder?

We consider it so because more than any other peak, perhaps including Everest, Fuji transcends its mere physicality. One of Japan's three holy mountains, Fuji, along with its surrounding realm, is indeed considered a sacred place by many of that country's citizens. There are temples and shrines dotting the area, and, fittingly, tradition holds that the first ascent to the summit was made in 663 by an anonymous holy man. (Back when, pilgrims wore white robes when hiking on Fuji, and women were forbidden from taking part, lest they stir jealousy in the goddess of the mountain.) A sect called the Fujiko considers their mountain so deeply spiritual that it possesses something that might be considered a soul. The etymology of the name Fuji is debated—one scholar long ago speculated that it means "a mountain standing up shapely as an ear of a rice plant"—but most Japanese stick with the interpretation that their mountain stands for "immortality" or "everlasting life."

And make no mistake, it is *their* mountain. Fuji has always been a national symbol as well as a religious one: eternally, along with the rising sun, one of the two emblems of Japan.

Returning to its physical beauty, Fuji's exceptionally symmetrical cone has probably been rendered artistically more often than any other Natural Wonder. A technically still active stratovolcano whose last eruption was in 1707, Fuji is graced, on its northern slopes, with five lovely lakes created by the damming effect of lava flows. If you've seen a picture of the mountain perfectly mirrored in still waters, you've seen a photo of Fuji taken from the far shore of the lowest lake, Kawaguchi.

To the least poetic and most secularly inclined among us, Fuji is undeniably exquisite. To many others, it is much, much more.

In early voting in the New7Wonders poll to choose the greatest and grandest spectacles in nature, Angel was trailing Niagara among waterfalls. However, we choose Angel as it is some 16 times higher than the famous horseshoe-shaped falls on the U.S.-Canadian border. And because it is truly, rapturously lovely.

Angel Falls

This is a superbly named Wonder. When you gaze up at this ethereal waterfall in Venezuela's Guayana Highlands, where it leaps from the edge of Auyantepui, a tabletop mountain, and plunges more than half a mile to the river below—the curtain of water diffusing and growing lighter as it goes—you think: Angel. Of course: Angel Falls.

That the moniker fits its subject so snugly is an accident of fate. The world is fortunate indeed that the name of the aviator from Missouri who flew over the waterfall on November 16, 1933, while searching for ore in them thar hills, and then reported his thrilling find, was James "Jimmie" Crawford Angel. Had Jimmie possessed a surname along the lines of, say, Brown or Black—or Little or Small or Short—then the appellation bestowed upon this tallest and most glorious waterfall might have provided a considerably less suitable match.

Angel Falls, which is in a remote jungle area and remains hard to reach today, is 3,212 feet tall—16 times the height of Niagara, three times that of the Eiffel Tower, more than twice as tall as the Empire State Building. It has two drops, the longer of which is a clear plunge of 2,647 feet. As for that diffusion of the water: It is in fact vaporization. The liquid is in free fall for so long, it is turned into mist by the winds.

The waterfall wasn't immediately named for Jimmie Angel after his 1933 discovery. He returned in his monoplane with three companions, including his wife, four years later, hoping to alight on the top of Auyantepui. The plane became stuck in mud upon landing, and the party had to trek off the mountain and fight through thick forest for 11 days before reaching civilization. When news of their intrepid adventure spread, Angel became a legend in Venezuela, and the waterfall was named in his honor.

The aviator died in Panama in 1956 after a flying accident. His sons returned to Venezuela four years later and, granting their father's wish, scattered his ashes over Angel Falls.

You've traveled now to the Wonders of the World. Which were your favorites? It's a question that we at LIFE asked ourselves, with you in mind. Which of the seven would our readers like to frame and put on the wall? We hope we have selected wisely, and that you enjoy the prints on the pages that follow, taken through the years by some of the magazine's most accomplished photographers—whose stories are told in the accompanying captions.

Please do not remove

The
7 LIFE
Wonders

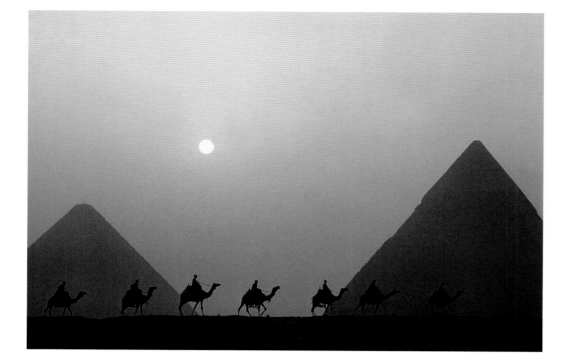
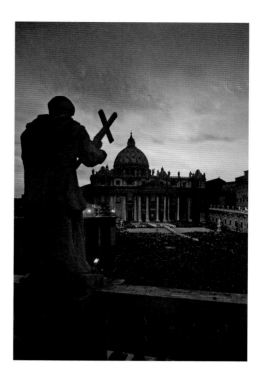
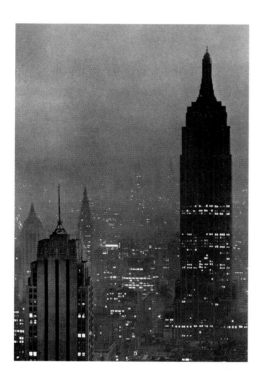

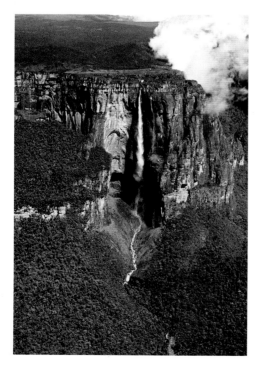
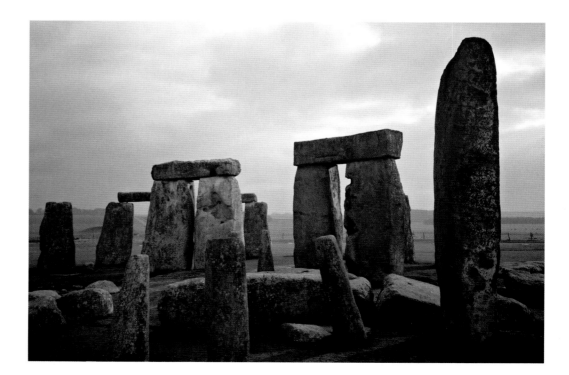

The 7 LIFE Wonders

The Great Pyramid of Khufu, 1962

Photograph by Eliot Elisofon, 1911–1973

Africa was one of Elisofon's great subjects, but then there were so many: war, Hollywood starlets, jazz singers, culinary still lifes, Tahitian natives. That he would become one of the world's most talented, intrepid and versatile shooters could scarcely have been predicted: At Fordham University, the eclectic Elisofon was a premed student majoring in philosophy. But it was at about that time that he took up a camera, and after graduating he forged a successful business in commercial photography. He gave that up to join the staff of LIFE. Noting that the camera "says too much," the driven Elisofon sought "to try to take pictures that are impossible to take." He carried his gear into some serious danger zones during World War II. Once, leaving North Africa, his plane crashed and burned the trousers right off him. According to war correspondent Ernie Pyle, "Elisofon was afraid like the rest of us. Yet he made himself go right into the teeth of danger. I never knew a more intense worker." After the war, he went everywhere and shot everything, returning time and again to Africa, capturing on film subjects ranging from tribesmen in the Belgian Congo to, in 1962, Khufu's monumental tomb. Elisofon's legacy lives on in the LIFE archives and also in the nation's capital. He bequeathed 80,000 photos of Africa to the Smithsonian.

Angel Falls, 1965
Photograph by Carl Mydans, 1907–2004

Back when Mydans ventured to Venezuela in search of Angel Falls, that Wonder was darned hard to get to. But then, Mydans already had quite a history of going to difficult places and bringing back extraordinary pictures. Having started out as a newspaper reporter, Mydans switched over to the camera and at the height of the Great Depression worked for the Farm Security Administration, documenting the travails of migrant farm families. After signing on with LIFE, he and his wife, Shelley, became the magazine's first roaming photographer-reporter team. In 1941 they were sent to China to cover Japanese bombing sorties there; late in the year they were trapped in Manila when the Japanese over-ran the Philippines, and they were held captive for nearly two years before being repatriated in a POW exchange. When the prison camp where the Mydanses had been imprisoned was about to be liberated, Douglas MacArthur sent Carl in with the first tanks. Mydans's picture of MacArthur "returning" to the Philippines is one of history's most celebrated photographic images, but he was also known for his intriguing portraits of such as Ezra Pound and William Faulkner and, as we see on the opposite page, for his sublime landscapes. As David Hume Kennerly once said of him: "Carl Mydans is a photographer's photographer and a human's human."

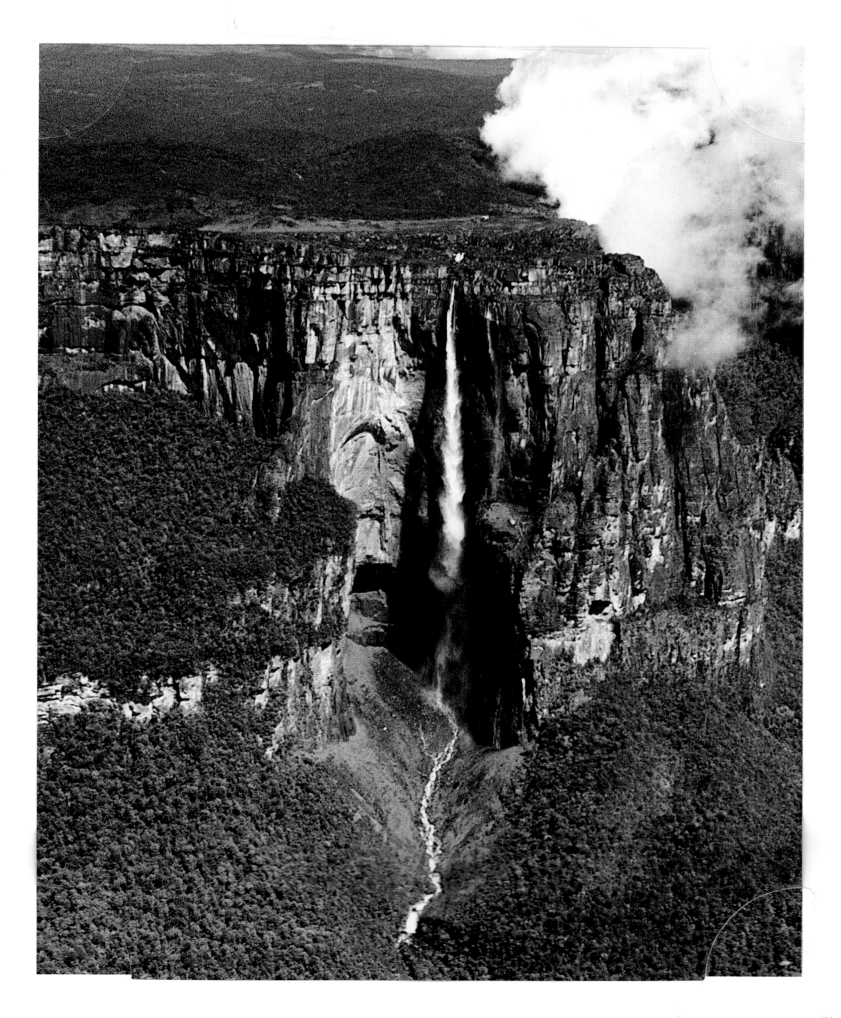

Stonehenge, 1955
Photograph by Dmitri Kessel, 1902–1995

It was said of Kessel, "He is an international human being," a telling reference to a man who lived well and long, in many places, and with many interests. He grew up in comfort, on his father's sugar-beet plantation in the Ukraine; as a boy he had a Brownie camera that he had gotten by trading a set of watercolor paints and brushes. But this tidy, idyllic life was swept away during the Bolshevik Revolution. Dmitri was drafted into the army at age 16, and that service doubtless informed his later photography of World War II. After escaping the Russian Revolution, he arrived in America in 1923 and began to concentrate on photography. His home base later became Paris, but he was a man who was at home only rarely. The world held too many attractions for this endlessly curious fellow, who was capable of shooting hard-hitting, eruptive news photos but also gorgeous architectural photography, notably of churches and cathedrals, along with stimulating photos of great artworks. Kessel was also known for his work in color. He began exploring the medium in 1937, and over the years became an expert color-printing technician. According to Kessel, his early years in photography yielded two vital lessons: "The first was the importance of self-criticism, the second how to print." Here, the superb fidelity of color harmonizes with a sureness of texture to produce a moody, haunting image—a definitive image—of often-photographed Stonehenge.

Please do not remove

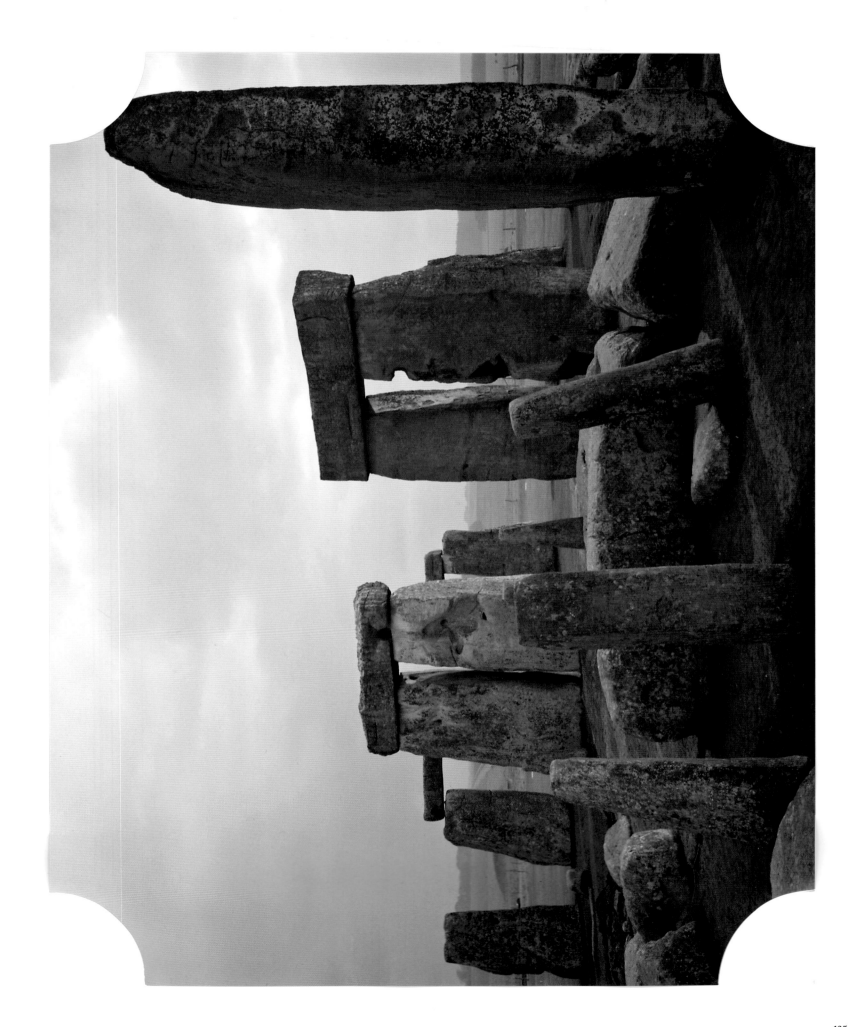

135

The Grand Canyon, 1946
Photograph by Frank Scherschel, 1907–1981

At age 14, Frank ran errands for a photo agency in Chicago. "Instead of going to high school and college, I learned psychology convincing murderers and divorcées caught with the other man to pose for pictures." By 19 he managed *The Milwaukee Journal*'s photography department, and several years later he took in his orphaned little brother, Joe, who would subsequently follow Frank to LIFE as a staff photographer. During World War II, Frank took pictures from bombers flying missions over Germany and the islands of the Pacific. At the Normandy invasion, as one of the magazine's six accredited photographers, he again shot from the air. "We thought it was going to be murder, but it wasn't," he said. "To show you how easy it was, I ate my bar of chocolate. In every other operational trip, I sweated so much the chocolate they gave us melted in my breast pocket." The skills he had learned shooting from on high during the war served him well the year after the armistice when he made this super-sharp landscape of the Grand Canyon; again, as with Kessel's Stonehenge, the strength and drama of Scherschel's photograph speak to the personality of the place in a way few other pictures do. Scherschel executed many other postwar assignments for the magazine all around the world before retiring to his wife's Wisconsin hometown, where he opened a camera store.

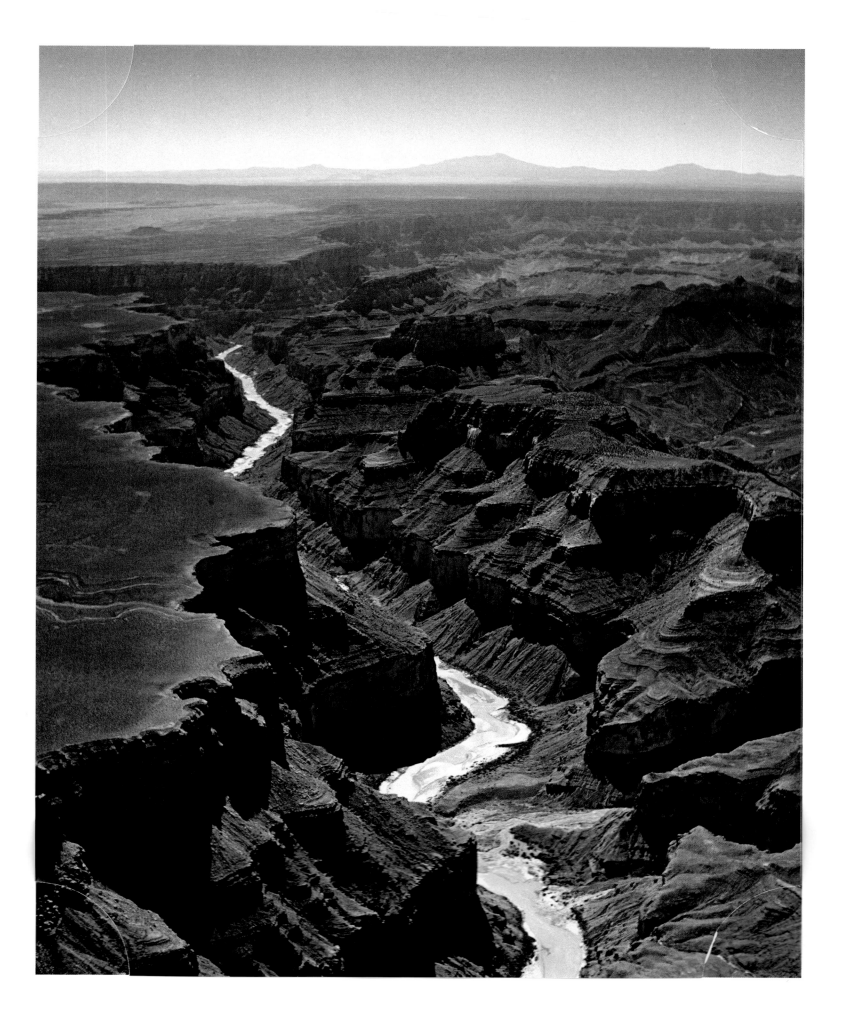

The Vatican, 1978

Photograph by David Lees, 1917–2004

We have met, in the photographers Elisofon, Mydans, Kessel and Scherschel, men known for portfolios made all over the world. Now we come to a chronicler of a specific place and time. In hundreds of photographs that appeared in the pages of LIFE, David Lees offered Americans an intimate history of Italy in the second half of the 20th century. He covered news events such as the elections of popes, significant archaeological digs, fashion shows in Milan and the devastation of Florence—its museums and cathedrals—when the Arno River flooded in 1966. And he fashioned lovely photo essays of everyday life; he is remembered still for a 1951 story about the wedding of an Italian girl and her wartime American boyfriend, which took place in the village of Passiano. All this, and he wasn't a native Italian (though he was born there to British parents stationed in Pisa). Florence was his adopted hometown, and that city and Rome were his constant subjects. In the Italian capital, Lees was equally deft at rendering a Michelangelo masterwork or a young couple buzzing by the Colosseum on their motor scooters. He was well known at the Vatican, where Pope Paul VI affectionately called him the "Florentine Englishman." When Paul died in the summer of 1978, Lees mourned, of course, and then went to work. On August 26, the world's eyes turned to the Vatican as the Catholic faithful pressed toward the steps of St. Peter's Basilica, where a High Mass was being said following the investiture of Pope John Paul I. Many photographs were made that day, but the one opposite is most special, capturing all the power and the glory.

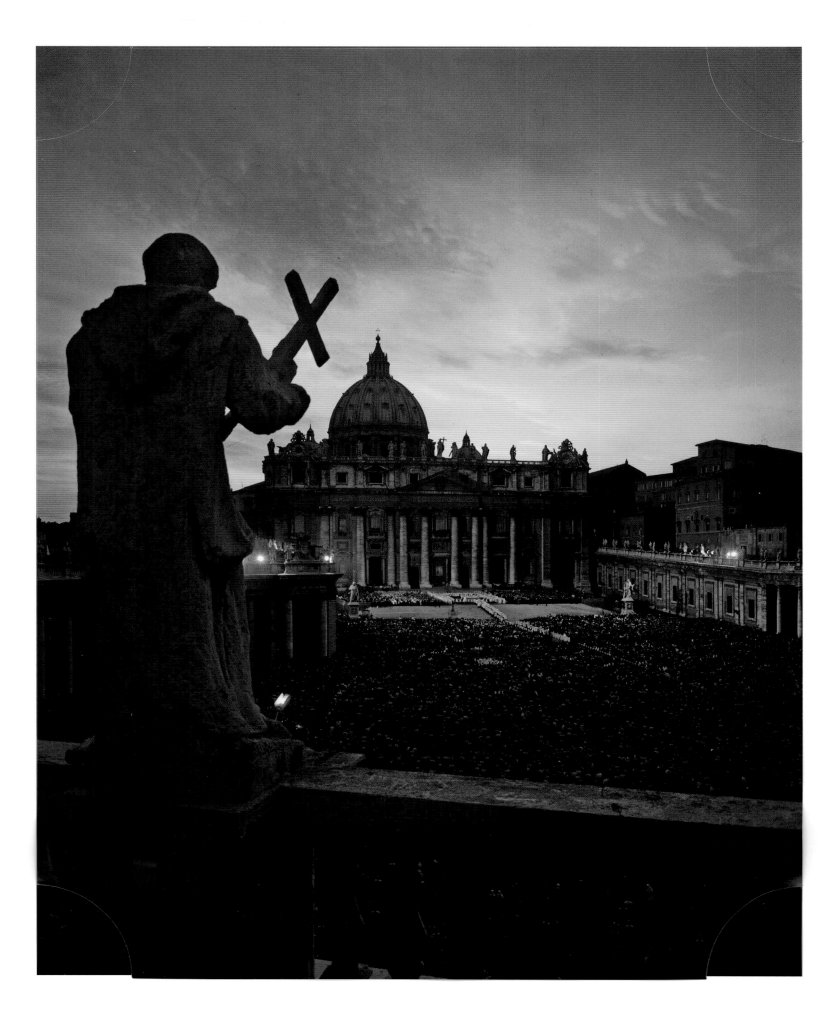

Mount Everest, 1972
Photograph by George Silk, 1916–2004

"I left school to punch cows and I left them to take pictures," said the New Zealand–born Silk. He joined the Australian Army as a photographer in World War II. Rommel's troops in North Africa captured him, but he escaped. While in New Guinea (following the Kokoda Trail for 700 miles on foot), Silk shot a picture of a blinded soldier that the Aussies tried to suppress; LIFE, however, printed it. Silk finished the war as a LIFE photographer in the Pacific. He said that he felt ashamed not to be fighting, "so I drove myself to show the folks at home, as best I could, how the soldiers lived and died." It seems we have dwelt, in these short biographies of our photographers, on their war experience. But they themselves admitted that it was what formed them, and informed all their later photography. Silk's empathy came across whether shooting fishermen or athletes. He became a noted sports photographer, despite considering some American sports ridiculous ("only girls played basketball in New Zealand"). A boatsman himself, he became the magazine's expert on sailing. And on cold weather: Silk visited the North Pole twice and once shot the America's Cup races from atop a 90-foot mast. He got plenty of cold and plenty of height during a 1972 expedition to the high Himalayas, where he made this image of Everest, a picture that compels the viewer to wonder: How ferocious must it be up there?

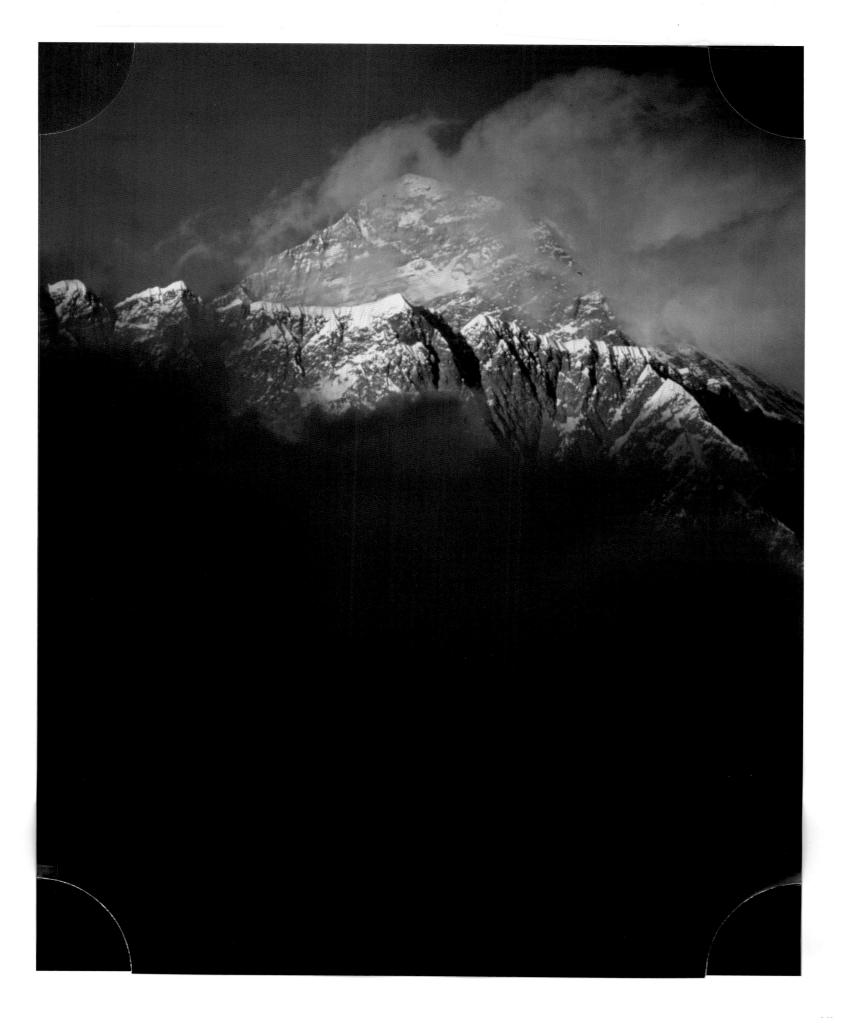

The Empire State Building, 1943
Photograph by Andreas Feininger, 1906–1999

IFE's photographers were known for their images of people, but Feininger was a profound exception. His concerns were basically with things, perhaps a continuum from his early career as an architect (he worked for a year with Le Corbusier). "Realism and super-realism are what I am after. This world is full of things the eye doesn't see. The camera can see more, and often ten times better." Not at all a people-person, Feininger wanted to carry out his work without any interference; in that chilly single-mindedness, he reminds one of Picasso. Yet it wasn't "photography" he was after, but a photograph: "I want to get shots of the things I'm interested in. I use it as a means to an end." In any case, he combined masterly technique with a discerning eye to produce work that is harmonious, incisive and formidable. A year ago, in our LIFE book *The Classic Collection,* we offered our readers a removable print of Feininger's masterpiece taken on Route 66 in Arizona in 1953: a Texaco station, a jalopy, a bus and the enormous sky above shouting a message concerning the American West. On the opposite page is the world's tallest building in 1943, its upper floors dark to conserve energy during the war years. This stark and ominous photograph speaks to America's strength—we built this phenomenal thing!—and also to the nation's potential: two elements that were, as the black windows signaled, at that moment being challenged.

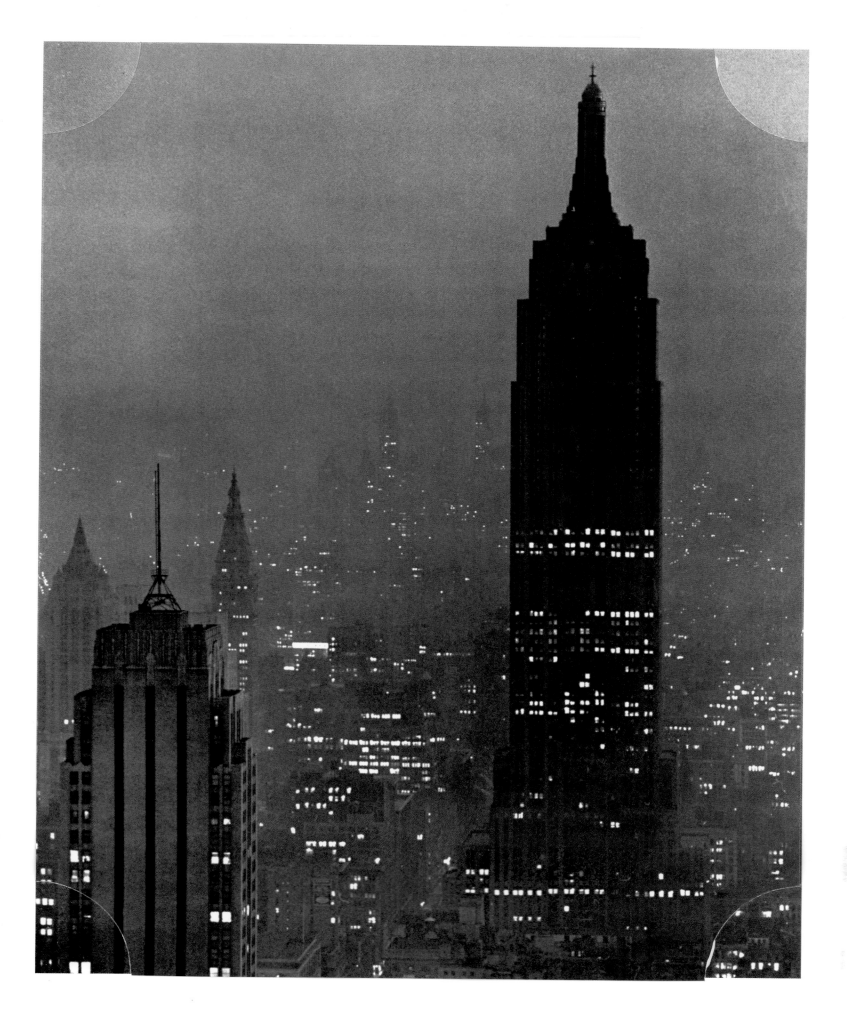

143

They are otherworldly Wonders, of neither the earth nor the sea, animated in the extreme but without animal spirit, a sensory experience beyond just the visual. They have been seen through the ages as omens, portents, signs and symbols. In the event, they are an interaction of particles, forces and gases that produces images of poetic beauty. The solar wind carries a "plasma" of energized electrons and protons cast off by the sun's corona. Within a couple of days of departing the solar realm, some of this plasma reaches Earth. Grabbed by the planet's magnetic field and pulled downward toward the north and south magnetic poles, the charged particles interact with atoms of oxygen and nitrogen, and juiced-up ions are produced. Energy is thrown off, and on the planet's nightside, the various wavelengths show themselves in patches, arcs and draperies of green, white, yellow, red and turquoise light.

The auroras borealis and australis—the northern and southern lights—seem miracles of the supernatural, though there are, as we see, rational, scientific, even clinical explanations for their splendor. Each of them, including this one over Kautokeino, Norway, is as natural as air. Each is a Wonder.

PER-ANDRE HOFFMANN/AURORA

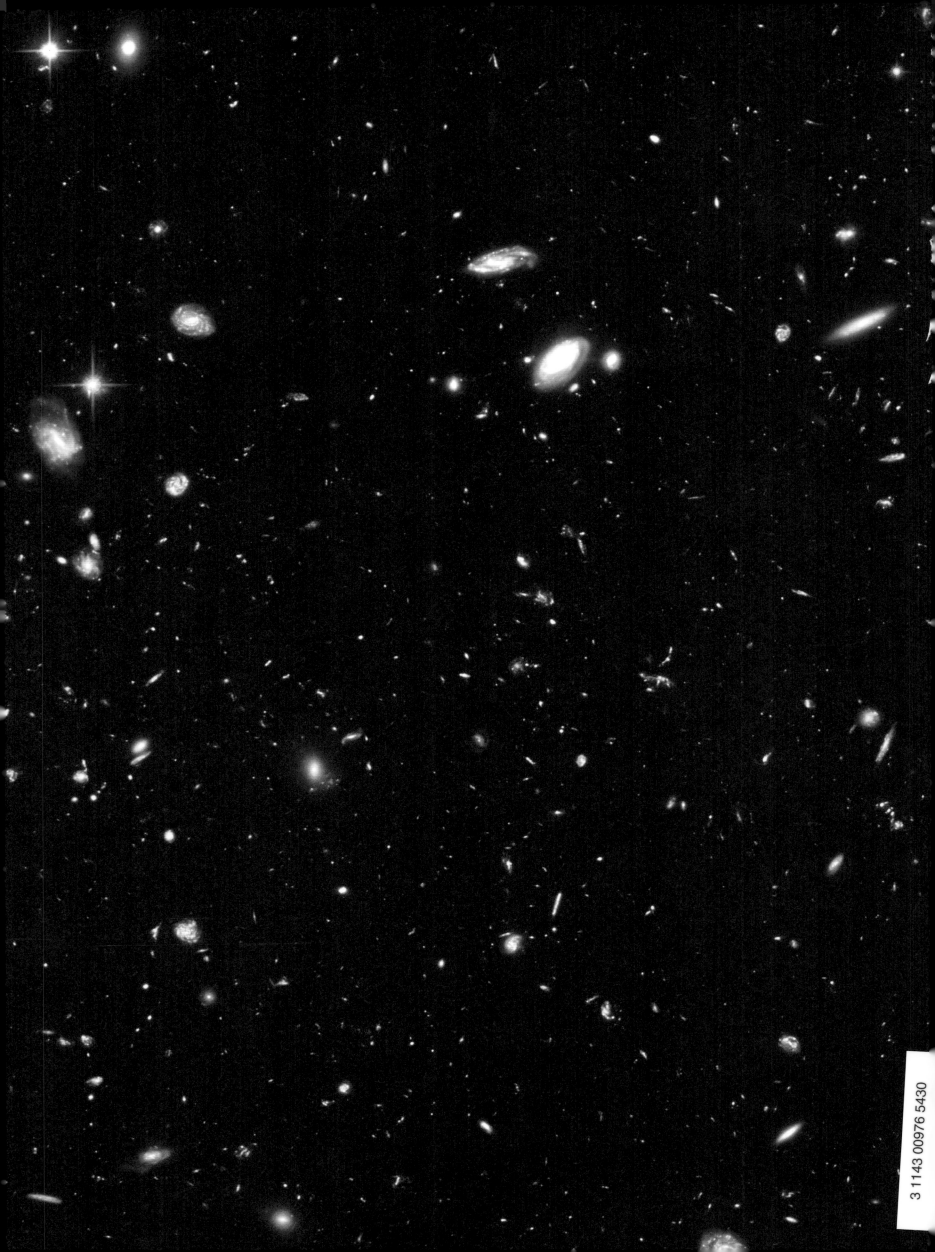